ARTISTS LAND NATURE

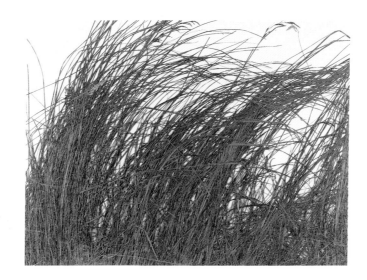

herman de vries
sedges
2000

73 x 102 cm

(detail on endpapers)

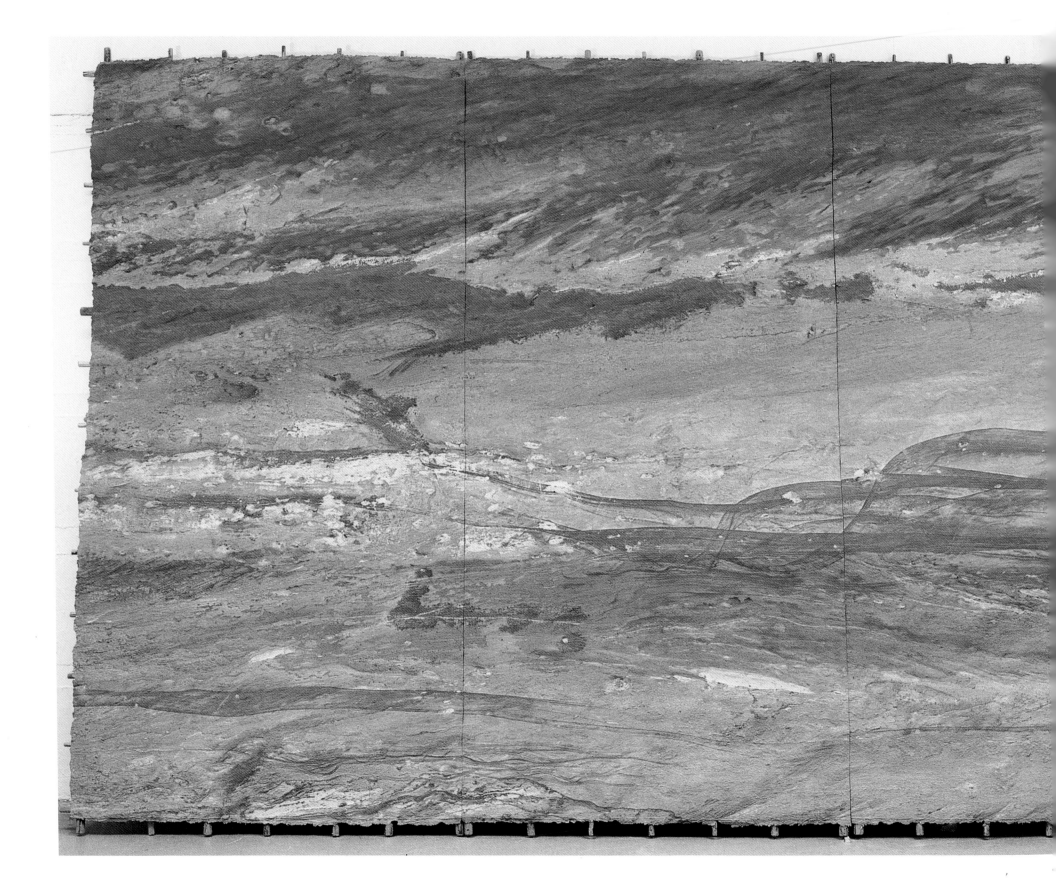

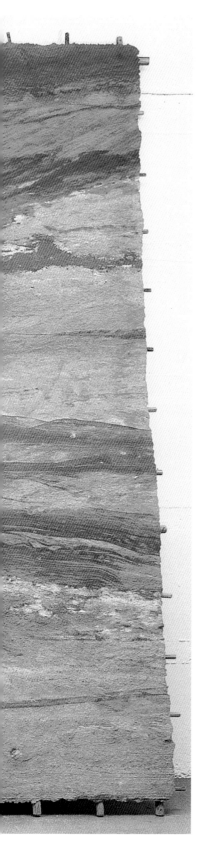

ARTISTS
LAND
NATURE

Mel Gooding

Interviews by
William Furlong

HARRY N. ABRAMS, INC., PUBLISHERS

Produced by Jill Hollis and Ian Cameron
Cameron Books, Moffat, Dumfriesshire, Scotland

Library of Congress Control Number: 2001134031

ISBN 0-8109-4189-9

Printed and bound in Italy
10 9 8 7 6 5 4 3 2 1

Harry N. Abrams, Inc.
100 Fifth Avenue
New York, N.Y. 10011
www.abramsbooks.com

Abrams is a subsidiary of

Frontispiece

Nikolaus Lang
GOOD HEAVENS, OLD ANGEPENA
Imaginary Figuration No.19
1989

Cross section of coloured sand deposits, polyvinyl acetate on calico and gauze, framework of sticks.
Maslin Sand Quarry (Adelaide), South Australia
345 x 527 x 14 cm, three sections

Contents

Listening to the Music

'The universe is harmonic or it wouldn't work.' Guy Davenport

The Mirror and the Lens

'The business of art is to reveal the relation between man and his circumambient universe at the living moment.' D.H. Lawrence

It is perhaps the primary purpose of art to enhance our awareness of the true nature of things. The artist holds up to the world a lens through which is refracted a reality that is concealed from our everyday perception. Art changes with developments in the technologies of measurement and observation in the natural sciences and in philosophy, which affect the ways in which the world may be understood and thought about, and thus perceived. Revelation, the discovering of reality, is also the purpose of science. In their pursuit of knowledge, technology and art both require skill and imply cunning or craft (knowing how). Knowledge emerges from the organisation of data. Technology provides the means to act upon the world and to gather data: as Marshall McLuhan long ago pointed out, it is an extension of the faculties by means of which human beings interact with their environment.

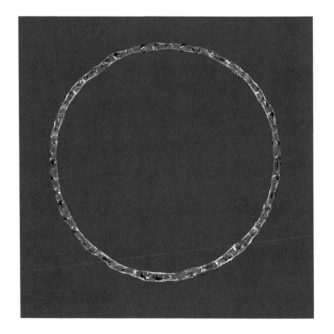

The human sensorium in the modern age has been enhanced by advanced technologies to a degree unprecedented in history, and aspects of the actual that are hidden from our ordinary senses and were for millennia invisible to mankind have been revealed by high-speed and time-lapse photography, by slow-motion film, by radiography, by advances in astronomy and microscopy, and so on. Patterns of structure and energy in natural objects, and correspondences between familiar and cosmic phenomena have been observed: the flow of bath water out of the tub and the turbulent spirals of distant nebulae are shaped by the same dynamic. A split-second cathode ray oscillation may be photographed to reveal a structure that resembles that of a whelk shell. Our sense of the world has been transformed: 'This is the constant urge of science as well as of the arts, to broaden the likeness for which we grope under the facts,' wrote Jacob

Bronowski. 'When we discover the wider likeness, whether between space and time, or between the bacillus, the virus and the crystal, we may enlarge the order in the universe; but more than this, we enlarge its unity.'

The idea of art (and of science) as a mirror held up to reality is an old one, a metaphor for the necessary process of organised mediation and representation – the revelation of the bright image – that makes it possible for us to see things clearly as they are (as opposed to those flickering shadows on the walls of Plato's cave, which are but vague distortions of realities we cannot see). I substitute the idea of a lens for that of a mirror because of the interaction between modernism in art and those specific developments in optical and photographic technology which revealed to the eye completely new aspects of appearance: what Gyorgy Kepes described as 'the new landscape'. The modern revolution in natural science led to the understanding that things exist in continuously dynamic relationships: evolutionary theory, relativity and quantum physics have this much in common. The world is different because we know it in a new and different way.

Pre-modern, Renaissance science conceived of the natural world as a closed system. It was based on an analogy with the machine, of which God was the originating creator: hence its beautiful order, like that of the chronometer or the printing press or the spinning machine or the lock. What was registered by the senses as the undeniable and constant turbulence of things on the surface of the world was merely a constant re-configuration, in R.G. Collingwood's phrase, 'changes of arrangement and disposition' of immutable material elements whose relations were governed by changeless mechanical laws. Advances in understanding consisted of clarifications or re-definitions of those 'laws' and empirical confirmations of mathematical speculation; the laws were immanent, and scientific genius could divine and define them. Alexander Pope's epitaph for Isaac Newton (1730) neatly encapsulates this thought:

Nature, and Nature's Laws lay hid in Night.
God said, *Let Newton be!* And all was *Light.*

Modern science, on the other hand, conceives of nature as an open system subject to constant and progressive change: the world and the universe of which it is a part are in constant flux. The cycles of nature with which we are familiar – of day to night, winter through spring to summer and autumn, of birth, copulation and death – are in this view but part of a larger process with its own *teleos*; they are like the many curling waves in an ocean that moves according to its own momentous destiny. This modern conception of nature is characterised by Collingwood as 'based on the analogy between the processes of the natural world as studied by natural scientists and the vicissitudes of human affairs as studied by historians'. Just as historians know that the structures of historical societies are really 'complexes of function' – ways in which people behave – so the modern natural scientist knows that 'a logically constructed natural science . . . will resolve the structures with which it is concerned into function.'

It might be noted in passing that many of the artists with whom this essay is concerned have shown great interest in the dynamic relation of those structures – the ways of behaving – of aboriginal societies with the structures of the natural world. It is as if the lives of such peoples belong at once to the order of history and of nature: Collingwood's analogy made manifest. At a deeper level this is true of all societies and all cultures, including the most modern: a city is an historical manifestation (a 'complex of functions'

Susan Derges
SOUND, WATER, LIGHT
1991

A small jet of water is vibrated at its nozzle by a loud speaker. Under constant light, sine waves cause the water to appear as a coherent standing wave; under strobe light (pulsing at the same frequency as the sound) the water is transformed into a series of individual droplets suspended in time and space. The combination of constant and strobe light reveal stationary droplets within the arc of flowing water.

indeed); it is a work of art, and it is a work of nature. No modern anthropologist has understood this so profoundly or expressed it as eloquently as Claude Lévi-Strauss:

> 'So it is not in any metaphorical sense that we are justified in comparing – as has so often been done – a town with a symphony or a poem; they are objects of a similar nature. The town is perhaps even more precious than a work of art in that it stands at the meeting point of nature and artifice. Consisting, as it does, of a community of animals who enclose their biological history within its boundaries and at the same time mould it according to their every intention as thinking beings, the town, both its development and its form, belongs simultaneously to bio-logical procreation, organic evolution and aesthetic creation. It is at one and the same time an object of nature and a subject of culture; an individual and a group; reality and dream; the supremely human achievement.'

Lévi-Strauss notwithstanding, the distinction between nature and culture, between wilderness and human settlement, has been a dichotomy at the heart of Western thinking, and, by way of Romantic thought, it has become a central desideratum of modernism. For Renaissance science, as I have indicated, the distinction took the form of a dualism that paralleled the Cartesian separation of mind and body, or more precisely, the Cartesian duality was itself a product of that larger body of thought that represented nature as insensate matter subject to mechanical laws: the world of nature, in this view, was, according to Collingwood, 'devoid both of intelligence and of life'. In our everyday consciousness of nature, we carry around much that we have inherited from the mechanics of the Renaissance revolution in cosmology. The ancient Greeks held another view: that nature, far from being like a machine, was actually a living organism, a macrocosm analogous to the microcosm of the human being. Its diverse components – plants and animals – were of an order of being separate from that of humanity, but were still imbued with vital life, having mind and soul. In the notion of a living system, of a process of functions, the modern view shares something with the ancient Greek.

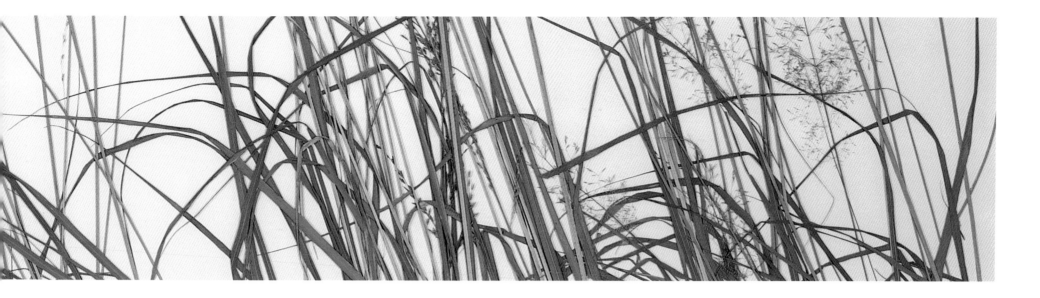

herman de vries
hasenperspektive/hare's eye-view
1995

25.5 x 180 cm

Overleaf

Chris Drury
SNOW VORTEX
1999

Five snowballs rolled in a dew pond
Firle Downs, Sussex
approximately 28 metres in diameter

Eastern philosophies of Buddhism and the Tao have also had a profound impact on the thinking of many of the poets and artists who have sought in their work to bring us back to a vital consciousness of nature as an entity, living and breathing in dynamic relation to the human: 'Therefore we may know the single mind of a single particle of dust comprises the mind-nature of all sentient beings and Buddhas . . . Who, then, is "inanimate" and who is "animate"? In the Assembly of the Lotus, all are present without division.' Quoting this observation of the 8th-century Buddhist monk, Chan-Jan, Gary Snyder observes: 'The Chinese philosophical appreciation of the natural world as the visible manifestation of the Tao made a happy match with Indian Mahayana eschatalogy.' And elsewhere he quotes Dogen, the great Zen master: 'Whoever told people that "Mind" means thoughts, opinions, ideas and concepts? Mind means trees, fence posts, tiles and grasses.'

Whatever scientists of the modern period (ever since Darwin) may have believed to be the case, and however those ideas of nature may have influenced the work of certain artists, the modernist imagining of nature is partly compounded of ideas that can be traced back to those earlier models – animistic and mechanical (and, one might add, alchemical and magical) – as well as to the modern idea of a progressive dynamism in which substance/matter and function/energy are one, a continuous process, now particle, now wave.

Art does not abrogate to itself the purposes of science; its negotiations with the natural world are intuitive and imaginative. (Of course, science at its highest levels of operation possesses precisely those qualities, but then its findings are subject to a different kind of testing.) Paul Klee, who thought as deeply on this matter as any modern artist, knew this:

'Does then the artist concern himself with microscopy? History? Palaeontology? Only for purposes of comparison, only in the exercise of his mobility of mind. And not to provide a scientific check on the truth of nature. Only in the sense of freedom. In the sense of freedom, which

does not lead to fixed phases of development, representing exactly what nature once was, or will be, or could be on another star (as perhaps may one day be proved).'

The intuitive and imaginative interactions with nature that characterise art in the modern period constitute after all something more than either a mirroring or a refraction of the actual (although both representational and abstract art claim these reflective and prismatic functions). Modernist artists do not see themselves as representing the world, but rather as reporting and recording from within it. The old view of art is not adequate to the new vision of nature. It is with modernism that art becomes an active, creative intervention in the world, and this is coherent with modern notions of nature as a dynamic process in which time and space, mass and energy are continuous. The uncertainty principal has its own history in art as in science; it became clear that the description of the world was subjective, that the observer and the observed could not be distinguished.

As science constructs realities, so does art, and both set out to define aspects of that intuitive self-awareness that is the essence of human experience. It might be that science considered as a whole – a vision of the world, a stupendous collaborative construction, always changing like the world it represents – constitutes the greatest human artefact of all. It is conversely true that art, in its manifold realisations, is a kind of science, a mode of research into the mysteries of the individuated human consciousness.

The procedures of both science and art seek to separate the figure of consciousness from the ground of unknowing nature. Nature is as multiple as the eyes that see it (and no more so). Outside that sum of relative perceptions nature is indeed unitary, but by definition unknowable; and it cannot know itself. Italo Calvino's Mr Palomar, swimming in the evening sea, surfaces to find 'the sun's reflection become a golden sword in the water stretching from the shore to him . . . wherever Mr Palomar moves he remains the vertex of that sharp, gilded triangle; the sword follows him . . .' Mr Palomar is inclined for a megalomaniac moment to think this light is aimed at him alone, a function of his position relative to that of the sun. But: 'Every bather swimming westwards at this hour sees the strip of light aimed at him . . . each has his *own* reflection . . . the sword is imposed equally on the eye of each swimmer; there is no avoiding it.' Mr Palomar is troubled by this question: 'Is what we have in common precisely what is given to each of us as something exclusively his?' The artists in this book – figures in the landscape! – demonstrate in their actions and their work the most profound understanding of his dilemma.

Their art, a new art of direct interventions in the landscape, of diverse actions on the land and of workings with natural objects, has a history of its own, but it is preceded, and accompanied to this day, by the work of those modern painters and photographers who have also understood that representing the world truthfully requires more than composing a view. Those artists know that we do not perceive the world around us as a series of pictures, that we do not perceive the space we inhabit as it was imagined and constructed by the great Renaissance theoreticians of mathematical and aerial perspective, as from a fixed viewpoint, as if framed by a window. Neither do we see it with the static clarity and singularity of image that is refracted or reflected on to the walls of the camera obscura, that other great adjunct to Renaissance artistic vision. Both devices were perfectly consistent with the mechanistic concept of nature that was the basis of contemporaneous science.

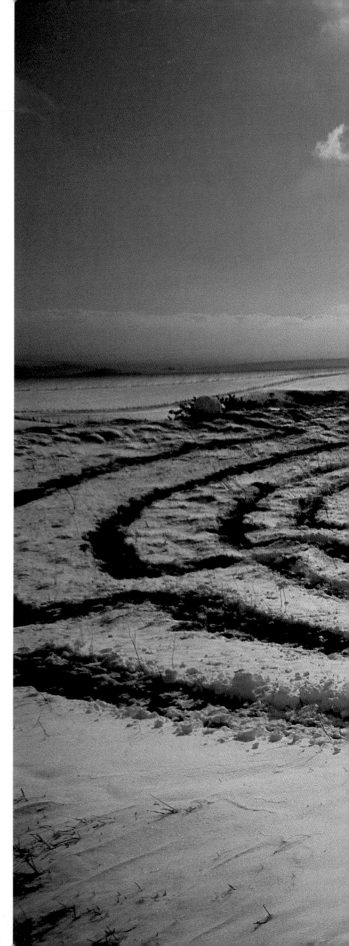

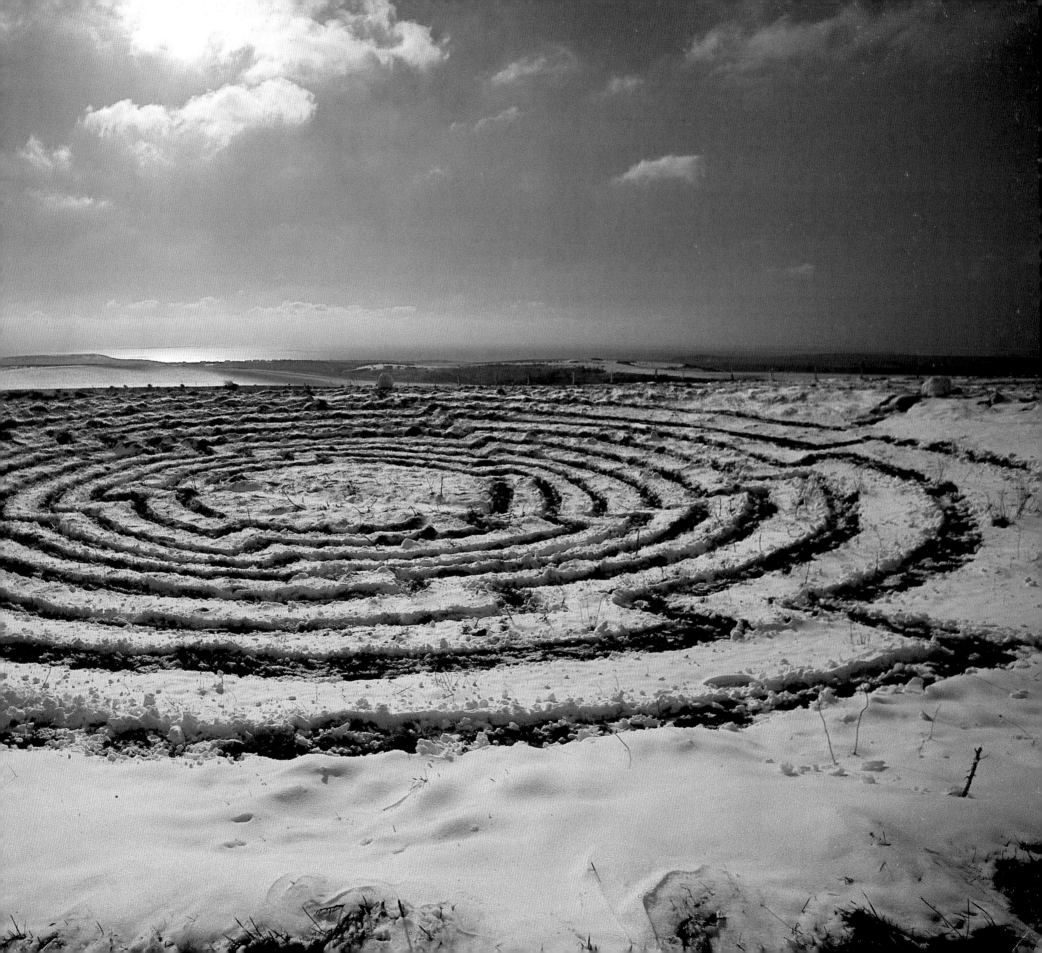

We experience nature, in fact, as simultaneous light, sound, temperature and texture. We are enveloped by what Gaston Bachelard called 'the roundness of the world': 'The world is round around the round being'. We experience the cosmos as from its centre, and apart from that experience it has no centre. Our apprehension of the world is relative and dynamic: as we change, everything else changes; as we move through space, light and time, every relation shifts. No picture can ever capture this complex actuality.

After Cézanne, the painters knew this, and they were, as never before, also aware of the psychological factors that play their part in this subjective engagement. In landscape painting, from its beginnings as a separate genre in the 17th century, and, indeed, in earlier depictions of landscape in painting, the constantly changing configuration of the elements of the visible have not only reflected succeeding ideas about the structures and dynamics of the physical world, but they have expressed aspects of the individual mind which seeks through art to comprehend the 'nature' of what is perceived. 'Appearances reach us through the eye,' wrote Leo Steinberg in a famous passage, 'and the eye – whether we speak with the psychologist or the embryologist – is part of the brain and therefore hopelessly involved in mysterious cerebral operations. Thus nature presents every generation (and every individual who will use his eyes for more than nodding recognitions) with a unique and unrepeated facet of appearance . . . And if appearances are thus unstable in the human eye, their representation in art is not a matter of mechanical reproduction but of progressive revelation.'

Writing to his son close to the end of his life, Cézanne expressed something of the difficulty an artist may feel experiencing such continuous epiphany. It was as if every time he shifted his gaze, the world was re-configured. Painting from nature, he describes the impossibility of attaining an objective fix on 'the world's instant' that it was his compulsion to paint:

> 'Finally I must tell you that as a painter I am becoming more clear sighted before nature, but that with me the realisation of my sensations is always painful. I cannot attain the intensity that is unfolded before my senses. I have not the magnificent richness of colouring that animates nature. Here on the bank of the river the motifs multiply, the same subject seen from a different angle often subject for study of the most powerful interest and so varied that I think I could occupy myself for months without changing place, by turning now more to the right, now more to the left.'

Cézanne's phrase, and its implications, bring to mind the dictum of A.N. Whitehead, perhaps the greatest exponent of the modern idea of science, that 'there is no instant in nature'. Quoting this, Collingwood glosses it thus: 'All natural functions are forms of motion, and all motion takes time.' What is by nature fluid cannot by definition be stopped. We abide in the Heraclitean flux: it is impossible to step into the same river twice.

The first cubists took their lead from Cézanne, their interest, as Picasso remarked, forced by his anxiety. Cubism's earliest discoveries coincided with Einstein's first formulations of the Theory of Relativity. Itself a representational art that sought to incorporate into representation the complexities of that process itself, cubism does not so much picture the world as demonstrate the dynamics of our perception and conception of it. The relationship of art to the nature that it had hitherto represented, as if reflected in a mirror, was

Andy Goldsworthy
FROST

Penpont, Dumfriesshire
3 December 1989

changed forever. Abstract painting, deriving in part from cubism, in part from the subjectivism of Kandinsky and others, sought to represent not the observable world but its invisible structures of energy, those 'complexes of function' – ways of behaviour – to which Collingwood referred. In the art of Klee, which was free of any stylistic constraint, and in which the distinctions between representation and abstraction, and between picture and sign, were confounded, substance was indeed resolved into function. In this he demonstrated an understanding of the true affinity of modern art with modern science that was unsurpassed in his time (and equalled in the 20th century only, perhaps, by that of Naum Gabo). Once more it is to Klee that we may turn for the formulation that best describes this central definitive aspect of modern art:

> '[The artist] does not attach such intense importance to natural form as do so many realist critics, because, for him, these final forms are not the real stuff of the process of natural creation. For he places more value on the powers which do the forming than on the final forms themselves . . . Thus he surveys with penetrating eye the finished forms which nature places before him. The deeper he looks, the more readily he can extend his view from the present to the past, the more deeply he is impressed by the one essential image of creation itself, as Genesis, rather than by the image of nature, the finished product. Then he permits himself the thought that the process of creation can today hardly be complete, and he sees the act of world creation stretching from the past to the future. Genesis eternal!'

Figures in the Landscape

'Art comes from a kind of experimental condition in which one experiments with the living.' John Cage

This book is not about a movement in art in the usual sense of that term. It presents the work of a number of artists, each of whom refuses to be categorised in any way that might suggest a limitation of historical or cultural interests, or a singular preoccupation with nature in itself. Their presence in the book is not intended to suggest that they feel particular mutual affinities. As their own words indicate, they are more concerned with the particularities of their own creative projects than with any sense of belonging to a definable tendency in art, still less to a specific art-historical grouping of however loose a kind. Indeed it is characteristic of artists such as those represented here, who work in different ways with materials taken directly from nature, or whose actions are in some sense interactive with nature, to be wary of generic definitions and specific classifications when the question of their critical and historical placement is raised. And yet, they do have things in common, and their findings, however diverse and different in kind, may seem to have a special urgency, a timely relevance to the plight of our civilisation at the beginning of the new millennium.

Human consciousness of the fragility of nature is a modern epiphenomenon. For over the millennia of human history, which is to say for the period in which there has existed a specifically human consciousness of a reality separable from human experience, the world has been conceived as potentially infinite in its ability to provide what is needed to satisfy human requirements. The respect of prehistoric and aboriginal

peoples for their environment, their conservation of natural resources through techniques of hunting, gathering and cultivation that allow for their renewal, are highly intelligent and, in the truest sense, economic adaptations to the local circumstances of a mythologised and revered circumambient environment. Techniques such as these make use of limited resources within a natural plenitude that is regarded as infinite. Natural catastrophes and concomitant human disasters have been explicable as indications of a natural power – divinely ordained (supernatural) or no – within an over-arching and unchanging stability of firmament.

Even in the modern era, the destructive exploitation of natural resources has been justified on the grounds of nature's apparent inexhaustibility. Now that we know of its finitude, its continuing destruction is no more and no less than a consequence of human inability to agree on the conditions of its necessary conservation, which is to say, of a complex political failure, or even perhaps the failure of politics as such. If it is the latter, and in the conditions of triumphant global capitalism this seems more and more to be the case, then we are in for a dark time. We contemplate now a world in which the very elements upon which life depends – air, water and earth – are polluted, and the canopy of our biosphere is pierced. Never has there been a time in all human history when the quality of our understanding of our condition in nature – the nature of our historical being in the world – has been more crucial to our survival as a species, and to the survival of all the species of the animal and vegetable world in the complex network of terrestrial interdependence. Some scientists have awakened us to the urgency of our plight. Others, under the guise of specialisation or in the name of an abstract 'progress', collude with governments and corporations in the continuing despoiling and destruction of the biosphere. We know now that among the endangered species is humanity itself.

Alongside ecologists and natural historians, artists and poets have played no small part in this transformation of consciousness, working in ways that are particular to art and its purposes. What makes the artist's contribution to knowledge and awareness distinctive? Art has previously reflected the evanescence of the perceived world by means of symbolic representations of things that remind of us of its vitality, and then, consequently, of our mortality: the light of dawn, the brightness of the day, the shadows of the evening, the cycle of the sun and moon, the candle and the skull; birds, beasts and insects; grass, tree, leaf, flower and fruit; rivers and seas in constant motion, and so on, through all the inventory of natural phenomena and objects that are the subjects of countless paintings in Western and Eastern art. (I am of course isolating these aspects from the mythic, religious and historical themes whose illumination has always been the crucial purpose of those representations.)

But the purposes of art go deeper than a mirroring of the actual or the illustration of significant stories. Art may be defined as an imaginative and metaphorical engagement with the world and its objects, answering to the most profoundly definitive of human impulses: to find meaning in the flux, to structure coherences, to express a truth about the underlying patterns of things, and to discover resemblances between them. This creative transformation of the actual into image, of experience into sign, symbol and metaphor, is effected by the workings of intuitive intelligence, the exercise of the informing imagination. What is *actual* is what may be said to exist, whether we recognise its existence or not, and there are whole worlds hidden from our ordinary senses that have been revealed by modern technologies. What is *real* is what we make of what exists, as we encounter it, in the act of recognition, the knowing of something in such a way that

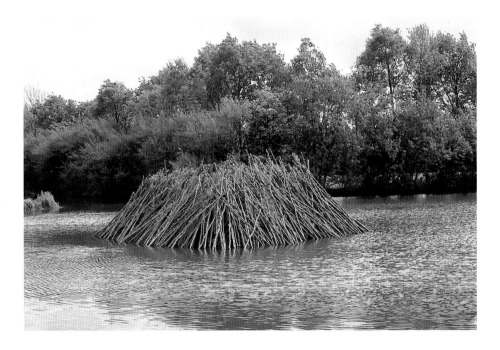

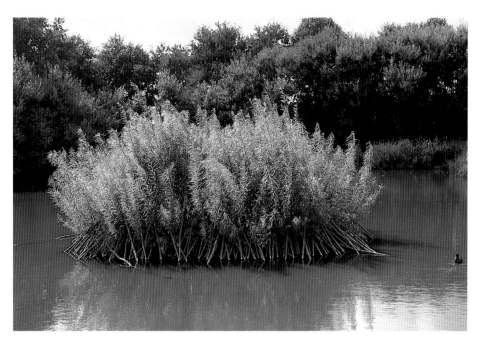

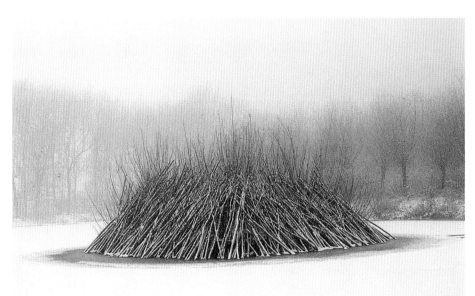

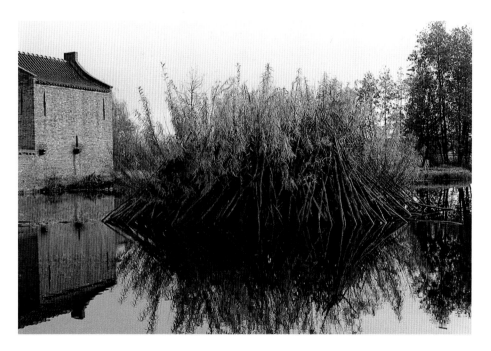

Sjoerd Buisman
HET GAT/THE HOLE
1995-1998

floating wooden frame, willow stems (*Salix viminalis*)
photographed in each season for a year
Moat of Het Oude Slot – The Old Castle, Heemstede, The Netherlands

This work, willows planted on a circular frame with a space in the middle, was made for an exhibition in which various artists explored the idea of the hole.

Since 1998, Buisman has developed the idea of island sculptures: willow cuttings are planted in shallow water; within two weeks they sprout, within three they have 'the glow of green'; soon, changing with the seasons from green to yellow to bare branches to bright green again, they accumulate debris around their developing roots, and within a short time there is enough of the matter that forms the earth on which they grow to create a 'new island'.

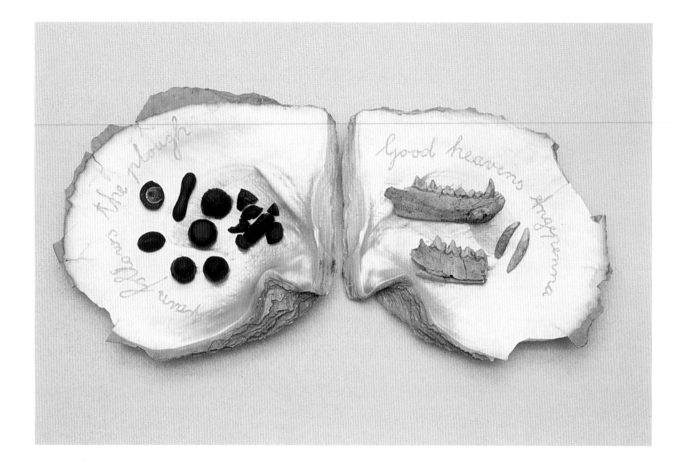

Nikolaus Lang
from CULTURE HEAP
1986-91

RAIN FOLLOWS THE PLOUGH

Half of a pearl oyster shell, incised and containing
seven australites and six australite fragments
Mount LIttle, Beltana, South Australia

GOOD HEAVENS ANGEPENA

Half of a pearl oyster shell, incised and containing
bones and teeth of extinct mammals (marsupials,
Tasmanian tiger?, Pleistocene marsupial fossils)
Mount Little, Hookina Creek, South Australia

we may know it again. There are many ways of knowing, many means to recognition, both physical and metaphysical; there are many levels of reality. The active discovery of the real, according to this definition, in terms of image, form, document and event, is that primary, revelatory function of art to which I referred at the beginning of this essay.

The imaginative faculty itself, in its creative shaping of our experience of external events, is empowered by memory, recollection and recognition, by the perception of similarities in differences and differences in similarities, and by those innate abilities, unique to our species, to make connections and distinctions, and to arrange and classify: the operations of both rational intelligence and emotional sympathy. This complex of cognitive and affective functions is literally embodied in our sensory experience, in our movement through the space of the world in its streaming light. 'All my changes of place figure in principle in a corner of my landscape,' wrote Maurice Merleau-Ponty; 'they are carried over onto the map of the visible. Everything I see is on principle within my reach, at least within the reach of my sight, and is marked on the map of "I can". Each of these two maps is complete. The visible world and the world of my motor projects are both total parts of the same Being.' Art increases our sense of what it is to alive, to be in vital relation to the world we inhabit. Such a relation comprehends what art reveals: the inescapable transience of things. We are aware, as never before, that we are part of the world, not privileged observers of it. We are embroiled in Klee's 'Genesis eternal!'

The artists in this book, and others whose work shares aspects in common with that presented here, are intensely aware of the historical representation of nature in art. But modernism discovered new ways of engagement with the actual, new means to a discovery of the real. To find its true beginnings a proper history of the kind of work that is our subject here would need to go back to Marcel Duchamp, and his rejection of painting, as well as to Cézanne and the cubists, and their critical transformation of pre-modernist painting. Among much else it would require consideration of the creative procedures of Kurt Schwitters and Hans Arp, and of Gabo's thrilling invention of an object-imagery of energy-structures. In the immediate past it would need to take account of Joseph Beuys, whose creative project was predicated on the recognition that the technologies of art, no less than those of science, mechanics and design, are essentially survival mechanisms. Two distinct and self-conscious movements of the 'sixties, especially, Arte Povera and conceptual art, provided critical and creative impetus.

Above all, what these artists effected was a paradigm shift in the artistic mediation of nature through art. To put it in a nutshell: dynamic strategies of inter-relation with the natural world replaced static representations of the world. As in much of what became historically identified as 'conceptual art', the objects of this new art are documents of record, reports on procedures. Its images are indexical registers rather than pictures or conventional signs. Its events are not composed or choreographed, or repeatable in formal execution, as in the making of modern dance and modern music, but unique and individual, like the events of life itself. You may follow the route of a walk made by another, but you cannot repeat the walk he has made, for that is an historical and unrepeatable occurrence. Nothing can ever be same.

The 'bright image' disclosed by the mirror that the scientists and artists of the Renaissance considered to be a reflection of the true reality, was, in fact, a representation. It was thus analogous to the Cartesian 'word', which is not the thing itself but the reflective idea that rescues it from the unknowing otherness of nature. It was the task of modernism to find a more direct interaction with the dynamic actual, and to present things in a manner that respected and revered the incessant and unstoppable processes of modern nature. Conceptual art, though it may have seemed to place an essential emphasis on the idea-as-artwork, did not claim that this was a true reflection or refraction of reality; on the contrary the 'concept' in conceptual art was more in the way of a proposition of objects, events and transactions that might or might not actually exist (or have existed) in material form. What mattered was that such objects, events and transactions might exist somewhere; it was then enough that they be reported in verbal, diagrammatic or photographic forms.

Germano Celant in his definitive introduction of Arte Povera, published under that title in 1969, interrogatively adduced other possible titles in his sub-title: *Conceptual, Actual or Impossible Art?* His texts, declamatory and rhetorical, continue to have a startling relevance to our theme: 'The book does not attempt to be objective since awareness of objectivity is false consciousness . . . The book, when it reproduces the documentation of artistic work, refutes the linguistic mediation of photography.' The photograph, then, is not a picture so much as a trace of the work. In his concluding essay, Celant goes to the nub of the matter, identifying precisely the ways in which the new art continues the project of modernism but moves beyond the limitations of the representational art. (Some forms of abstraction and constructivism had made a similar move in the pre-war period.)

'Animals, vegetables and minerals take part in the world of art. The artist feels attracted by their physical, chemical and biological possibilities, and he begins again to feel the need to make things of the world, not only as animated beings, but as a producer of magic and marvellous deeds . . . Among living things he discovers also himself, his body, his memory, his gestures – all that which directly lives and thus begins again to carry the sense of life and of nature . . . Thus he rediscovers the magic (of chemical composition and reaction), the inexorableness (of vegetable growth), the precariousness (of material), the falseness (of senses), the realness (of a natural desert, a forgotten lake, the sea, the snow, the forest) . . . [the artist is] thus discovered as an instrument of consciousness in relation to a larger comprehensive acquisition of nature . . . He abandons linguistic intervention in order to live hazardously in an uncertain space . . . He abolishes his role of being an artist, intellectual, painter or writer and learns again to perceive, to feel, to breathe, to walk, to understand, to make himself a man.'

It is possible to see modernism as having been a multi-faceted effort to synthesise the feeling and hope of romanticism and the discipline and optimism of classicism in the conditions of an accelerating technological progress that is alienating and dehumanising. (Siegfried Giedion, himself one of the most influential of apologists for a severely classicist-modernist urban architecture, identified this 'mechanization' as creating 'the gap that has split our modes of thinking from our modes of feeling'.) Modernism may be said to have found its supreme expression in the secular culture of the city, containing tamed nature in its parks and useful nature in its surrounding farmed countryside, beyond which lay the permitted wilderness of the national parks. There is now no wilderness on Earth that does not need protection. The wild in Europe is more a metaphor than a reality.

However, the most powerful early modern expressions of a philosophy that recognises the modern idea of a continuous interpenetration of nature and human nature are those of the great progenitors of Romanticism: Jean-Jacques Rousseau, William Blake and William Wordsworth; and in America the naturalists and poets: Henry Thoreau, Louis Agassiz, Ralph Waldo Emerson and Walt Whitman. All of them were from time to time solitary walkers upon the surface of the Earth, lovers of its strangeness and beauty, for whom emotional and spiritual individuation paradoxically depended upon some loss of the self in general nature. Here is a passage from Rousseau's *Reveries of the Solitary Walker*, recalling his self-imposed exile from the city, on the island of Saint-Pierre on Lake Bienne, where, among other things, he had embarked upon an exhaustive *Flora Petrinsularis*, which would describe every single plant on the island:

'. . . I would make my escape and install myself all alone in a boat, which I would row out into the middle of the lake when it was calm; and there stretching out full-length in the boat and turning my eyes skyward, I let myself float and drift wherever the water took me, often for several hours on end, plunged in a host of vague yet delightful reveries, which though they had no distinct or permanent subject, were still in my eyes infinitely to be preferred to all that I had found most sweet in the so-called pleasures of life . . . At other times, rather than strike out to the middle of the lake, I preferred to stay close to the green shores of the island, where the clear water and cool shade often tempted me to bathe . . . one of my most frequent expeditions

was to go from the larger island to the smaller one, disembarking and spending the after-noon there, either walking in its narrow confines among the sallows, alders, persicarias and shrubs of all kinds, or else establishing myself on the summit of a shady hillock covered with turf, wild thyme and flowers, including even red and white clover which had probably been sown there at some time in the past, a perfect home for rabbits, which could multiply there in peace, without harming anything or having anything to fear. . . . rabbits [were fetched], from Neuchâtel, both bucks and does, and we proceeded in great ceremony . . . to install them on the little island . . . the pilot of the Argonauts was not prouder than I was, when I led the company and the rabbits triumphantly from the large island to the small one . . .'

In an age of anxiety and fear, such as we live in, irony becomes not so much an act of intellectual poise, in which opposing truths are weighed against each other, as a self-protective manoeuvre which suggests, without the requirement of propositional clarity, that there is no truth, on either scale or in the middle, that can ascertained. A great deal of art now is preoccupied with the spectacle of the city and the political, sociological and psychological complexities of contemporary metropolitan society, and much of that art is inflected with a distancing irony, a wry glance at the brilliant surfaces of things which hints knowingly at the darker reality of modern life. A laconic Baudelairean optimism is found less convincing than the analytic Benjaminian exegesis of prevailing ideologies. In these circumstances, it is not uncommon to find in artists whose attentions are directed towards the relations of humans to the natural world a wariness of any characterisation of their work as essentially Romantic, for they detect in that description the suggestion of an uncritical sentimentality. Yet the expression of an affective empathy with natural phenomena is charac-teristic of most of those artists who work with or, as we might say, within nature; these artists acknowledge the natural domain as their field of work, its objects and events as their immediate materials, its reality as their underlying subject and theme. And in this respect their work carries forward a crucial programme in the modernist project.

To speak plainly: if there are anxieties about the viability and relevance of the Romantic vision then it should be acknowledged that some of the greatest art and poetry of the mid twentieth century is essentially Romantic in impulse and in practice. Much of this art has been fuelled by desire for the realisation of individual dreams, and hope for a change in circumstances that would create those conditions conducive to creative individuation. As far as practice is concerned, its characteristic forms are fragmentary and dis-ordered, having no regard for classical unities or decorum; its manifestations are fugitive and transitory, imitative of nature (which includes for them the culture of cities) understood as at once progressively evolving and entropic. Picasso stands as exemplary, but one could cite artists of successive generations and very different tendencies: Francis Picabia, Max Ernst, Joan Miró, Kurt Schwitters, Hans Arp, Lucio Fontana; Jackson Pollock, Willem de Kooning and a great many of the abstract expressionists; Robert Rauschenberg, John Cage, Cy Twombly and Joseph Beuys. (It could be stated that Andy Warhol stands in the philosophical company of Fernand Léger, Henri Matisse and Piet Mondrian, asserting classical values of emotional control, objective distance, formality and repeatability. There is an argument that might be pursued here: that the work of these artists nevertheless represents a classical aspiration in conditions that demand and

determine the Romantic. That is a subject for another essay.) In fact it is the Romantic impulse in modernism that has triumphed, and nowhere can its most positive manifestation be seen so clearly as in the work of those artists whose work is the subject of this volume.

Strategies in the Field

'The new scientific vision of the world may affect and enhance the artist as a human being but from there on the artist goes his own way and his art remains independent from science: from there on he carries his own vision bringing forth visual images which react on the common psychology and transfer his feelings to the feelings of men in general, including the scientists.' Naum Gabo

It is time now to turn to the diverse ways in which these artists work. As I have indicated, the essential move they have made is from *representing* aspects of the visible world to the *presentation* of objects from the material world, of reports of experience and of traces and documentations of events in which the artist has been in some way purposively involved. Surprisingly little has been done critically to distinguish between the different strategies that artists have employed in this field of action, in the natural domain, in the landscape, in the wilderness, in the park or garden, even in some cases in studios which have more the character of a laboratory than that of an atelier. It hardly needs to be stated that any attempt at a typology of such creative strategies is bound to be loose and open-ended; many of the artists with whom we are concerned employ a variety of approaches and make works in ways that combine different procedures.

Large numbers of artists in the last thirty years or so have left the representational behind them, and brought to the gallery various objects touched and transfigured by their art, or sometimes reports on

Andy Goldsworthy
Stick dome hole
made next to a turning pool
a meeting between river and sea
sticks lifted up by the tide
carried upstream
turning

Fox Point, Nova Scotia, Canada
10 February 1999

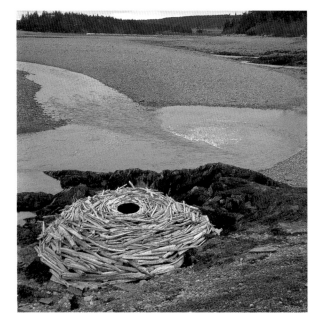
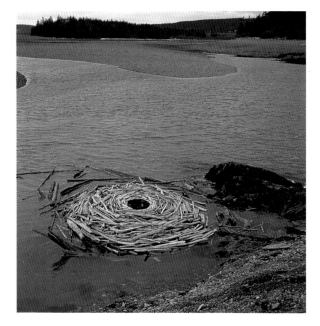
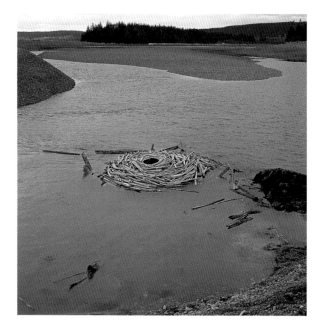

experience or records of events: photographs, videos, films, texts. These reports come from the domestic front, from the studio, from public places and spaces, the street, the plaza, the highway: in other words, from the metropolitan sites of modern life. The media and procedures of this urban art are similar to those deployed by artists such as those who figure in this book. But differences of subject, field and focus make in many cases for significant differences in feeling, mood and pace, which in turn reflect profoundly divergent positions with regard to the nature of reality. It is odd how banally theatrical so much installation and video art is, how close it is, philosophically speaking, to the literal fictions of naturalistic figurative painting. A change of methods does not always entail a transformation of vision, a paradigm shift.

In this section, I am proposing a provisional categorisation of the procedures employed by those artists who work with nature, and whose work constitutes a dynamic intervention of the kind whose principles I have defined in the previous section of this essay. No art springs fully formed from a vacuum, and it is well to have in mind the immediate beginnings of this new art in conceptual art, Arte Povera and such diverse art actions as those of Beuys, John Cage, and those American artists who have come to be categorised under the unsatisfactory heading of Land Art, most notably Walter de Maria and Robert Smithson. We should recall also the place of this new art in relation to the history of painting, and more particularly to the long historical dominance of landscape art as a major expressive vehicle for changing philosophies of nature. This history might be said, incidentally, to include the 18th-century English landscape park, which was, in fact, a proto-Romantic reaction to the sequestered French and Italian classical gardens of previous centuries. In the latter, picturesque and grotesque features imaged a negatively conceived unruly 'nature', implicitly sexual, which it was the purpose of the civilised to bring to a figured and formal order. In the landscaped park, on the other hand, the wild was metaphorically untamed but harmoniously integrated with the domestic: garden and pasture were continuous with lake and woodland, hill and clouded sky, and open to the elements. A park was a place for the study of natural objects, for walking, for reverie, for imagining the state of being-in-nature.

1. Symbolic Interventions

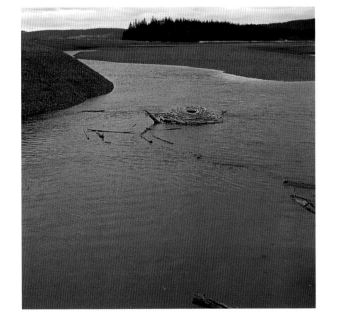

In Rousseau's recreational botanising on his island park, in his walking and reveries, in his benevolent inter-ference with the ecology, and then in his report on those experiences, we have an exemplar for the modern artist of nature, who works in the landscape and plucks from the unceasing flow of data such items as will suffer themselves to be re-configured into meaning. Walking has indeed been the primary mode of artistic action for Richard Long and for his contemporary, Hamish Fulton. This is but one art-procedure within the first of my provisional categories, which I shall term 'symbolic interventions'. In general terms, the strategy might be described as an action in the landscape which constitutes the work, whose existence is known to the artist's public by way of a report or a photograph, a marked map, or a text (which may be simply descriptive, poetically evocative, or minimally referential), or by any combination of these forms of information. Structures that are deliberately ephemeral (as in the work of Chris Drury, Andy Goldsworthy and Peter Hutchinson), water stains and beaten paths (Richard Long), shadows thrown, drawings made in snow or tidal sand, sculptures that disintegrate (Goldsworthy), ice works, mirror works (Bruce McLean): all of these, among much else, belong to my first category.

Long's interventions in the landscape have taken many forms: lines created by walking, walks taken with a particular geometric or conceptual logic, the former describing a circle of a particular scale in a given landscape, the latter determined by a programme that links natural features such as coasts, rivers, mountains, or natural phenomena such as tides and winds, the passage of days and nights, of sunlight and shadow; walks that involve minimal actions, the carrying of a stone from one place to another, the leaving of a stone marker at camping places; walks marked in the recording of specific objects and events, feathers found and birdcalls heard, creatures seen, buildings and people encountered, such records always made without comment or elaboration in a distinctive sans serif typeface on wall or screenprint. From early in his career, Long began to make works in the landscape that had a minimal sculptural formality: lines and circles of stone or wood in remote locations, their existence know only through the plain and beautiful photographs that record them. Those works by Long which consist of the same natural materials (stone, driftwood, slate, etc.) arranged in geometric patterns on the gallery floor or wall belong to a different category, though the underlying impulse remains constant, namely, to present a vitally affective conjunction of the cultural and the natural, of human order and natural contingency, in ways which give equal value to each.

Although they have something in common with Long's interventions, Fulton's walks are actually quite different from Long's. Fulton's works consist almost entirely and simply of his movement through the landscape, which is thereby touched by his body as he walks, sleeps, pauses to touch an object such as a boulder with his hand; these things are registered by his senses, but they are neither modified nor re-arranged in the slightest degree. These walks are the work, and we know of them only as events that have occurred in time past. We can only contemplate their significance (and in a profound way, their insignificance) through his records and reminders of them in photographs, diagrams and texts. 'It needs to be said right at the start,' he has written, 'my art is about physical movement.' The photographs, of an object in the landscape or of some part of the terrain traversed, are sometimes inscribed with the minimum information necessary, sometimes captioned, the texts and diagrams mounted boldly in an unvarying typeface on to gallery walls, sometimes in configurations that allude to their form (form here being the shape of the trajectory of the walk through time and space). Books also present these texts, diagrams and photographs. The information relates to the place and terrain of his walks, to their dates, length, timing, duration, starting and end points, with sometimes the remarking of an object (bird, beast or plant, rock or river, cloud and skyline, etc.) or a natural phenomenon (sunrise and moonrise, eclipse, solstice, etc.). The spirit and purpose of these walks/works is implicitly exemplary, and their documentation is a reminder of that fact. In his manifesto-catalogue *Walking Artist*, Fulton wrote: 'At the end of our 20th century, if we say we respect nature – out of what materials can we make art?' adding the injunction: 'CHANGE PERCEPTIONS – NOT THE LANDSCAPE. THE LANDSCAPE AS LOCATION – NOT RAW MATERIAL.'

Chris Drury and Andy Goldsworthy, among other artists, have built cairns of stones found in the immediate landscape, in Drury's case often in remote places. These too find their way into the discourse of art by way of photographic documentation, and in their place of making they will often have collapsed long before their presentation to the public in photographic form (indeed Drury sometimes dismantles them himself). The cairn is by its very nature a marker of human presence, often made precisely to register such presence in a location remarkable for human absence. Drury has written of their multifarious meanings:

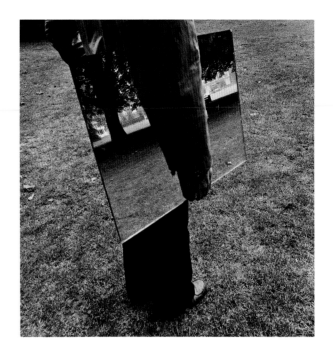

Bruce McLean
MIRROR WORK
1969

Barnes Common, south-west London

Richard Long
PHENOMENA
2002

FROM A HIGH TIDE TO THE VERNAL EQUINOX SUNSET

FROM APPLE BLOSSOM TO QUARTZ CONGLOMERATE

FROM A CUMULUS CLOUD TO A RIVER SOURCE

FROM FIRST MOONLIGHT TO A FOX BARK

FROM A BLACK LAMB TO A BIRD'S NEST

FROM A SUNRISE TO A LOW TIDE

A WALK OF FIVE DAYS AND ONE NIGHT IN AVON ENGLAND 2002

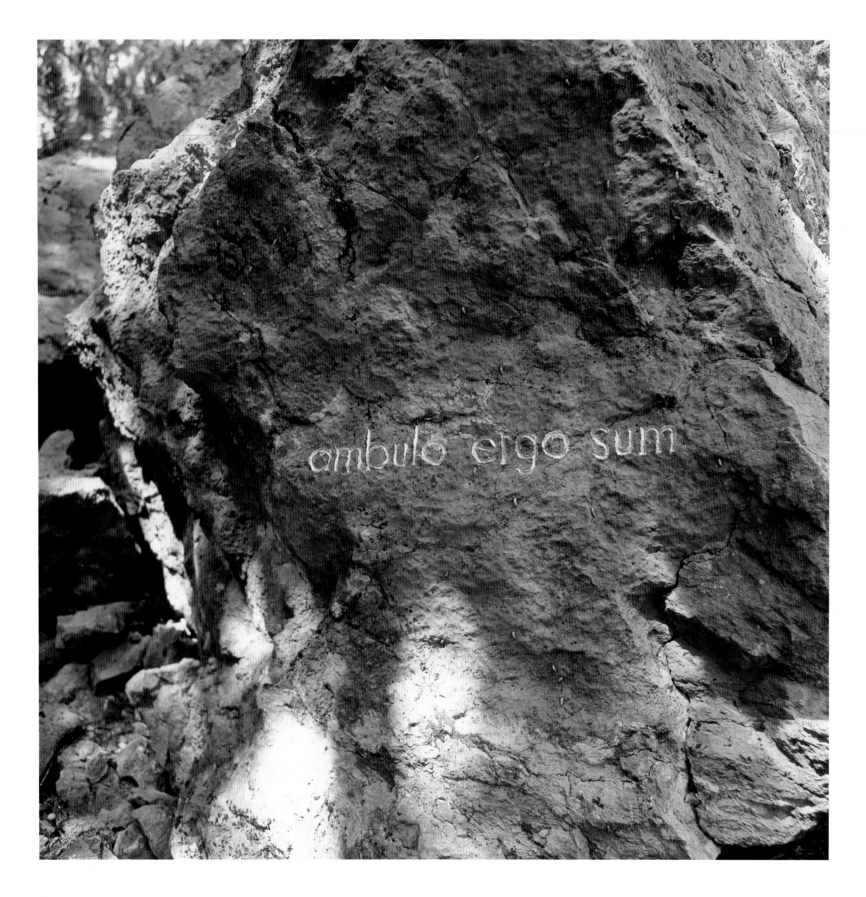

herman de vries
ambulo ergo sum
'i walk therefore i am'
2001

sanctuaire de roche-
rousse, digne-les-bains,
haute provence, france

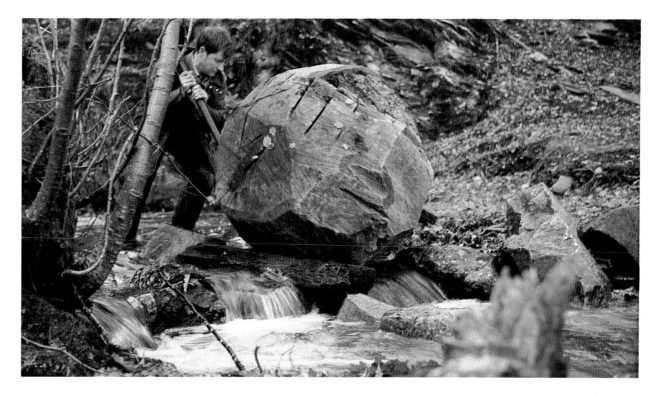

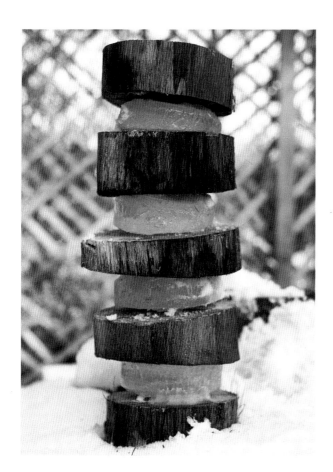

'In Europe we mark trails and summits with stones. In other parts of the world cairns have a religious significance and may contain a relic. They are also memorials to the dead. In 1997, while walking in Ladakh, I saw many cairns which simply marked a place of significance: the first view of a village, the place to cross a river in order to see a rock carving. For me it was like coming home, for this is the reason why I pile stones up: to mark a moment and place in time.'

Goldsworthy's dry-stone walls and sheepfolds have a similar memorialising purpose, reminding us of the skills that deploy with respect the materials that nature brings to hand, and recognising that human habitation and usage are part of nature. In Drury's fire cairns, the transitory element of fire is added to stone and wood: they are ovens for the traveller in remote places, a temporary hearth. Before long they will be assimilated once more to nature.

I sense something similar in spirit in David Nash's fire-blackened wood objects, caught as it were, in a process of transubstantiation between vegetable greenness and mineral ash. But perhaps Nash's most poignant 'symbolic intervention' of my first type, and a perfect example of it, is *Wooden Boulder* of 1978. In conversation in 2000 he spoke of this roughly cut sphere of oak: 'I rolled it to the head of a waterfall and pushed it in. It lodged half way down and immediately it felt right that it should remain in the stream. It quickly turned black through the reaction of the iron in the water with the tannin in the oak. In 22 years it has moved seven times, its edges have eroded and it has come to look more and more like a stone . . .' In Peter Hutchinson's totemic *Ice Sandwich* (1994), ice is the ephemeral element, whose melting will return the sculpture to a simple stack of rough wooden roundels, wood for the fire that will be the next stage in its elemental journey.

2. The Array

The second creative strategy that I identify consists in procedures of gathering or collecting materials and objects from nature and bringing them to the gallery, or publication, in forms that imitate those of scientific or of ritualistic array. It is in the nature of art that such presentations in our time are neither scientific nor ritualistic: art is not science and it is not religion either. I consider it legitimate to separate the two modes even as I include them under one rubric, for both serve purposes that are closely allied. The scientific array, that we may associate most particularly with the procedures of 19th-century classification and naming, and with the presentation (!) of exhibits in the 19th-century museum, but which also includes the modern periodic table, has an essentialising function. It seeks to indicate a generic similarity in the setting forth of dissimilar specific items. Something hidden from common sense is revealed to the eye. The ritual array is, conversely, a means to the revelation of the sacred in the presentation of natural objects in formal arrangements that have symbolic resonance. Things whose existence is bound by the contingencies of natural processes and endless transformation are set apart and placed within the order of the eternal.

Thus it is that the reverence of herman de vries for nature, his loving fascination with its infinite differentiations, and his restoration to our consciousness of the view of the natural world as a living entity (an aspect of a philosophy that has much in common with that of Giuseppe Penone), are functions of a project which refuses to distinguish the scientific study of the living world from the artistic and spiritual engagement with its processes. In conversation with Paul Nesbitt at the Royal Botanic Garden in Edinburgh in 1992, de vries, many of whose works present natural objects in museum-like array, addressed the question of the difference between the artist and the botanist by distinguishing their immediate purposes while asserting their underlying affinity: 'they have different points of departure to do with consciousness i hope, and the herbarium [a reference library of over two million preserved plant specimens] where we were working yesterday is a collective work of art – it certainly fits into what my idea of art is – but that is not so important, what is important is that such differences do not always exist.'

Certain works by Nikolaus Lang serve perfectly to exemplify the insight that the systematic array of found objects or materials may at once have instructive value and a spiritual significance. In the case of *Colour Field* (1987), specimens of ochre and sand are set out in a perfect grid, the primary model of scientific analytic separation, which confers on each item equality of attention and significance (*see* p.97). These earth samples were fetched from ancient Aboriginal collecting grounds, the sources of these very materials for use in ritual ceremonies, the decoration of artefacts, paintings and medicine. By presenting them in this pseudo-scientific manner, Lang gives each sample its individual place in an act of recollection and homage; his own considerable effort in accumulating them and bringing them into the ambit of modern art becomes a poignant, expiatory act. By arraying them in a geometric grid, he ironically acknowledges the analytic-rational, mechanical systems of the civilisation that ravaged the Aboriginal cultures of kinship with the things of the earth. There is no sentimentality in this project; the presentation is mute, its implications open-ended.

Lang's *Culture Heap* (1986-91) emphasises this intellectual and moral poise (*see* pp.117-118). It resembles in miniature one of those early modern ethnographic museums or institutions, which arbitrarily assembled materials brought from all over the world from 'other' cultures, displaying them for their strangeness, oddity and curiosity, jumbling together items of dress, weapons, sacred objects, tools and artefacts, labelling them

David Nash
BEAK TWMP
2000

charred ash
102 x 74 x 8 cm

One in a series of works inspired by the huge 300-year-old twmps (mound-like clipped yew hedges) in the garden of Powis Castle, Wales. Elsewhere in the garden, reports Nash, 'there are yews, of the same age as the twmps, that have been left to grow naturally. Dark, brooding trees with vertical trunks and horizontal branches reaching their foliage out to the light; normal trees we accept as quite distinct from us in their own tree-world. By comparison the twmps are full of human intervention . . . They have outlived some twelve generations of mortals. It is this sustained human presence that makes the twmps stepping-stones between us and the otherwise remote, and independent, world of plants.'

Of his charred wood sculptures, which he began to make around 1975, Nash has written: 'With wood sculpture one tends to see "wood", a warm familiar material, before reading the form: wood first, form second. Charring radically changes this experience. The surface is transformed from a vegetable to a mineral – carbon – and one sees the form before the material. [. . .] Rudolf Steiner spoke about human responses to carbon being on two levels . . . The feeling instinct – connected to one's soul – is repulsed, withdraws; while the thinking instinct – connected to one's spirit – is attracted and advances. These two simultaneous experiences vie with one another.'

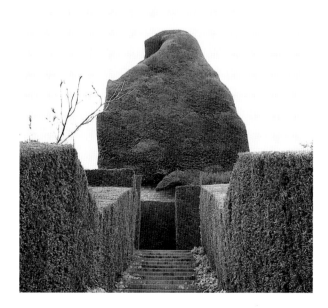

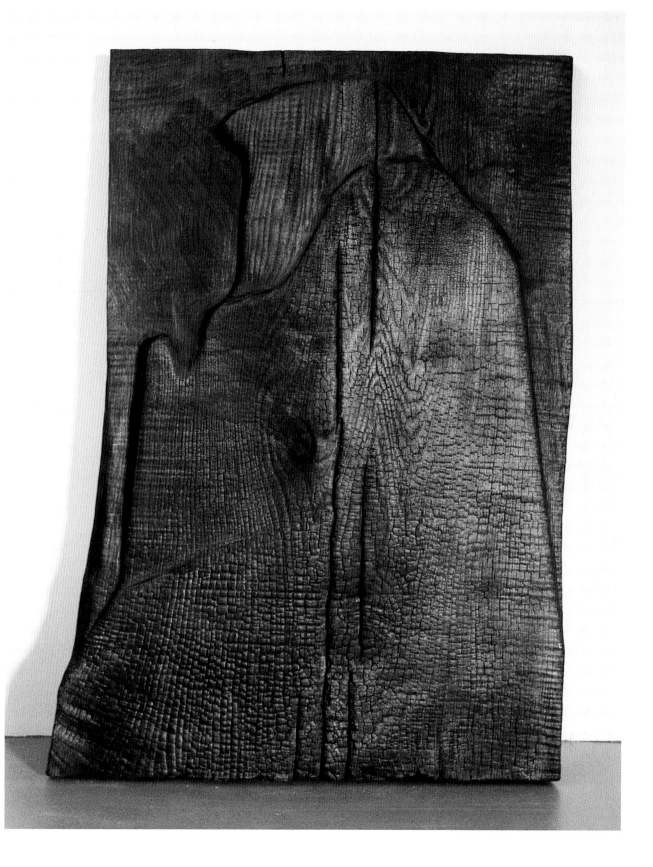

with sublime ignorance as to their use and significance in the cultures from which they were appropriated. Lang's 'heap' has, of course, a different purpose: it invites and proposes an ambiguous response, and in evoking his own presence in a complicated and unfinished history, it provokes contemplation of the individual story within the greater drama of the cultural collision that Alan Moorehead memorably described as 'the fatal impact'. For the Europeans who first reached Australia, it was an empty land, *Terra Nullius*. In his work of that title, Lang resorts to one of the most universal forms of ritual array, spelling out the Latin expression in a circle, a wheel with an empty centre. It is formed of things made and used by the living, dreaming, loving, walking, spiritually sophisticated and materially skilled inhabitants of this 'no-place' (*see* p.116).

The circle, the disc and the diagrammatic wheel have an ancient history in the cultures of humankind: they are the signs of the world, of the moon and sun; of the cycle of the year, of life, and also of unending eternity; they are symbols of fidelity to the gods and to one another; they are diagrams of space, from the immediate to the cosmic, for every human stands at the centre of his or her own world, bounded by the encircling horizon and beneath the upturned bowl of the heavens. For Chris Drury, the motif is inescapable, the constant formal expression of his artistic philosophy, the ground plan of his shelters and structures, even of the cairns, the shape of the print left by the mushroom's spores, of his bowls and baskets and spheres. Its richest exemplification is *Medicine Wheel* (1983), in which 365 natural objects are brought into the compass of a circle whose spokes divide it into 24 fortnights centred on a mushroom print, the sign of

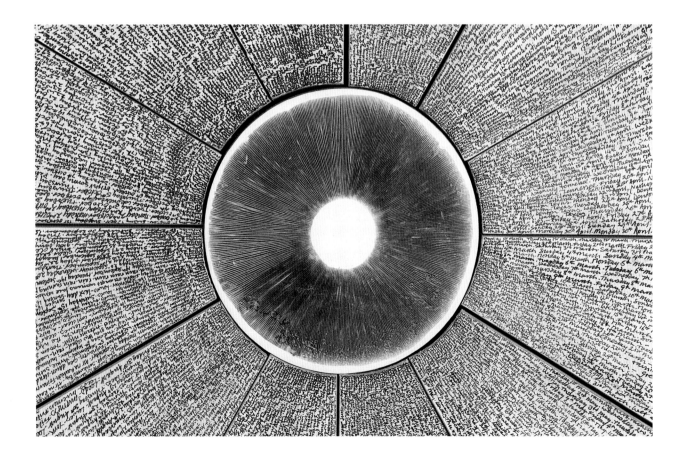

Chris Drury
Detail of MUSHROOM WHEEL
2001

Mushroom spore print at the centre of the wheel.

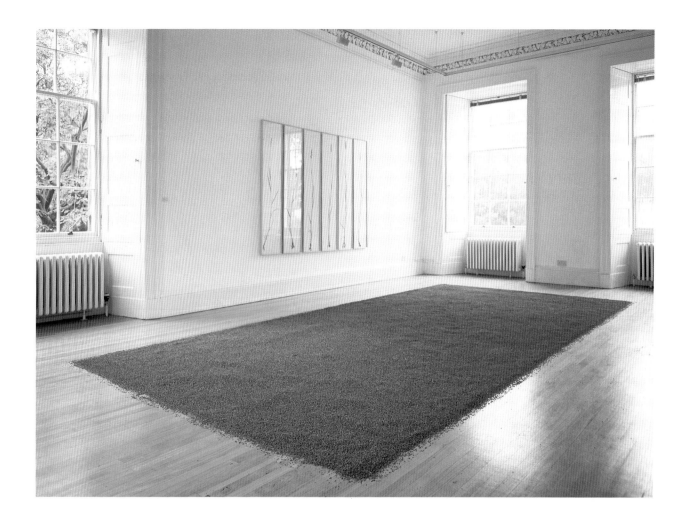

herman de vries
108 pounds of lavender flowers
1998

inverleith house, royal botanic garden edinburgh, scotland

endless renewal. 'Walking in the stubble fields/looking down/waiting for the first lapwing feathers of the year/two feathers lying together . . . As I bent down to pick up those two lapwing feathers, I realised instantly that I should make a work by doing just that: picking something up off the earth every day for a year to make an object calendar.' *Medicine Wheel*, like those cosmological constructions of the Native American whose name it borrows, is self-evidently a ritual array: 'Contained within this one work, Drury has written, 'are the seeds of everything I have done since.' The more recent *Mushroom Wheel* (illustrated and described on pp.77-78) is a development of this earlier work.

Long's gallery works, the *Mud Circles*, *Mud Lines* and *Hand Circles*, the stone and driftwood *Lines* and *Circles*, fall into this category, being natural objects and materials arrayed in geometric configurations universally acknowledged as ritually or spiritually significant (as they are in much modernist abstract art). And also under this rubric we may place the pollen carpets of Wolfgang Laib, horizontal, earth-bound presentations of a generative natural substance, not a sign but the thing itself, visually reverberating in ways that inescapably resemble the effect of paintings by Mark Rothko or the similarly spiritually freighted *Monochromes* of Yves Klein. de vries's rectangular carpet of lavender flowers, *108 pounds of lavender flowers* (1992) made for his exhibition at Inverleith House in Edinburgh's Royal Botanic Garden, performed the

purpose of reminding us of the regenerative function of the flower in the vegetable cycle, its colour and its smell for us a delight, for bees an irresistible attraction. Both responses are, for de vries, equally part of a natural process that can never lose its essential mystery: 'i think i know, understand, less and less of the processes going on around us and start more and more to wonder. . . art relates to attributes such as competence, ability, knowledge, wisdom, these are words for human qualities, not attributed to plants (and animals), but it ought to be plausible that they have equivalent qualities even if not yet recognised by us, not yet assessed, measured, registered, although we may not have recognised certain things, the possibility of their existence should not be ignored . . .'

3. Creative collaborations

In its acknowledgement of the unknown but not necessarily unknowable, de vries's insight is, of course, that of a scientist as well as of an artist. It is in its essence remarkably close to something said by Giuseppe Penone in an exchange with John Hutchinson in 1999:

> **JH** In your work the conventional distinctions between 'nature' and 'culture' don't appear to apply.

> **GP** The distinction between man and 'nature' stems from man's wish to mark his difference from the reality that surrounds him. It is an identity problem caused by the conventions of a religious or philosophical belief that attributes to man a value and power that is superior to every other form of life. It may be linked to the species' sense of self-preservation. Man is nature, and there is no material difference between them. To me, if you accept the facts of existence, that can be the only conclusion.

> **JH** But isn't one of the differences between man and 'nature' precisely the fact that man can reflect on his thoughts, feelings and actions?

> **GP** You only have to look at a tree to see that the shape of its growth is influenced by voluntary actions and reactions to the environment. The same tree growing on the flat or on a slope will develop different root systems, and its branch formations will not be the same. Just like a man, trees have an awareness of materiality which is expressed in their will to live.

It is not fanciful, in the light of these ideas, and of the imaginative conviction in which they are held, that artists working with nature, its objects and phenomena, should consider certain creative strategies to be essentially collaborations with its energies and intelligence. Intelligence is the active process of organising information to purposive ends, and the view that nature itself is just such a process unites the modern scientist to the ancient, the modern artist of nature to the aboriginal maker of signs and rituals in which the distinction of human and non-human nature is dissolved, and the utile is of the same continuous order as the sacred. 'The world is watching', wrote Gary Snyder: 'one cannot walk through a meadow or forest without a ripple of report spreading out from one's passage. The thrush darts back, the jay squalls, a beetle scuttles under the grasses, the signal is passed along. Every creature knows when a hawk is cruising or a human strolling. The information passed through the system is intelligence.'

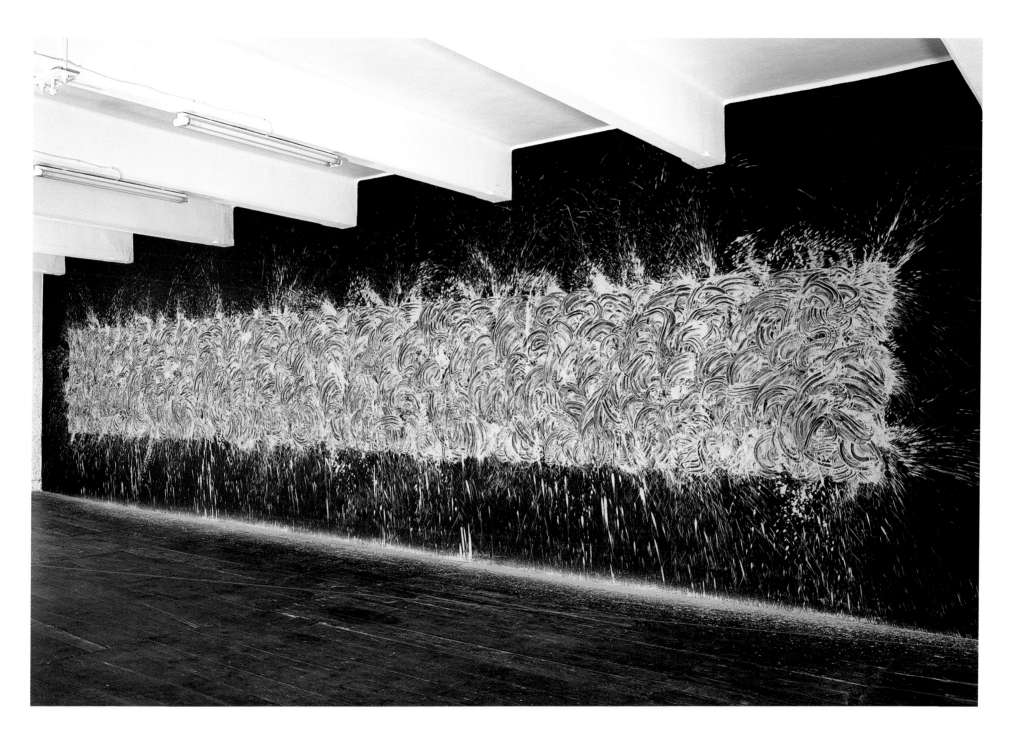

Richard Long
MUDDY WATER LINE
1989

Galleria Tucci Russo, Turin, Italy

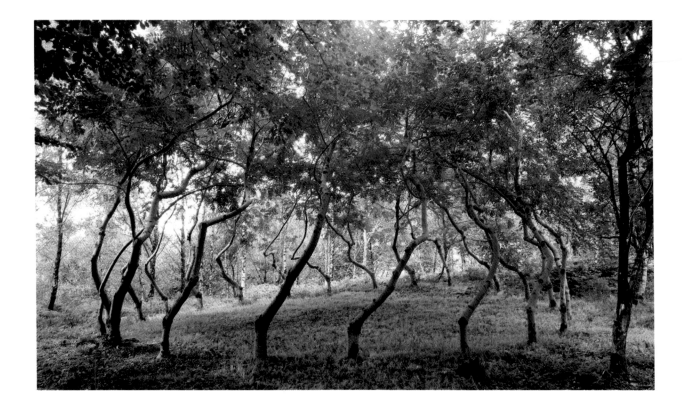

David Nash
ASH DOME
planted 1977,
photographed in summer 1999
and winter 2000-2001

Cae'n-y-Coed, Vale of Ffestiniog, North Wales

Penone's art is an outgrowth of his natural being, a condition he cannot separate from his physical existence in the world, being himself a natural phenomenon subject to constantly progressive development. (We may remember Collingwood: 'The tendency of all modern science of nature is to resolve substance to function. All natural functions are functions of motion, and all motion takes time.'). 'Reality' says Penone, 'and our perceptions of it, change every second. So does the condition, but not the nature, of being alive. A work of art retains, in the present, the necessity that first generated it . . . The choice of work [for his exhibition, *To Breathe*, at the Douglas Hyde Gallery in Dublin in 1999] was guided by the amazement I still feel when I consider the transformation of charcoal dust into a drawing; the repetitive nature of breath; the character and form of leaves.' (*see* pp.148-149)

Breath itself becomes in this account an expression of being-with-nature: in breathing we partake of its energy. 'Breath', wrote Gary Snyder, 'is the outer world coming into one's body. With pulse – the two always harmonising – the source of our inward sense of rhythm. Breath is spirit, "inspiration". Expiration, "voiced", makes the signals by which the species connects.' Penone's *Soffio* (*Breath*) series (1977) is in this way 'collaborative', it begins with and elaborates a natural phenomenon felt within the experience of the material body: 'I feel the forest breathing and hear the slow inexorable growth of the wood. I match my breathing to that of the green world around me; I feel the flow of the tree around my hand placed against the trunk.' (de vries, again, is close in spirit: 'when i breathe nature enters my lungs, sometimes I have the feeling that i am not breathing, but the outside world is breathing me . . .')

Penone's art has always been made in this spirit of collaboration with the natural world: 'I try to work in the language of things . . . The use of materials in a manner that enables them to communicate emotions,

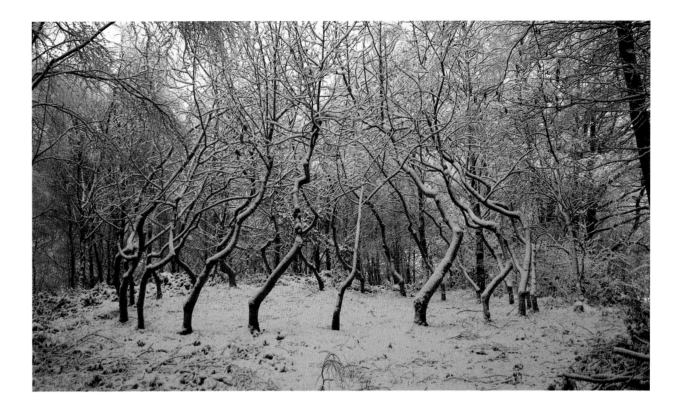

sensations, reflections, and a sense of wonder is an activity that is now almost entirely confined to art.' His project has been consistently coherent and thrillingly various; he exemplifies the artist as collaborator with nature. He is not alone in this, and many artists have in many diverse ways enlisted nature, so to speak, in their workings, to enable its voice to be heard through the objects they present to us. David Nash's *Ash Dome* (1977) is a perfect example of this strategy: a living sculpture of trees shaped to speak in form to the domed hills at the head of the valley where it grows, green wood to hollowed slate, vegetable softness to mineral hardness.

Utterly different but nevertheless essentially collaborative in the manner I have defined are the 1997-98 River Taw photograms of Susan Derges, made at night when darkness allows the exposure of light-sensitive paper submerged in river and coastal waters, where the light from a flashgun registers on the paper the otherwise invisible energies of flow and counter-flow, turbulence, eddy and ripple in the water. Other presences – moonlight, the shadows of overhanging leaves or of the artist herself or her helpers – may also be trapped and traced in the images, forming what Derges calls 'a kind of collective memory made visible in the photograms.' It is the collective memory of nature itself, the trace of neutral actuality – the intelligence of the moment – made real and beautiful, brought into the purview of human consciousness. In other works, such as *Sound, Water, Light* (1991), Derges similarly stops time (as only the photograph can) to reveal a circle in natural formation, and proceeds to appropriate it to art.

In the work of Roger Ackling it is the daytime sun, source of all terrestrial energy and light, that is pressed into creative service. Ackling works with solar light and heat, intensifying it through a hand-held lens and re-directing in a controlled manner on to driftwood and other found fragments, into which it burns horizontal

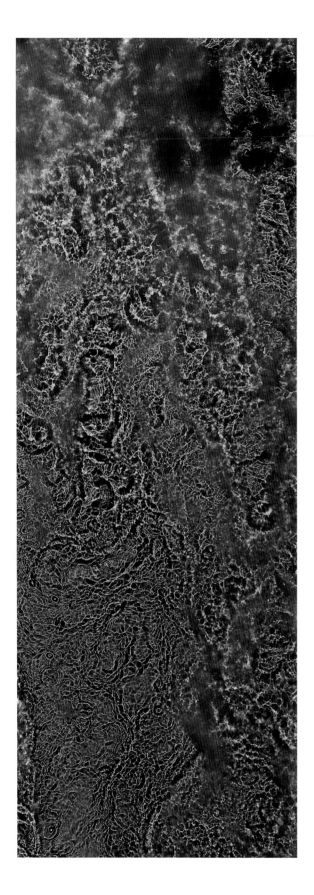

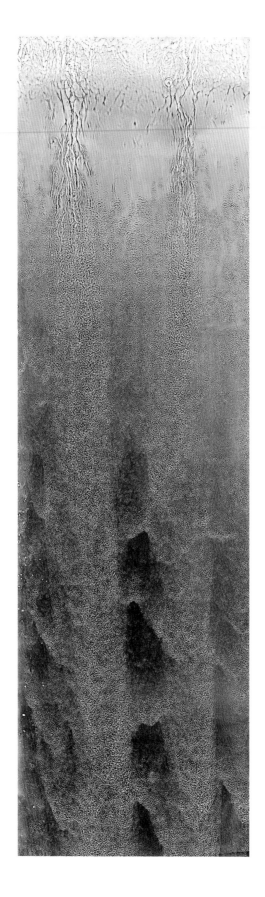

Susan Derges
RIVER TAW
21 January 1998

Cibachrome photogram
169 x 61 cm

RIVER TAW
7 April 1997 (New Moon)

Gelatin-silver photogram
220 x 61 cm

At night the river is used as a long transparency or negative and
the landscape as a large darkroom. Photographic paper held in
an aluminium slide is submerged just below the water's surface
and exposed to a microsecond of flashlight that prints the flow of
the river directly onto the light-sensitive paper. This is processed
as normal in the darkroom to create a permanent record of the
river at the time of exposure. Ambient light in the sky adds a
colour cast to the Cibachrome (colour positive) images, which
ranges from deep blue at full moon to dark green at new moon.

black lines whose direction and interval are determined by the artist, creating what he calls a 'forceful order'. As Sylvia Ackling has pointed out, these lines are 'photographic in its truest sense' – they are literally drawn by light.

As early as 1967 Bruce McLean made *Splash Sculpture* and *Mud Sculpture* works that, like the *Floataway Sculptures* of the same year, and *Vertical Ice Piece* (1968), were predicated on the impermanence of their form, their immediate assimilation into the natural flow of things, and their existence as no more than

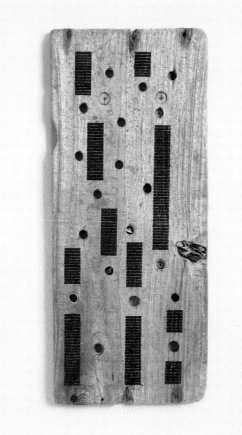

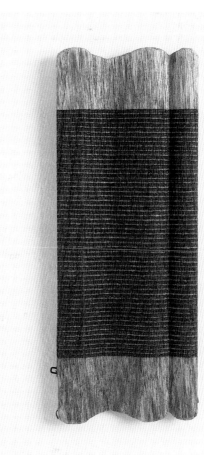

Andy Goldsworthy
Sticks
laid in different directions
to change with the light
late afternoon
early morning

Galisteo, New Mexico
24, 25 July 1999

memories registered in photographic traces. Many of the best early works of Goldsworthy were similarly ephemeral, but lacked the ironic reference of McLean's works to the arbitrary formalism of much of the abstract art of the 'sixties. These early works of McLean have a poetic resonance, and carry a sense of his wonder at the inventiveness of nature as artist-collaborator. His sense also that landscape painting as a genre was no longer adequate as a response to the dynamism of nature was wittily registered in the *Mirror Works* of 1969, in which the treescape of Barnes Common in south-west London is temporarily reflected in the mirror, and is retained only as a trace of a moment's light in Dirk Buwalda's photographs. In *Seascape* and *Treescape* (both 1969), McLean demonstrated the impossibility of truly 'painting from nature'. These works and actions were regarded by contemporary commentators as punning witticisms, but have acquired with time a critical poignancy.

If I include the varied and fascinating work of Sjoerd Buisman within the category of 'creative collaborations', it is with a keen sense of his affinity with scientists, and of his subtle borrowings from scientific experiment. He wrote revealingly in 1978 of his mode of presentation:

> 'I present my work in a very dry, extremely systematic and almost scientific manner. The plants, often presented in pristine white boxes, are classified named and described. Some people

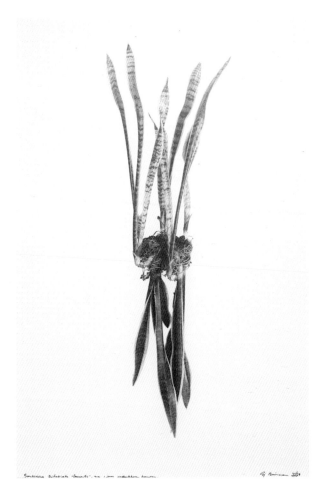

Sjoerd Buisman
AFTER 1 YEAR UPSIDE DOWN SANSEVIERIA
Sansevieria trifasciata
1976-1977

The original, now-woody leaves do not change their direction of growth; but the new flexible shoots grow upwards.

GRAFTED CACTI
1971

mixed media on paper, 42 x 29 cm

CACTUS HOMAGE TO BRANCUSI
Corryocerus ayopayanus
1971-1976

Each time the cactus produced another sprout, Buisman cut the sprout in half, choosing which areola to leave so that the direction in which the cactus grew was slightly influenced by his intervention, producing a growing, balancing column.

might consider this form of presentation too objective and too detached, but the work process and the selection of the subjects are in themselves such emotional and subjective affairs that only a systematic and cool way of presentation can ensure that the specific process is communicated in a clear and comprehensive manner, and the final result is a balanced one.'

It might be observed that the collaborative strategies of some of the artists I have described in this section are in certain crucial ways closely akin to the procedures of scientists, for what is modern scientific enquiry if it is not a working with nature to discover the hidden truths of determinacy, process and transformation? It might equally have been appropriate to enter Buisman's work under the heading of 'the array'. The truth is that these categories are porous, and there is much work in this book which might simultaneously fall into more than one of them.

Buisman's work most characteristically consists of interventions in the growing process of plants and trees that will, as their consequences are manifested, illuminate some aspect of that process. More particularly, it is the presence of time in the growing organism to which he draws our attention: past time, present time and future time are simultaneous in the natural world, what will be is already now, what is now is already past, and what is past is embodied in what is now and will be. In his various willow works, especially,

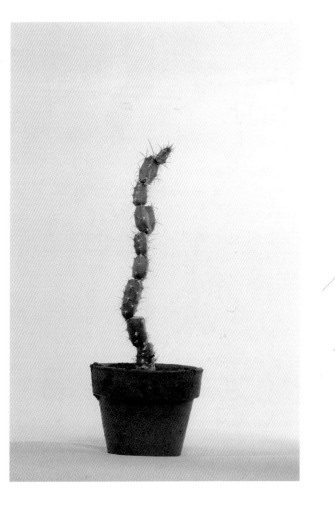

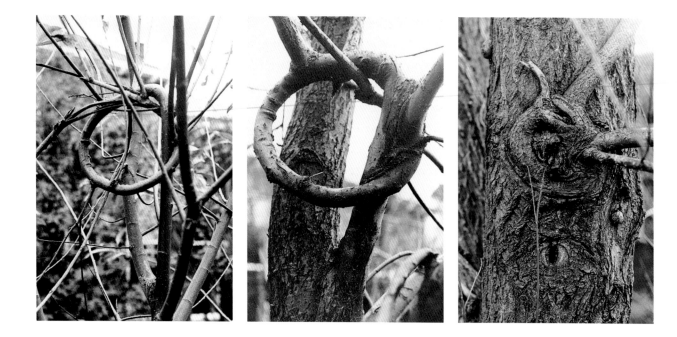

Sjoerd Buisman
KNOTTED WILLOW BRANCH
Salix alba
1975, 1978 and 1985

Haarlem, The Netherlands

'When you work with nature, you may have a general idea of what you want to do, but nature will always surprise you with what actually happens.' Buisman made several works where he knotted a stem, and they all behaved differently. In this one, after ten years, the knot was becoming incorporated into the trunk; when he returned to the tree two years later, the knot had disappeared completely. 'That reminds me of what you can sometimes see when you cut open a tree around which honeysuckle has twined at some point: although nothing is visible on the outside, on the inside you can still see the spiralling path of the honeysuckle stems.'

Buisman refers to *Salix* as 'the willing willow', so accommodating and vigorous is it in the manner and position in which it will grow.

Buisman collaborates with natural time, and as we encounter them (at whatever stage) we are invited to adjust our own sense of time, and by extension to consider the experience of our own never-ending transformations. Buisman himself conspires with his chosen plants to create spectacular demonstrations of reality, but his work goes beyond that. It increases and sharpens our awareness of our own living moment on the face of the earth: we live in collaboration with a dynamic nature that is both within us and outside us. It is a salutary revelation of natural interdependence, sometimes touching, sometimes comic, sometimes enigmatic.

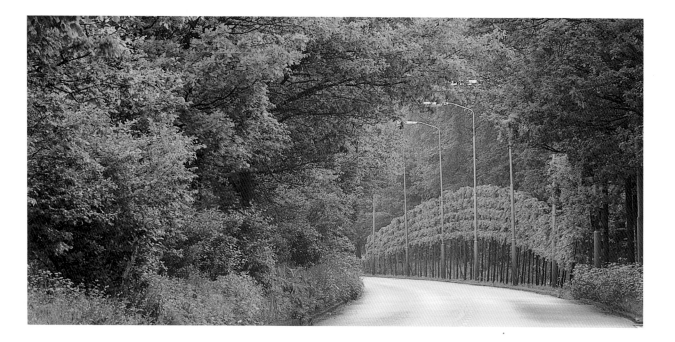

Sjoerd Buisman
LINDENBOGEN/LIME TREE ARCH
Tilia platyphyllos
Photographed in 1997 after six years of growth.

Haarlemmerhout, Haarlem, The Netherlands

4. Protective Strategies and Benevolent Interventions

In many cultures, the garden is symbolic of a state of human happiness. It is the image of nature enclosed and protected, and it speaks of the possibilities of human harmony with the natural world. The garden is the opposite of the wilderness, though even the wilderness can be described as an Arcadia. (Canada, in which the wilderness maintains to this day a tenuous and fragile actuality, derives its name from the word.) 'Arcadia', Penone has said, with characteristic acuity, 'is a notion, a mental space that has haunted man ever since the day that organised physical labour became part of his daily routine. Its traces can be found in poetry even more ancient that Virgil's; it isn't just an aspect of Romanticism. It is present every time that someone creates a relationship between his own being, his cultural and social background, and the reality of things that exist beyond himself in the world at large. It is a space for reflection, not a real place.'

It is not surprising that certain artists have found in the creation of a protected garden the possibilities of a work that is at once emblematic and real. herman de vries is eloquent on this subject, and goes to the heart of the matter: 'what is the difference', he asks, 'between *beaux arbres* and *beaux arts*? . . . bringing together trees and art is a challenge – for art, a park, a botanical garden or arboretum is not nature! the collecting of plants and trees (from nature) is a cultural act. A botanical garden is, then, art – for it has to do with being conscious and the process of becoming conscious – and in the botanical garden you can sense (see, smell, feel, and sometimes hear and taste).' The modern botanical garden – such as that in Edinburgh where he was speaking – combines aesthetics and functionality, science and horticulture. Significantly, the design of such gardens, following that of Kew, the greatest of them all, borrowed heavily from the idea and practice of the English landscape park, with its artful and paradoxical implication that within it nature was free from human interference. It is in this respect that the landscape park, and the botanical garden, which combines scientific system with this benevolent illusion, may be said to operate as simulations of nature, even as they provide sheltered space for contemplative recreation (which word, now somewhat hackneyed, carries within itself the principal meaning of *re*-creation: the very function of art in the receiving consciousness).

de vries has extended the notion of the protected space in a number of original ways. *die wiese*, his own meadow at Eschenau in Bavaria, about which he speaks in the conversation recorded in this book, is an example of one kind, and his recent work in the Dutch province of Overijssel, working alongside agriculture with reclaimed lands on a much larger scale, is another: both are in their way exemplary. They provide a model of what is possible in the real world, when the artist-naturalist and the imaginative ecologist are enlisted to modify the domination of the land by the farmer-industrialist and its destruction or despoliation through insensitive urban sprawl and giant highways. Drury's *Basket Dew Pond* (1997) at Kingston Downs in Sussex, and his on-going reed-bed project at Lewes in the same county, *Heart of Reeds* (2000-) are similarly exemplary. These works borrow methodologies of conservation and land management that have been pioneered by ecologists and naturalists in the creation of 'natural' habitats necessary for the husbanding of game birds and animals, and the protection of endangered species of wild creatures and plants. In de vries's capacious and generous definition, a reserve of marine marshland, lagoons and reed-beds such as that at Minsmere in Suffolk on the North Sea coast (the first of its kind in Britain when it was founded in 1948) 'is, then, art': it is a protected place, a beautiful sanctuary for beautiful creatures, and for those who wish to see them. Nature, technology and aesthetics combined: intelligence!

Ian Hamilton Finlay
TEMPLE POOL
and WOODLAND GARDEN (general view)

Stonypath, Lanarkshire, Scotland
photographed 2002

Art, when it enters the domain of political economy, does so on its own terms, and effects alterations in human consciousness in ways particular to its own workings. It impinges on the mind and spirit, precisely, through image and through sound, by way of the senses. In different ways both science and art provide diverse channels by means of which the intelligence of nature may be integrated into the individual imaginative intelligence, and work within the exchanges and negotiations of sociality and politics. Such integration, as anthropologists and artists have shown us, was seemingly effortless for the aboriginal peoples, whose adaptations to the natural world were imbued with reverence; in the conditions of industrial mechanisation, achieving this oneness seems almost insuperably difficult. Art grows out of a given set of circumstances, economic, political and philosophical. It presents reality, and invites consideration of its implications: that is how art works in the political domain. The artists in this book are listening to nature: they believe the world is speaking to us, singing to us, and that we must pay attention.

de vries has himself constructed two 'sanctuariums'. The first, a circular palisade of wrought-iron railings, occupies a few square metres of urban grass at a highway junction in Stuttgart, wealthy city home of one of the most successful motor car manufacturers in the world. Its little enclosure is open to view, it is simply a place set apart for the wild plants to colonise at their will without the interference of the contractors who cut the grass and apply the weed-killer to keep the roadways verges pristine and tidy. Its railings cannot

protect it from the incessant invisible fall of hydrocarbons emitted by the exhaust pipes of the millions of cars that pass by in the course of turning year. Its purpose then is purely emblematic; whatever will come to grow there and survives for however long is real – the thing itself, present and by its sequestration, *presented*. It is also a sign, a reminder of another world that is otherwise banished from this place, banished indeed from the city altogether. The Münster *sanctuarium* (1997), set in parkland at the edge of the city centre, works in a different way (*see* pp.66-67). In form it recalls the great Orto Botanico in Padua, the first of its kind in Europe, in which an ordered scientific garden was enclosed within a circular brick wall 84 metres in diameter. The balustrade that surmounted the wall at Padua as a formal classical frame for the busts of the garden's founders, is replaced, so to speak, in de vries's miniature version by a concrete coping into which is inscribed, in Sanskrit lettering, a circular verbal canon: 'this is perfect, that is perfect. perfect comes from perfect. take perfect from perfect and perfect remains.' Into the wall at the cardinal points are let four oval apertures, windows on to the perfectly enclosed domain. Here nothing will grow whose seeds and pollen are not carried there by the winds, or by birds and insects. Within the sanctuary we may suppose as time goes by that successions of plant populations will prosper, until finally trees will occupy the protected ground, expiring their oxygen to the city, providing sanctuary for birds, food for insects, and food too for the thoughts of those who, denied access to this space may contemplate nature at work but not touch it.

Ian Hamilton Finlay's garden, at Stonypath in Lanarkshire, is in its form and intention at a pole from the 'sanctuariums' of de vries. For though it may be seen in some sense as an *hortus conclusus*, an enclosed and sequestered space created on a hill in open upland pastures, within its confines is a complexly interrelated ensemble of objects and sculptures that refer in ways many-layered and subtle to the history of nature in culture and vice-versa. The garden has then an implicitly discursive aspect, though its mode of utterance is apothegmic and poetic, a matter of juxtapositions of word and object. At the centre of Finlay's unique project is a profound meditation on the relation of the word to the world, the word's work as the definitive mediation between unknowing nature and the knowing of nature. Its operation is succinctly and wittily encapsulated in Finlay's concrete poem (the poem as object) 'Arcady'. It consists simply of the alphabet in roman capitals. It presents itself to the eye as a classical landscape; in Finlay's own words, '[the] fields and forest, mosses and springs of an ancient pastoral landscape':

ABCDEFGHIJKLMNOPQRSTUVWXYZ

In the garden there is a poem-object in the form of a block of stone placed on a waterside clump of vegetation into which is inscribed Albrecht Dürer's famous monogram. It is titled, after Dürer's famous watercolour, *Das Grosse Rasenstück* (*The Great Piece of Turf*). This is also the title of a well-known work by de vries, which consists of actual plants, dried, set on paper and framed. These, in their different ways, pay proper homage to Dürer as a great naturalistic artist, whose closely observed fragment of turf stands at the very beginning of the modern representation of the natural world, not least in its attention to a part of nature that was unregarded, having no immediate use. de vries has said, without doubt in all seriousness, and with strict regard for the truth: 'but mine is more real!' Finlay's work draws similar attention to the actuality of the turf on which the inscribed stone (a metonym for classical honorific statuary) is placed, but speaks too,

DAS GROSSE RASENSTÜCK/
THE GREAT PIECE OF TURF
1975

stone
Temple Pool, Stonypath, Lanarkshire, Scotland
photographed 2002

herman de vries
das grosse rasenstück
1979

with a poetic concision that is characteristic of all his work, of the problematic nature of reality. The garden at Stonypath is indeed a richly complicated work of art, a piece of the world protected and cultured, an artefact reflexively appropriate to its theme of art in nature, nature in art. Its poignancy is increased by the visual prospect of the impoverished sheep-grazed moorland of its setting, a ground that was once one of the primal forests of Scotland, a kind of Arcadia, destroyed by another kind of enclosure, and lost to our generations. This was recalled, incidentally, by de vries in a text work which listed the lost forests of Scotland at his 1992 exhibition in Edinburgh's Royal Botanic Garden.

Arcadias, as Penone has indicated, are of the mind and the imagination. Among the most beautiful gardens imagined by a contemporary artist are the mixed media photographic collages of Peter Hutchinson. Hutchinson is acutely aware that the landscape as we know it is almost invariably the outcome of man acting upon nature. Everywhere he goes man modifies the world. 'The landscape', he has written, 'empty of obvious human touch, might be that of pre-civilisation, or post-holocaust.' (By 'pre-civilisation' he means, I think, before man came into the land and began to change it to his purposes; that silent time when there were no ears to hear the sound of a forest tree crashing to the ground.) In a collage such as *Land Bridge* he plants together flowers from different continents in gridded array (a word we often use of the display of flowers in the planned plotting of a garden); behind them can be seen the distant mountains, subject to the massive geological upheavals that over aeons create the habitat of the most fragile flower. 'The mixed landscape', says Hutchinson, 'has always been happening.'

Hutchinson, like many of the artists in this field, is fascinated by language and its mediation between the world and the receiving mind, feeling and spirit. The words in his work are his own, unaffected and affectionate towards the objects of his interest, simple narratives and reflections that reverberate with the images and objects. *Land Bridge* contains this laconic text: 'In the distant past, when a land bridge formed between Asia and North America, many species of plants and animals migrated Eastwards. I crossed from Japan to San Diego on my first visit to the U.S., only I came by boat.' It is natural that the gardener-artist should be interested in language, for it is, with drawing, one of the two primary and definitive media of human culture, and the garden, as an art work, is inevitably concerned with the relation of the cultivated enclosure to the world beyond its walls, whether the city, the country or the wilderness. Mountains, forests, deserts, the sea and rocky coast feature repeatedly in Hutchinson's work, constant reminders of that dichotomy of culture and nature. His *Thrown Rope* works similarly raise the question of the wildness or otherwise of the cultivated flowers we see in the ordered beds of public parks, enclosed by pathway and lawn; here they loop in arabesques across the grass, their configuration the outcome of chance. They are living emblems of the inexorable scatter of species, and of human agency and accident alike as determinants of our habitat.

Peter Hutchinson
ARTIST THROWING ROPE
1996

Artists' Garden, Bauhaus Universität, Weimar, Germany

FOUR-PART THROWN ROPE
Spring 1979

red begonias, white begonias, African marigolds, blue *Ageratum*
American Pavilion, Venice Biennale, Venice,
approximately 9 x 9 metres

LAND BRIDGE
1994

photo-collage, gouache, oil-crayon, ink, text
108 x 138 cm

5. Simulations of Interdependence

There may sometimes be detected in the work of the artists in this book, and others whose creative effort is directed to the discovery of affinities and connections between the human and the natural, a sense of loss. Nature is the Arcadia where once we were, the garden from which we have been expelled. These images need no religious or even spiritual elaboration; they are poetic realisations whose affective force may be felt whenever we consider the world as it is, subject to accelerating deterioration and on the edge of ecological disaster. We should remember that those words, ecology and economy, derive from the ancient Greek *oikos*: house. In talking about our relations with nature we are concerned, as Gary Snyder puts it, with 'Housekeeping on Earth'. 'Economics,' wrote Beuys, 'is not only a money-making principle . . . Capital is humankind's ability to work, not just money. True economics includes the creativity of people.'

Without in any way indulging in a sentimental nostalgia, artists such as Beuys, Lang, Drury, Nash, Penone and de vries have been convinced that there are things we can – must – learn from ways of living on earth other than those of our contemporary civilisations. The benefits and comforts of modern life (for some, if not the many) should not be underestimated: artists, anthropologists and ecologists also drive cars, travel by plane, enjoy swimming in pools, eat food out of season and dress in fabrics from far-away places. But the ways of those cultures whose motive energies are collaborative rather than competitive may be deeply instructive, not least in their understanding of the interdependence of all living things, and of their reverence for the world's being. Art plays it part in forcing our attention towards those central

Chris Drury
DRAWING IN SPACE
1998

willow
Refusalon Gallery, San Francisco, USA
488 x 46 x 30 cm

Drury visited the Horniman Museum in London which holds several Inuit kayaks and took precise measurements from one of them. He then made plywood sections and threaded them on to a central rib at intervals of about 20 centimetres to provide a form around which he bound willow.

On the wall is *River Vortex* (approximately 300 cm in diameter), drawn with muds from the Sacramento River in California and the river Ouse in Sussex, England. The pattern derives from a design used in Native American baskets in the south-west of the United States.

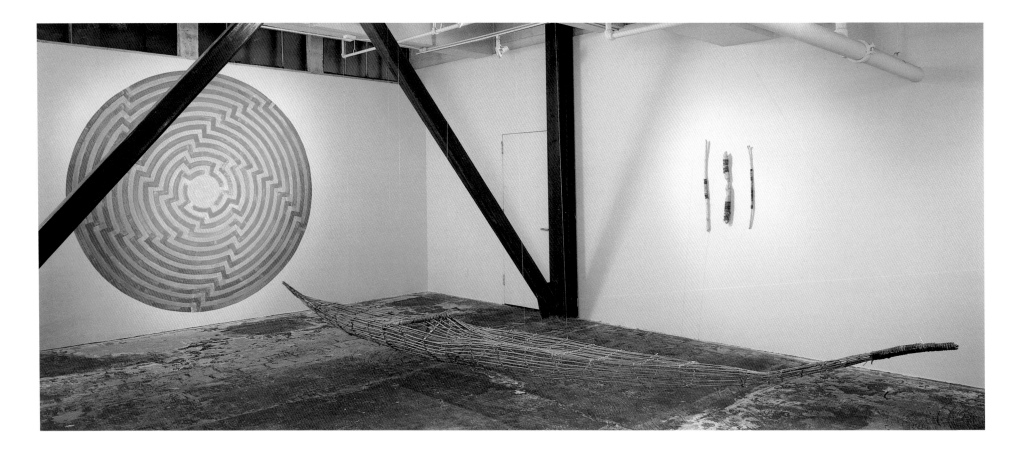

David Nash
VESSEL AND VOLUME III
1988

charred chestnut treated with linseed oil
outside piece: 86 x 28 x 16.5 cm
inside piece: 61 x 24 x 11.5 cm

principles of aboriginal and pastoral life. Hutchinson indicates how an art which images the arcadian might usefully be understood: 'A peaceful landscape might best be defined, like many things, by its opposite, by what it does not show, by what it negates: urban sprawl, slums, the unrelenting use of concrete, car and factory emissions, war, acid rain, the disappearance of plant and animal species.' To which catalogue of disasters we should add the elimination of those surviving human cultures that do not meet the requirements of economic progress as defined in the great cities of the world.

It is in the strategies of harmonious survival of those very peoples – the tribal peoples of the tropical forests, the Native Americans, the Australian Aborigines, the Inuit, the shepherds and farmers of the central plains and hills of Eurasia – that certain artists have found object-images and actions that convey by way of implication the necessity of human interdependence with nature. I call these aesthetic ploys 'simulations' for they are characterised by imitations that have only an allusive or signifying function. Beuys's recurrent use of felt and fat served the purpose of reminding his public – a sophisticated metropolitan art public – that warmth and insulation were conditions necessary to the exercise of any function higher than merely staying alive. Beuys recognised that the technologies of art, no less than those of science, mechanics and design, are survival mechanisms. Art is a strategy for survival, among others: that is what Beuys sought to convey by making a myth of his own survival.

Beuys understood with startling clarity that the existence of the human species, with all its richness of experience and complexity of consciousness, is closely linked with the lives of all other living creatures and with the vitality of the earth, the rivers and the seas: with things animal, vegetable and mineral: 'Here is a man, here is an animal, here is a plant, here is a rock, here is matter. We are already talking about life, feeling, instinct, consciousness.' He declared his kinship with hare and coyote, and constantly used a stock of evocative materials, organic and mineral:

fat felt sulphur copper iron
beeswax gold leaf iodine
hare's blood
honey

And here he is speaking of breath in a way that may remind us of Penone and de vries: 'The interrelationship between the rules of life in this world comes through plants. Plants are like the organs of people. Plants are the outer lungs of people. Without them people can't get any air into their inner lungs.'

The shelters and baskets of Chris Drury are essentially emblematic, reminding us of other such structures, in other environmental and cultural circumstances, which make ingenious use of natural materials in their construction (stone, wood, hide) and often have more than one purpose (shelter from the elements, a place to sleep and to dream). In certain cases he has made shelters, such as the Beara Shelter at Allihies in West Cork, Ireland, intended 'to provide a space for being and contemplation'; even these structures, however, are exemplary and evocative before they are functional. Constructing such rudimentary shelters in the gallery emphasises their essential artistic nature: they are actual objects whose physical presence (their material texture and their visible primitive technology) confronts the viewer with the idea of survival. Drury's baskets, and his boats, fulfil a similar purpose: 'Baskets' he writes, complete the circle. Shelters can

be made like baskets, baskets like shelters. Making woven baskets is one of our oldest crafts and is buried deep within our culture: some of the earliest boats were constructed using technologies of basket-making.' Drury's shelters, baskets and kayaks, like Nash's burnt boats, are poetic constructs: they propose that all humankind makes its perilous journey through time and space by the exercise of the imagination on the materials that nature provides.

Nikolaus Lang's painstaking re-tracings of Aboriginal journeys and collecting expeditions, and his energetic re-enactments of specific events, such as the active re-telling of *Peter's Story* (which included such actions as the wearing of the specially made grass cape, the re-tracing of Peter's journey, the knapping of stone implements), are elaborate simulations. Their purpose was to effect a transposition of the artist's consciousness from one culture to another, to create a sense of what it was like to have been in another relation to the earth: 'By being someone else I learnt to find my position as an artist in that context'. In these actions, Lang imagines and sometimes enacts for us other people's experience of the land, of the impact of strangers who came to it, of nature itself: 'What about my view and our view of other people and what about their view of me and us?'

Lang's is one of the most thoroughgoing projects in which simulation is the primary creative strategy. Central to his mode of operation is an active exercise of the re-creative imagination which might be described as empathetic immersion. It is a strange and wonderful adventure on which he has embarked (gone forth, as in a boat): 'My dream is to create a workshop on wheels, so that I can go from A to B and even push into the bush, walking and experiencing land, people, plants, animals . . .' He has, in his own words, 'criss-crossed from nature to culture and from culture to nature': 'I believe in bringing everything under one heading – it's all nature.' Perhaps the most powerful work he has made is *Roadkill* (1999). Those ghostly figures, brought back to vivid graphic life by an act of simulated ritual, have the beauty and pathos of the Paleolithic paintings of antelope and buffalo on the cave walls at Lascaux: hunted, revered and honoured. The violent and pointless deaths on Australian roads of these beautiful kangaroos and dingoes, snakes and lizards, and the significance of their continuing destruction, constitute an appalling

References

Page numbers at the end of each entry indicate the page in this book on which the reference occurs.

Gaston Bachelard, *The Poetics of Space* (translated by Maria Jolas, Beacon Press, Boston, 1969; originally published in French 1958) – page 12

Jacob Bronowski, *The Common Sense of Science* (Heinemann, London, 1951) – pages 6-7

John Cage – quote on page 13 is taken from Germano Celant, *Arte Povera* (1969)

Italo Calvino, 'The sword of the sun' in *Mr Palomar* (translated by William Weaver, Secker & Warburg, London, 1983; originally published in Italian 1983) – page 10

Germano Celant, *Arte Povera: Conceptual, Actual or Impossible Art* (Studio Vista, London, 1969; originally published in Italian 1969) – pages 17, 18

Paul Cézanne, letter dated 8th September 1906 to his son is quoted in Richard Kendall, *Cézanne by Himself* (Macdonald, London, 1988) – page 12

R.G. Collingwood, *The Idea of Nature* (Clarendon Press, Oxford 1945) – pages 7, 8 and 12

Guy Davenport, 'The Critic as Artist' in *Every Face Evolves a Form* (North Point Press, San Francisco, 1987) – page 6

reproach. Our lack of affective relation to the quick life they embodied is one aspect of our fall from grace, our loss of a vital relation to the natural world.

The work of the artists in this book, in their diversely intelligent ways of knowing, and the directness of their presentations, serves to bring us back to an apprehension of the harmony of the universe: to help us to hear within that great symphony the song of the earth.

> On the beach at night alone [...]
> As I watch the bright stars shining, I think a thought of the clef of the universes and of the future.
> A vast similitude interlocks all,
> All spheres, grown, ungrown, small, large, suns, moons, planets,
> All distances of place however wide,
> All distances of time, all inanimate forms,
> All souls, all living bodies though they be ever so different, or in different worlds,
> All gaseous, watery, vegetable, mineral processes, the fishes, the brutes,
> All nations, colours, barbarisms, civilisations, languages,
> All identities that have existed or may exist on this globe, or any globe
> All lives and deaths, all of the past, present, future,
> This vast similitude spans them, and always has spann'd.
> And shall forever span them and compactly hold and enclose them.
>
> Walt Whitman 'On the Beach at Night Alone' (1856)

Mel Gooding Barnes, London, July 2002

This essay is for Jill

Hamish Fulton, *Walking Artist* (Annely Juda, London 1998) – page 22
Naum Gabo, 'Art and Science' (1956) reprinted in Gyorgy Kepes, *The New Landscape* (1956)
John Hutchinson (ed.), *To Breathe* (Douglas Hyde Gallery, Trinity College, Dublin, 1999) – page 30
Paul Klee, *On Modern Art* (translated by Paul Findlay, Faber & Faber, London 1948; originally published in German, 1924) – pages 9 and 13
Gyorgy Kepes, *The New Landscape in Art and Science* (Paul Theobald & Co., Chicago, 1956) – page 7
D.H. Lawrence, 'Morality and the Novel' (1925); reprinted in *Phoenix*, (Heinemann, London, 1936) – page 6
Claude Lévi-Strauss, *Tristes Tropiques* (The Modern Library, New York 1997; originally published in French, 1955)
Maurice Merleau-Ponty, 'Eye and Mind' in *The Merleau-Ponty Reader* (Northwestern Univesity Press, 1993) – page 16
Alan Moorehead, *The Fatal Impact* (Harper & Row, New York 1966) – page 28
Jean-Jacques Rousseau, *Reveries of the Solitary Walker* (Penguin Classics 1979; originally published in French, 1782) – page 18
Gary Snyder, ' "Wild in China" reprinted in *The Gary Snyder Reader* (Counterpoint, Washington D.C., 1999) – first reference on page 8; 'The
 Etiquette of Freedom' (1998) reprinted in *The Gary Snyder Reader* – quote from Dogen on page 8; 'The world is watching . . .' on page 30.
Leo Steinberg, 'The Eye Is Part of the Mind' in *Reflections on Art* (ed. Susanne Langer, The Johns Hopkins Press, Baltimore, 1958) – page 12

herman de vries

William Furlong I believe it was 30 years ago that you decided to abandon urban life and chose instead to live here in the small village of Eschenau on the edge of one of Europe's largest unspoilt forests. How do you operate as an artist working so far from the city?

herman de vries in the 1970s i had it in mind to go to ireland to look for a house, when i discovered this place by accident. i didn't want to live in the city any more. i had lived in arnhem in holland, a city with a hundred thousand people. and i didn't want to be part of the art scene there. the dutch art scene was very close-knit and there was a kind of control, a kind of scene control, and i wanted to be outside it. it felt very good to be away from thinking about art like other people do and to just direct myself towards the work i was doing. at that time i didn't work with nature. i was a lover of nature but i didn't work with it. i was working with programmed randomness. at that time i still thought that randomness was close to nature, that it follows a law of nature.

the village where i live is not the main thing for me, it's the nature around it and the situation of the village in the landscape. i am not social in the village. i have good relationships with most of our neighbours, and that's it. I never go to the church, which is the social centre of the village, i think.

WF Looking at your early work, I see that you worked with minimalist formal elements . . . with rectangles and squares and formal abstract shapes. Then at some point something led you to start working with nature. Was it the sort of randomness that you were exploring then and now? Is that the connection?

hdv i worked with randomness because i thought that randomness would give me a chance of doing objective work without the interference of the idea of the artist. it was open, it was free. i used rectangular and geometrical elements because they were easy to programme. i could arrange a programme and let randomness work it out. i used a list of random numbers from a book of statistical tables. then after a while i started to think about what randomness actually is: i found definitions and i tried to define it myself. we are not able to have an overview of all the causes that lead to a certain situation, and this we call randomness. in fact it's a complex of causes. and that brought me to the idea of chance. chance is not the same as randomness. chance became quickly for me connected with change. chance and change are a couple of words i have used many times since 1970, because without change you have no chance. it's a dynamic process we are participating in. working with the idea of chance and change, i first started documenting these things in photographic series: 'a random sample of my visual chances in eschenau'; or in

from the same plant
aruncus dioicus
1980

104 x 144 cm

72 x erophila verna

1994

73 x 102 cm

luang-prabang (laos): 'a random sample of the seeings of my beings' – of the things i saw. my wife had a list of timings. she would take a picture of me and say 'stop' and at that moment she would give me the camera and i had to take a picture of whatever i was looking at. it is not only what an artist is doing, making or thinking that are part of his concept, but also what he perceives, what he takes up into himself. he is connected to the world by his senses: his eyes, his sense of taste and his ears. it's not just the environment, it's his life-space and he is connected to his life-space all the time, not least by his breathing. he takes air in, he lets it out, he takes it in, he lets it out, like everybody else.

WF At what point did you decide to embrace all those ideas about experience, about 'life-space', by working directly with nature as opposed to impersonal geometric structures?

hdv the first time i worked like this i was still concerned with the idea of randomness. i was on a beach in the seychelles and i collected two handfuls of partly broken pieces of coral. it was a white coral beach. every piece was different, but made by the same process; every piece had its own changing individuality. then i started to pick up small shells. they all had black and white patterns, but every shell had a different pattern. you could see they were all from the same species, but they were all individual. so i came to realize that nothing is the same. every chance of a realisation in our primary reality is a new chance. nature never, never repeats itself. you could pick a thousand leaves from one tree and when you compare them you wouldn't find two the same. they can be similar but they are different. they have a kind of programme of their own and it works out always in an individual way. you have different trees, you have different leaves. even two leaves beside each other on the same twig are not the same. i found an interesting quotation from von uexküll, a german ecologist who was writing in the 1930s. the book was called *lebenslehre*, which means life teaching or life knowledge. in one section he speaks about there being no limits between physics and metaphysics and says that biologists should not be afraid of metaphysics: life may be a metaphysical process. when he talks about leaves he says that their lengths and widths are not fixed, that there are big variations but that what is fixed is the relationship between lengths and widths of leaves, and that this is an inherited relationship – non-existent until the leaves actually grow.

WF In the late 'sixties there was the whole Arte Povera movement and there were certain fashionable centres in Europe and North America, but you consistently stayed outside these, even to the extent that you stayed away from the city. Why did you make that decision?

hdv independence. to be completely independent. i stopped reading art reviews. i didn't want all these ideas of others and influences. i still had contacts. i made exhibitions sometimes and met other people, other artists. but i wanted to be independent. and the distance from centres of art allowed me to follow my own way and not be influenced too much by the ideas of others and their judgements.

WF Yet so much of what was going on in art was coming out of the city. But then there seemed to be a moment in the late 'sixties when this question of identity led a small number of artists to work in open landscapes. I'm thinking of people like Richard Long and Giuseppe Penone. These artists were using their experience of those environments and bringing it back into their work.

hdv nature is our primary reality. our human environment, our human life-space in cities and offices and factories and city streets and traffic is a secondary reality for me. all these things are derived from nature and follow certain laws of nature, but i want to be in the primary reality. the big forests i found here, with little streams here and there and small meadows, were an impressive experience for me. to start with, i was still working with my random programmes but after a while i started to document things happening in nature and i lost my interest in the many programmes i still had in preparation. i'd say, my random drawings got more and more complicated and slowly a kind of world view came into these abstract drawings and they became almost like models of thought forms. one evening, talking with my wife susanne i said, i need a model with more possibilities. it has to have three, four or perhaps more dimensions, but i don't know how to achieve it. and then we both laughed because i realised that i should simply address myself to the primary reality directly. that's the model we have, and it's always active. what it can give us as information is expressed in itself. and then i began to use my work as a kind of documentation of these facts, but always with a sense of wonder at the poetry in reality. i didn't want to make poetry out of it, because it was already poetry for me. i had made concrete art and concrete poetry. but then i became aware that all these things were happening in the lifespace around me, so i didn't need to make concrete poetry anymore. i just had to show the facts among which i was living. this was my poetry.

WF This is the primary reality you're talking about, the space we're sitting in now, surrounded by nature.

hdv well we are sitting in a library: that is human culture. and outside i can hear the birds and see the landscape, and that's where nature starts. so I'm sitting here next to an open window on the border between these things.

WF Looking at the way in which you've used the primary experience, as you describe it, and at your working methods and how you organise the materials of your work, it seems to me that you are an unusual artist. Looking around the house with you I have seen earth samples, leaves, twigs, which are indexed almost as though

they are an inventory of artist's materials in a highly organised, even scientific manner. It seems to suggest the way in which a scientist or a botanist or archivist or researcher works rather than the methodology of an artist. Your initial training in horticulture and botany seems significant here.

hdv my scientific background gave me practical insights into working in a disciplined way, and i still make use of this because of wanting my own standpoint to be at the zero and in this way to allow freedom to the spectator. i don't have to tell the spectator what i think, i need only to show the facts directly. so what i'm doing is *presenting*, and that's a very modest function. i am collecting and presenting and using my knowledge of scientific methodology to give me the opportunity to follow this very simple aim: to do only what is necessary to present the work, without any personal additions. when i use a grid to decide where i place leaves, the grid is not determined by my aesthetic thoughts or feelings, it is determined by the shape of the biggest leaf. in this way, every leaf occupies the same-sized space so that you can compare the leaves ranged together. this does not exclude their beauty. i love their beauty. i feel the poetry of the things that i work with, and i cannot explain it but i do not have to add myself to this.

WF Formal innovation would somehow get in the way of this direct simplicity that you're talking of? It reminds me of some of the books you were showing me last night – the 19th-century encyclopaedias in which there is a sense of discovery and great curiosity. This house feels as though it is animated by intense curiosity.

hdv yes, when i look around i realise i live in the midst of a perfect wonder. what surrounds me is intensely beautiful. but i do not have to talk about beauty, i can show what i have been seeing, keeping as close as possible to the real facts.

WF What are the fundamental issues and principles that you're concerned with in this relationship with nature?

hdv when i breathe, nature enters my lungs. sometimes i have the feeling that i am not breathing, but the outside world is breathing me, because i am obliged to breathe. a couple of years ago i made a book called *i am what i am: flora incorporata* and in this book are the names of all the plants that i have ingested – as medicine, as drugs, and as food. i was able to remember 484 plants that i have taken in by mouth, whether it was a homeopathic medicine like *aconitum* or rye in my bread or marijuana which i smoke. i represent what i have eaten. i am what i eat. in the same way i use my eyes to take things in and sometimes i collect what i see and then i can show it. it has to do with my identity.

WF Could you work with other sources? Could you ever go to a town or city and work with the things that surround you there? You'd still be experiencing it in your own body as your own human self, so that wouldn't change, but the external environment would.

hdv well, i cannot stay long in the city. i have to go away from it again, because i am no longer accustomed to it. but when i am in the city i see the little plants that manage to grow in the cracks in the pavement. i see the things people throw away: they are walked over, driven over, rained on, become wet and slowly lose their original form, and these i call artefacts. artefacts are for me objects of human origin that are taken into circulation again by the nature of natural processes. i love to look at artefacts which are withered or broken, that have fallen apart. in the cities i love the wastelands that become occupied by life again, by plants like mugwort, brambles, nettles, elder. nature is always present everywhere.

WF You have also said that art is about becoming conscious.

hdv yes, i think making artworks is part of the process of the artist becoming conscious. the artwork can be seen as a document of this process, so if you are following what an artist does you will see how his work changes many times. that happens as a result of his own experience of his work and, of course, of other experiences that he brings to it. i'm not the same, i'm still the same, but i am not the same.

WF Rather as the leaves are not the same as each other.

hdv sure. and time doesn't exist. time is a human invention. it's very practical, but in fact time is not something real.

WF Are you saying it is an artificial construct?

hdv it's an artificial construct that comes out of observation of the ongoing process. we can say that we will see each other at 11 o'clock – that's practical, but if our watches are not set to the same time, it makes no sense. it's just a human agreement. if i come from another place, say morocco, and there's an hour's difference, then our watches won't agree any more.

WF Although we're sitting in this idyllic country setting, we are nevertheless located within the industrialised world, and an hour's travelling time from here are power stations, factories, railways and so on. We therefore cannot relate to nature in the way, say, that people had to in the past when their economies and survival determined their relationship with nature. In your art, you are attempting to construct new relationships with the natural world.

hdv what do you mean by construct?

WF In the past, the relationship was very practical, very pragmatic; people had to relate to nature to survive. Now we don't have to. We don't, for example, have to

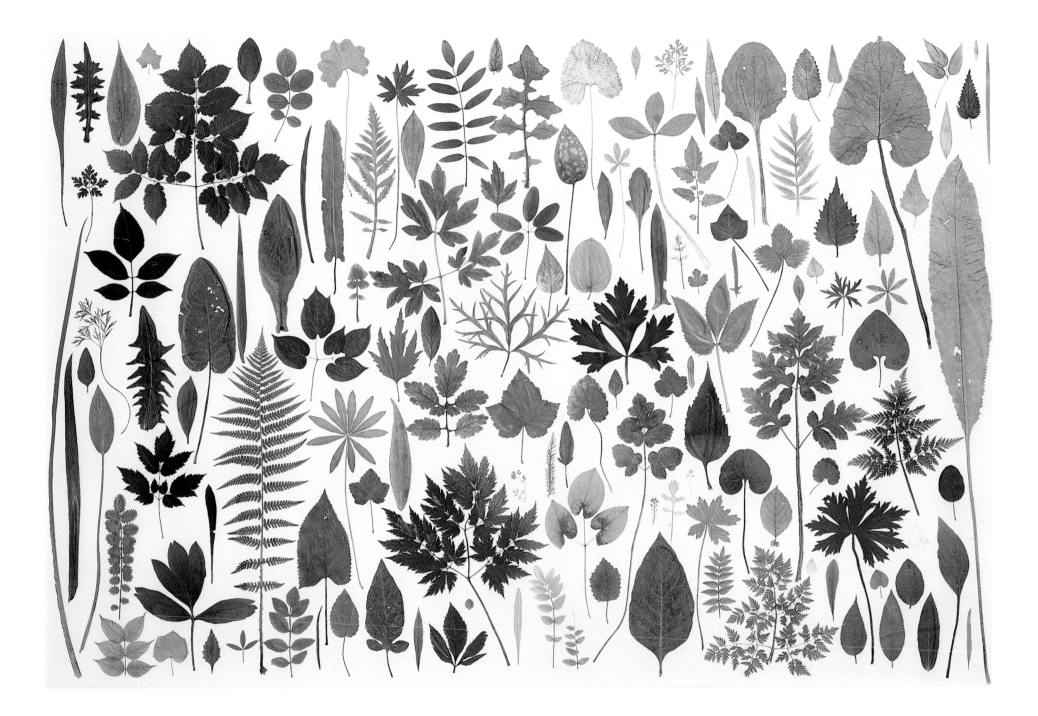

from our garden
1987

123 x 182 cm

148 x salix elaeagnos
1993

76 x 104 cm

grow plants to eat, we can get them from the supermarket, but nevertheless, this reality that surrounds you is very meaningful, very intense in this modern world. So what is the basis of your enquiry? What value do you think it has? Are you perhaps exploring something that is much more fundamental than the fact that you're living and working near a forest? Is this really to do with the human condition and human survival?

hdv yes, of course it has to do with the human condition, and my work only makes sense because there are cities and people live in cities. they have lost their relationship to many things, and some of these missing links can be given in my work – that's one side of it. but for myself, it's a fairly fundamental relationship that i have to nature. as a child i already had great admiration for the dunes near where i lived and for the plants and butterfly world that i got to know along the dutch coast. every sunday that my parents had free, we all went into the dunes or into one of the little forests that you can find in holland, and i enjoyed that very much. much later, when i went back to holland for the first time with susanne, i wanted to show her the dunes where i had had such important experiences as a child: i used to get into a kind of ecstatic trance looking at the sea, listening to the birds there and sitting among creeping willows [*salix repens*]. but when we got to this valley in the dunes, we could not enter it because there was a big fence. and behind that fence was the first dutch atomic plant. that was a big shock. i don't like atomic plants, you understand, and talking about this still moves me. when i realised these valleys were gone, i almost wept. so you see i had already had a fundamental experience of nature in childhood.

WF So those relationships are really very deep-rooted. The increasing attention that people living in cities are paying to your work makes it seem as though there is a recognition of something that has perhaps been forgotten or has been lost, and that you are reclaiming this relationship with nature.

hdv yes. that is, i think, more or less my function: presenting. this is my place. i'm aware of the fact that i live far away from the cities, but i am also always aware of my human social function. this is my place, this is my function, this is what i want to do, i like to do and i have to do.

WF You've gathered earth samples from all over the world. How many do you now have in the collection?

hdv over six and a half thousand.

WF And this really is another way in which your work comes back into the centre of the industrial, urban political world, perhaps. Although you work in this idyllic village, some of the work that you've made seems to me to be quite profoundly political. If we consider the earth piece you made in which you presented earth

from ancient Aboriginal sites in Australia, that in a sense speaks of the struggle of this indigenous group of people who have now been all but wiped out. You've taken earth from Chernobyl which is the site of one of the most devastating nuclear catastrophes ever and you've just spoken about the nuclear power station in Holland. You've taken earth from the area around Buchenwald.

hdv buchenwald or beechwood –

WF – which is an innocent translation of the name of one of the largest concentration camps of the Third Reich. Of course many of the other samples don't have such vivid associations, but in taking samples from the three sources I mentioned, was it your intention to make a statement with some political potency?

hdv certainly, certainly. i had an exhibition in erfurt, a town near here. buchenwald is not far away, and lies between erfurt and weimar, so through weimar it is also connected to german classical times. it was also a region where goethe met friends to talk with them. buchenwald is such a hard but strong place. i realised that if i was to have an exhibition there, i would have to take this aspect of the region into account. i had also collected earth around erfurt: a roaming picture of the different earths in this landscape. i took a sackful of earth from the centre of buchenwald from barrack 15 where they did experiments on people. i presented it on a piece of white cloth in the museum in a space that was itself white. i just laid it down as a surface measuring one to two metres on the floor. that's about the size of a human, one to two metres – the shape of a grave. and i strewed the earth. we don't see very much earth any more. the earth takes everything and anything to itself, but it's still witness to all the facts. there was a little button off a shirt i found in the earth – a human moment in the earth. when i showed this earth, i saw that the people who came into this little white space became very silent and were impressed, even though what they were looking at was only earth. when the people from the museum's technical department asked me what to do with the earth after the exhibition – 'shall we throw this away?' – i said, 'oh no, you can't throw away this earth. i will come personally to take this earth back to the place where it comes from, where it belongs.' the australian earths were brought to me by friends and they are a very valuable part of my earths collection, because they were collected at places where aboriginals gathered earth to make their wall drawings: red or yellow, and these drawings (which they still make or at least renovate) are an example of the oldest surviving culture in the world. this is a culture which has had a stable relationship to nature with a spiritual insight that still more or less exists and has been existing in this way for twenty, forty thousand years or perhaps even more. that's very important earth, i think. i also have some earth collected by a friend from the place where, according to tradition, buddha had his enlightenment. thousands of people have been there and maybe my earth is just

von acht brandstellen/from eight bonfire sites
eschenau, bavaria
autumn 1991

73 x 107 cm

dust that has been brought there on their feet, but it's still earth from this place. i think that's important earth too. but in the first place, it's just earth.

WF It's a witness in a sense to what took place on that earth.

hdv yes, and of course i am also the witness. i am the witness of everything that is happening around me and this is brought back into the work.

WF But if you're putting earth on a gallery floor or placing it in a certain configuration, you're actually exploring associations and meanings aren't you?

hdv well, of course, meanings are connected to it because of the name of a place, like buchenwald, for example, because of what we know about the history of the region. i also had a political installation in warsaw. i had thirty-two samples, each making a surface one to two metres long which together formed a polish field that i called 'polish earth – polska ziemia'. about one third of the samples came from a region in poland which had originally been german. i wrote on the wall of the gallery the current polish names of the places from which the samples came, not the historical (german) names that are now part of the past. later i showed this installation in germany, and there were some very emotional reactions from visitors to it who were originally from these regions. but I was only showing facts. recently the terrible things that can happen when people insist on trying to return to a status quo that is past have become only too evident in ayodhya [india], bosnia and israel.

———————————————————

WF We're now walking towards a forest, very close to where you live.

hdv yes, we are on a piece of land called *gereuth*, from the german word *rodung* meaning cleared woodland, uprooted forest. a long time ago this area was all forest, part of the wonderful, complex skin that once covered most of the earth. on old maps our meadow, where we're now going, is called *köhlerin* – a female charcoal burner.

WF And the forest where you gather your flowers and twigs and seeds and leaves?

hdv well, sometimes i pick up something, something of value, an object that can inform us, but then everything has something to say, so the choice is big and mostly what i do is just spontaneous. it's not like a scientist working systematically. i might, say, press part of a clump of vegetation between two pieces of wood, and cut it off at the ground, and then, when it is dry, frame it, then i have a 'part'. i call this a 'part' because it is never a whole, it's always only a part representing the whole.

WF This is where your practice really departs from scientific process and becomes intuitive?

hdv yes.

WF You take the material you've gathered in that way back to your studio and then you start to order it in ways that are perhaps associated with scientific presentation.

hdv when things like leaves or rows of earth samples are shown beside each other, then it comes close to the scientific form of presentation, but when i take the 'parts' they are just pieces of vegetation that i have seen, taken and framed so that i can show them. In that case, i don't change anything, and there is nothing scientific about this presentation.

WF This field we're looking at – is it just lying fallow at the moment?

hdv this is used for growing hay. it has been heavily manured, so this field later in the year will have grass a metre high, and if the farmer is lucky he will be able to make three cuts. once we have reached our meadow (insofar as it still is a meadow), you will see that it looks different. some years ago wild boar were active in our meadow and made holes in the earth to look for beetle larvae. the meadow next to ours had almost no holes because it had so much less life in it.

although there are quite a lot of them round here, i seldom see the wild boar, because they are very shy. sometimes when I go through thickets I can smell them. sometimes I hear them running away, but it's very rare that I see them.

WF Your meadow, which we've just reached, is located in the centre of arable land, but the difference in the plant life is immediately clear: it's covered in yellow flowers.

hdv primula. in the field next to this there are almost no primula, but here there are a lot. and a lot of white anemone flowers grow here too.

WF What have you done to establish this meadow? How long has it been here?

hdv we started it in 1986, when it was just like the fields around it. we planted hedges and fruit trees and once a year we cut the grass and removed it so that the land was not manured. so in becoming poorer it became richer in plants (because tall grass keeps other plants away). the land we've just walked across is manured and fertilised. it's a strange word, 'fertilised', because fertility is something different from what you achieve with artificial or chemical manure.

WF In a way you've established a sanctuary here and you don't do anything with it other than observe it and see what grows. Is that correct?

hdv when there are apples on the trees, we eat the apples; when there are nuts on the trees we collect them, but if the animals eat the nuts, that's okay. we have cherry trees and also wild cherries – mostly the fruit is eaten by birds. we've also planted about 120 wild roses in the hedges. the roses often flower at the same time as the hay is cut, and then the farmer comes and spreads liquid manure over

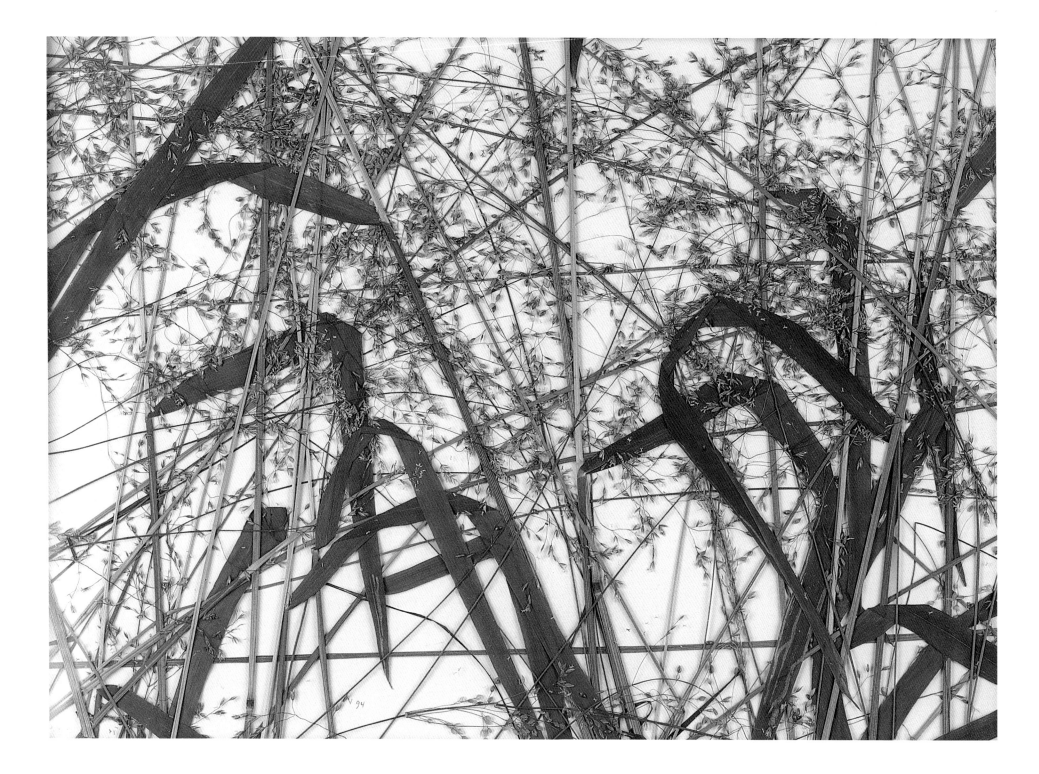

part – milium effusum
1994

21 x 30 cm

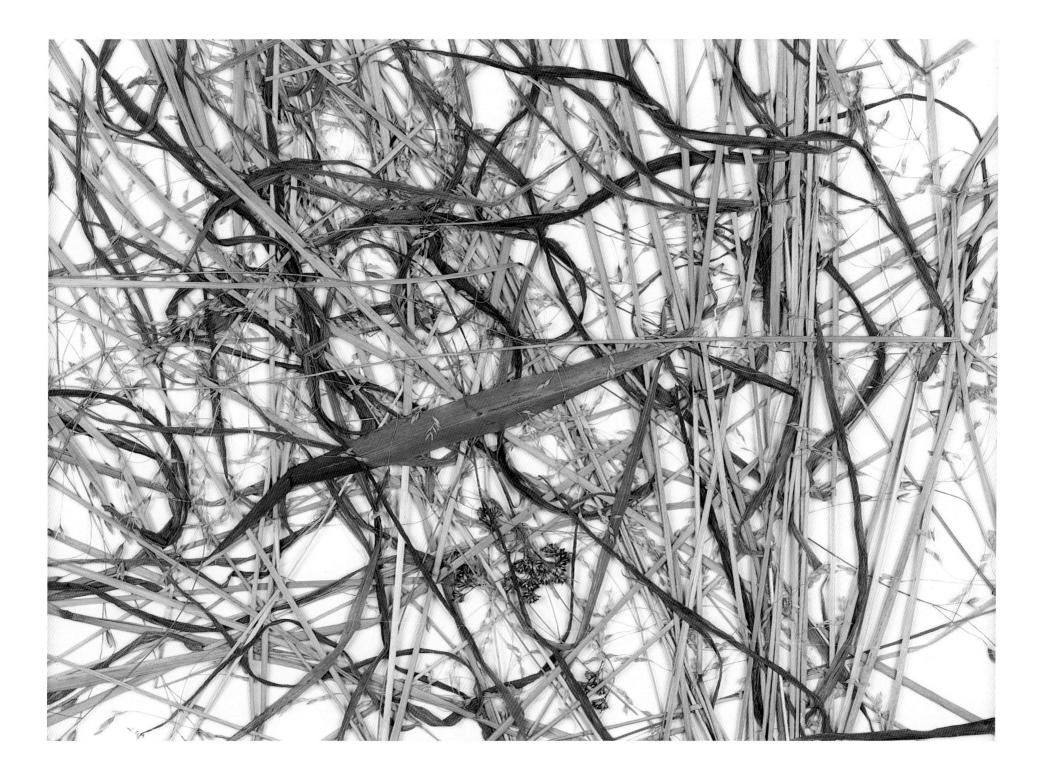

part – milium effusum

1994

22 x 31 cm

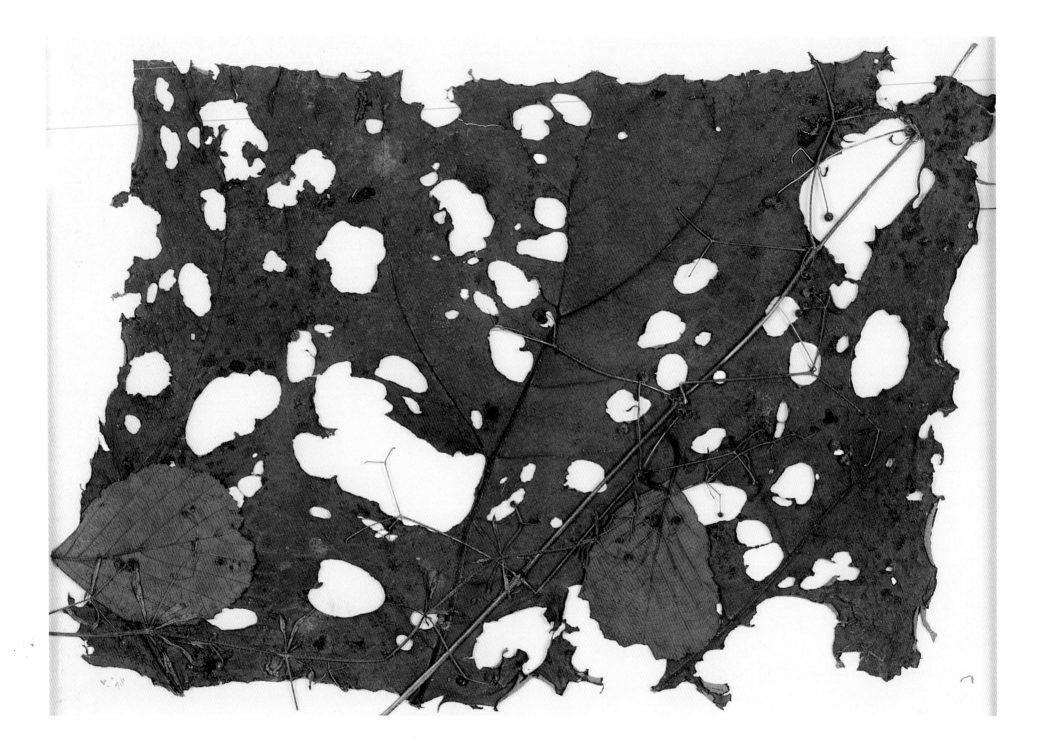

part – coltsfoot
1998

22 x 31 cm

the land and it stinks, and you can't smell the roses any more. inside the hedge, i have a little room – a small private space which we keep free of undergrowth.

WF A kind of sanctuary within a sanctuary.

hdv well, it's more a living room inside a sanctuary. there's one very large thicket which consists mainly of dog roses. it, too, used to have a space in the middle which we would get into, but it's now overgrown and i didn't like to cut the growth away so we can no longer sit in it. five or six different kinds of bird nest here now.

WF So you use these spaces in almost functional terms?

hdv no, just for enjoyment. gradually we allow the hedges to grow up. at present, we still keep some of the vegetation cut back so that an open space remains, but one day perhaps we won't do anything anymore and slowly the shrubs will take over. then it will go completely back to nature. this not doing anything any more will be the art.

WF Do you invite people to come and visit this?

hdv seldom, i keep it quiet. sometimes when i have friends or guests, we go to this meadow and have a look at it or sit down and have a small picnic, but it's not a place for a party.

WF You don't see it as a site-specific sculpture?

hdv well of course it is, but it's not necessary for people to make excursions to it. i want to keep it quiet. the forest here extends for some twelve to eighteen kilometres with, here and there, brooks and small meadows. roe deer live here, and wild boar, foxes, martens, and badgers. the badgers almost died out when they were trying to get rid of rabies by gassing foxes, which often lived in badgers' setts. baits with rabies vaccine are now laid and the foxes are vaccinated by eating these, and a forester told me recently that in our region there are now about twenty places where the badger is living again – a lot of the setts are very ancient, and several parts of the forest have names that refer to badgers.

WF Is all of that knowledge part and parcel of what interests you about working in this sort of environment?

die wiese/the meadow
1987, 1994, 2001

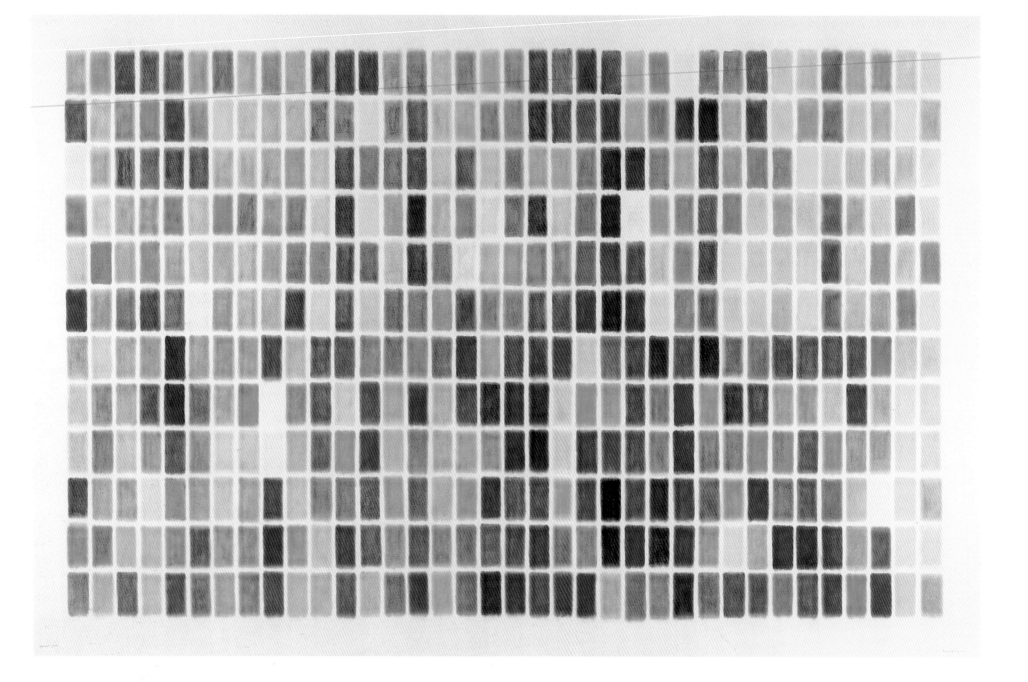

from earth: la gomera

2001

120 x 180 cm

hdv almost every day i spend between one and five hours outside. if i have, unfortunately, to do other things, i still go out for a short time, so that i can keep my relationship with my surroundings going and experience the changes that happen in them. i used to think that nothing changes in late summer, and then i discovered that, on the contrary, the vegetation still has many changes to go through before autumn comes.

WF Do you collect every time you go for a walk?

hdv not every time. collecting is mostly done when i go out spontaneously, but there are times when i go on special trips if i know where i can find something in particular.

WF Do you collect things purely to bring them back to your studio and catalogue them and then wait until you want to make a piece of work, or do you come out here into the woodland and have an idea for a piece of work just from looking at the objects on the ground around you?

hdv normally it is a spontaneous decision, just an observation and perception that this is what i want to do. but i do collect for future reference. mostly the work is done in the weeks afterwards. my wife susanne does part of it. we discuss how it should be done and she then mounts the plants. and i am mainly responsible for doing the earth rubbings. our collaboration is important. i usually take the decisions, but the talks we have together about the work and how to carry it out and how we see aspects of the work happen in the evening. i don't know how my work would be if susanne were not participating in it. it would certainly be different.

WF So this is a real collaboration. It's not as though you could send instructions to someone in America to make this work!

hdv that wouldn't be easy. of course i do get earth from friends who know my work and send me parcels of earth they have collected. about ten to fifteen per cent of the samples in my earth museum were not collected by me. i like this idea, because it makes it more general. it makes it less fixed to me. but i always want to know where the earth has come from. to make the earth rubbings, i take the dry

herman and susanne de vries
in the forest near eschenau, bavaria 1999

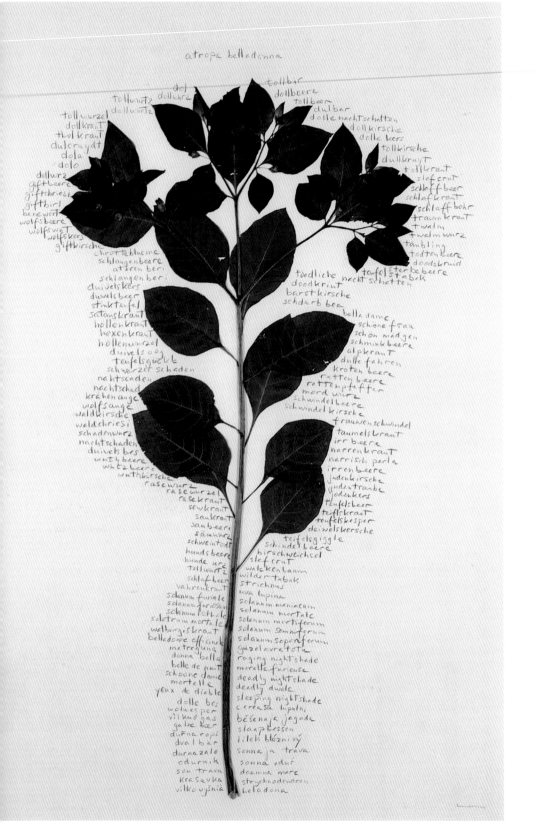

earth and, if need be, sieve it until it is fine enough to rub directly on to the paper; if it is very hard pieces of dried loam, i pound it in a pestle and mortar.

WF So it becomes a pigment?

hdv well, it is still earth. and then i rub it into the paper and then i have a surface the colour of the earth. you see the colour, which has been applied directly to the paper with no added ingredients, and you can see the process of making because the rubbing marks made by my fingers are visible.

WF So it is the process that is really the artist's signature?

hdv well, the artist's signature in this case is very simple because i try to do it in a very plain way. there's no expression in it.

over here is a very modest indication that this is a private piece of land. there's an opening that looks like an entrance, so i've put thin rope in front of it. it wouldn't stop somebody if they really wanted to go in, but it's an indication that this is somewhere private. you can cross the line but it is marked. not many people come in. mostly they just stand here. just this piece of rope keeps most of people out.

i chose to create a natural situation here, by making our meadow and letting nature move in, but the decision to do this is a cultural one. so is it nature? or is it culture? or are we somewhere between the two?

WF You were saying earlier that you use a lot of the herbal plants from the forest for medicinal purposes.

hdv every year, for my private medicinal purposes, for herbal teas, for my bronchial system or for other things, i collect as much as i need. sometimes i give something to friends who ask for it, but normally i use this privately. and i love to collect mushrooms to eat. there's a plant here called *mädesüß*, whose roots can be mashed up and placed on rheumatic joints to ease the pain. the name comes from *made*, an old german word for meadow and in the early 19th century they discovered in it the substance that is now known as aspirin, so it was entirely logical that people should have used this plant. this substance also occurs in the willow – as salicylic acid. it was discovered in this plant in germany in 1838; it had been discovered in france in 1827 in the willow.

WF Right. So the history of the plants and their application in medicinal terms or medical applications is something that you've studied.

hdv yes. my book *natural relations* is in fact a large catalogue of an exhibition of the same title which opened in the osthaus museum in the hague and is now permanently on show there. it contains about 2000 plant samples. one section consisted of plants collected around here. the other three were made up of items bought in markets and from herb and spice merchants in morocco, senegal and india. each

opposite page
belladonna
1999

144 x 103 cm

am ahornbrunnen
beneath the maples beside the spring
1992

120 x 180 cm

sample is identified and there are additional notes about the folkore connected with the plant, its significance in religion, the history of its use, the etymology of its name, and so on.

i have quite an extensive library on ethnobotany and i'm a member of two ethnobotanical societies – the only artist in either of them, by the way. some years ago, i had problems with my heart rhythms, and I took tea made from hawthorn berries or hawthorn flowers. and now my doctor prescribes preparations like these for other patients with this problem. i love the hawthorn, i love how it appears in the landscape, how strong its little stems are, and how they endure really hard conditions. and I love the smell of the flowers (though some people don't). and of course i have a relationship with it because it contributes to my being healthy.

WF You have made pieces where you put sheets of paper or card underneath the trees and wait for the leaves to fall. Are you're looking at randomness again, the chance ways in which leaves will fall?

hdv well, in the past i saw this as another example of randomness, but now i see it much more as a moment of process. the leaves are falling anyway. i just put a sheet of paper under the trees, and after a while i take it away, and what i have is just a moment taken from the process of what is happening. the idea of randomness is now used in relation to statistics, but it used to be part of what the mystics talked about. that's an interesting change.

the leaves are glued on to the paper where they have fallen. i have no desire or need to change their positions, because what sense would it make to change the process, or to add to the process? i hate the idea of art in nature, because nature doesn't need this art. it is already perfect, as the sanskrit line on the sanctuarium in münster says: 'this is perfect. that is perfect. perfect comes from perfect, take perfect away from perfect, perfect remains.' but it can also be translated in other ways: for example, it can mean 'this is full, that is full, take full away from full, full remains' or 'this is all, that is all', and so on. reading oriental literature has had a lot of influence on my ideas. the diamond sutra has a stanza which I have quoted many times, because it was very close to my ideas about transience. it goes something like this: 'so should you think of this whole fleeting world: a shooting star, a bubble in a stream, a flash of lightning, a summer cloud, a flickering lamp, a phantom and a dream.' i love this because it has a sense of wonder. people think

science takes away the wonder of nature and the wonder of the world, but I don't think so. it deepens our insight into the processes. it makes the wonder still bigger and still greater, but it can never express the wonder. the wonder has to be experienced. science just helps us to see more of it.

WF The use of texts and labels is something you've worked with a lot. You've made a lot of poetry.

hdv of course i'm labelling, but the labelling is mostly simple. because i don't want to indicate too much. i can say, this is a document of chance, but i can also give it another name. i can call it 'documents of a stream' and that gives some idea of what it is about, but I'm careful not to give too narrow a name, because that closes off possibilities. language is of great help to humans because it allows us to exchange experiences, but language also sets things apart, so by using it *unity* is lost. that's another aspect of my way of seeing and experiencing things. it's a unity which i see and experience, and i am part of this unity. i cannot decide to be anywhere else because i am part of it, just as others are part of it. but not everybody is aware of this. i like the word awareness, because it means that you are awake, you are able to experience things openly and receive them. awareness allows me to see that i am an aspect of the world, and i will play my role as an aspect of it. i do not always experience unity because in daily life this sometimes gets lost. it gets lost when you talk too much, but there are beautiful moments when you can experience unity again. and that's what the work is about. it's about the unity behind all appearances.

WF So this idea of unity is an underlying principle?

hdv certainly. look here: the hole is still alive, there's a field vole living here. you can tell because he has taken grass inside and he's been eating little bits of grass around the entrance. there are also dormice around here, who live in hollow trees or take over birds' nesting boxes. they eat almost our entire nut harvest.

WF Are there cattle and horses on the farms around here?

hdv not outside. the cattle in this part of the country spend the whole year inside. it's a pity for the poor animals, but it does gives me a lot of freedom to walk through all the fields, because there are no fences. holland is a country full of fences and when there are no fences there are signs prohibiting entry. i hate fences and 'no trespassing' signs. it's beautiful that there are no fences here.

WF You mentioned that you have a special permit to go into the forest.

hdv it's very difficult to get one, and when i talked to the head forester, he said, it's a nice idea, but i can't see any reason to give you a permit. i asked him who got them, and he said 'scientists who want to work here'. so then i told him that in the german constitution art and science are given equal value. he looked at me and said, 'that is a good argument. i will propose it to the directors'. and I got a permit.

WF Does your local town know about your work and support you?

hdv no, there is no support, and i don't ask for any. when i came here i was quite happy to be a foreigner. i like being a foreigner because it means you are free of the social conditions of a place.

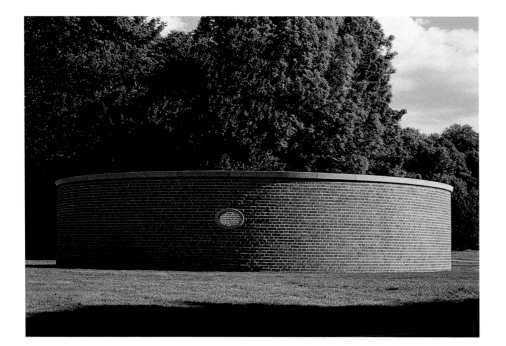

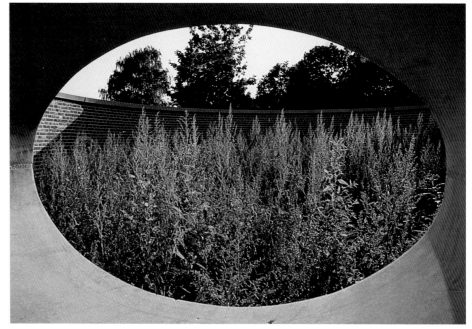

there's a project in tilburg, holland, that i should tell you about. i made a cata-logue of all the trees living there so that everybody could know about them. and in the hague, 'the tree museum' is in a new part of the town that covers about three and a half square kilometres. my idea was there should be at least 200 species of trees to make a real museum of trees in the streets. in the catalogue, i gave not only botanical details but also the country of origin, the time of flowering and in many cases more information, often historical, so that the tree is no longer just something green but it has a name, and a connection to people, and the natural relations between people (often in other countries) and these trees become clear. in one place, i wanted to have a whole avenue of different oak trees. there are hundreds of species of oak in the world. oak has been an important tree since europeans were still hunters and gatherers, and acorns were a food staple. there's a certain technique you can use to get the acid out of them, for example, but this is all forgotten now, so it was nice to write in the catalogue a chapter about the oak. in both tilburg and in the hague, i have placed in the pavement close to each tree a stone with an outline drawing of its leaf and its botanical name. so every time you walk past you are confronted by this information. once you know the name of a tree you can talk about it

WF Maybe this connects with the Münster Sanctuarium, but were you actually making a work for an inner city?

hdv yes. it's an adaptation for the city. all good cities are planted with trees. there may not be much other vegetation there, but at least there are trees, which is good for the atmosphere and also good psychologically. but most people don't know anything about these trees and I want to give the people who live in this new part of the city the opportunity of having a relationship with trees again, by telling them about the way people in the past lived and worked with trees and used them. every household in the area will receive a copy of the catalogue.

another big project is one in eastern holland, in a region of wetlands, reeds and scrubby forest. one area is a national park, then there is land devoted to agri-culture and then there is another stretch of nature reserve. the aim is to join the two areas of nature, so that there is an exchange of organisms between them. the agricultural region is lower, it's a polder. my plan will involve about eight and a half square kilometres of agricultural land being given back to nature.

i had to read a lot of historical and scientific literature, including papers on hydrology. i also studied plant sociology, and i visited the place for three weeks, going around in small boats along little canals, and then i developed an idea as to how this region could be changed so that nature can take it over with a range of different ecological possibilities. i think there is a good chance of realisation because several of the regional authorities have contributed to it.

it involves different depths of water in different areas. where the water is 1.8 metres deep there are no reeds, but there are water lilies. then when the water is one metre deep, the first reed can get a foothold, and although the ideal habitat for reeds is water that is up to 30cm deep. over 50cm the reed will slowly disappear. at 60cm above the water table, we can expect birch forest. the soil is original moor-land with sand beneath it. the moorland peat has been taken away for burning

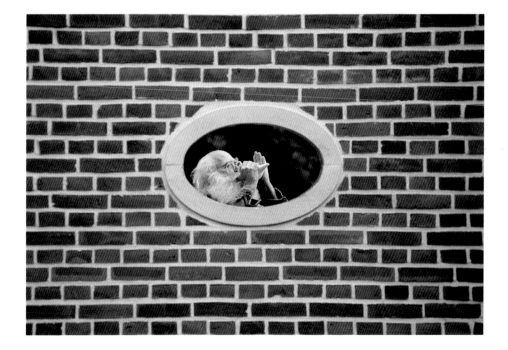

sanctuarium
1997

münster, westfalen, germany

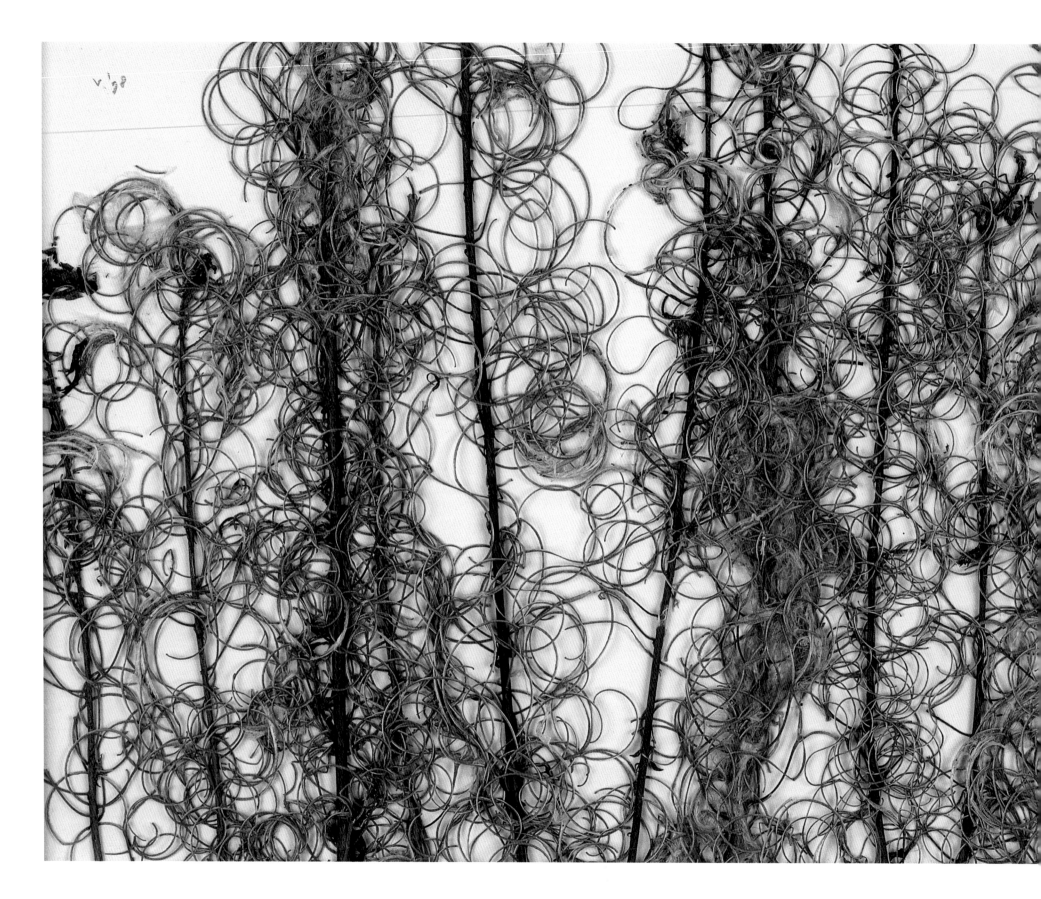

part – epilobium angustifolium
1998

22 x 31 cm

and then sand has been mixed into the peat that remained to make soil for agriculture.

WF I'm reminded of a resonant phrase of yours: 'i have to make visible that which people don't see anymore'. That's true of this project and many others that you've made: you're looking for patterns and for realities that we've lost the ability to see.

hdv by presenting things from primary reality, from nature, i draw attention to these things happening, and to the poetry of it, to the astonishing things that are taking place that we've lost the ability to see. and perhaps here and there this will provide the possibility of an opening, a window for people. this is part of what i call my social participation and my social responsibilities.

i have always thought about the social position of the artist. what is he doing, what is his place in society? with the work i do, i know exactly what my place is and what i am doing: it is a social contribution to a general consciousness. i do the commissioned projects like those in holland in addition to my other work. they can sometimes be very important, but my main work is still here.

WF You have always published books. You created the eschenau summer press and the temporary travelling press. Are books important to your work?

hdv very early on i realised that books offered possibilities for artistic work. i think the first artist book i made was in 1960 or 1961. it was one of the first art book publications in holland. i have always loved books, and i like the idea of using the possibility of a book as a work. and i also thought, publications can be done differently. one of my eschenau summer press publications contains no text, but when you open it, inside there are dried rose flowers. you can see them and you can smell them.

WF Did you go to art school?

hdv no. i never went to art school and i am glad about that, because i wasn't subjected to any art influences through being taught. I was able to develop freely without these other things that teachers might lay on my shoulders.

WF So what drew you from the natural sciences and into being an artist?

hdv i was not completely satisfied with my work in scientific institutions so i started to do artist's work. i enjoyed working as an artist, but it was a long time time before i was able to work only as an artist and give up the other work. it was a slow process. i worked for eighteen years in two institutions in holland: the plant protection service of the ministry of agriculture and then later on at the institute of applied biological research in nature, where, among other things, i was assisting in a research programme on the development of populations of a certain caterpillar; later i had a part in a research programme into the population dynamics of the

hare. in the plant protection service i had to do very terrible work testing rat poisons. when i had my second lsd trip in 1970, it made me look again at what i had done in my work, and the next day i became a vegetarian. occasionally i eat fish, but i still never eat meat.

lsd was a very important experience for me. it helped me to see the unity of life. and the use of hashish and marijuana has given me many free moments when i could observe things happening for hours: i could look at the flowing of a stream or the wind moving the trees. i don't know if my artistic work would be as strong if i had not used these two drugs. they have contributed a great deal to the development of my thinking. i think it's basically alright for people to use these drugs. in the past, so-called primitive civilisations used drugs, as part of their culture, to go on 'vision quests', but in modern times this purpose has been lost; young people still try to do this, but often rather clumsily. in our industrial information society, we have no contact with nature which was the source of drugs in the past, so now we have chemical drugs, although it would be better to use natural ones. i think i owe part of my good health to lsd because in the past i was a heavy asthmatic, and i said goodbye to my asthma on an lsd trip! with the asthma, i had a life expectancy of a maximum of 50 years. my heart is a bit weak from the old asthma attacks, but now i am 67, so i have gained at least 17 years from the use of lsd. i don't use lsd any more, but sometimes when i have it available i take a little pipe of hash. i have used it for many years.

WF You've created an identity and way of working that is independent of art movements and you've managed to stand apart from the various fashions that have come and gone in the art world, which is quite remarkable.

hdv i was outside but i did not lose contact. i was aware that i had a social function, so i still needed to show works to connect my work to people.

WF But now you show in museums and mainstream galleries.

hdv yes. i have nothing against it. that means that some of what i do has started to be understood or accepted, or perhaps the stream that I was part of is slowly coming to be recognised. i stay outside to give work back to the inside.

WF Do you teach or have you survived solely by being an artist?

hdv no, teaching is not my role i think. my role is to do my work. i think it might even be dangerous to impregnate people with my ideas through teaching. artists should develop themselves, and a lot of teaching does not help them. young artists should ask themselves, 'why I'm doing this?' 'why do i want to be artist?' and 'what i am doing by being artist?' 'what's the reason for it?' those perhaps would be the most important things to ask people when they are students.

WF Have there been artists whom you have found particularly influential?

hdv early on i very much admired the work of jackson pollock and piet mondrian. mondrian provided an example of social engagement and in his paintings he was searching for a kind of balance, trying to bring various elements into equilibrium. what i liked very much in the work of jackson pollock was that there was no central viewpoint; you could look into the picture and your eyes could drift anywhere in it, you were not drawn by a a central point or by perspective or anything like that. it was chaotic and that fitted well with my young anarchistic ideals. no part of the picture had more value than any other part. that's also the reason why I write my name and my text and my work in small letters, because i don't accept authority. well, i can accept authority in some ways, but i don't accept hierarchy. i was an admirer of the work of peter kropotkin, a russian anarchist who wrote a great deal about social situations and of a dutch anarchist reformer called domela nieuwenhuis, and what i learned from the thoughts of these two writers led to my writing small. sandberg, a former director of the stedlijk museum in amsterdam, also used only small letters, and he called it democratic text; everything and everybody has value and you don't have to express different values by using capital letters. it was important for me to write my own name without big letters, and also i like the aesthetics of text in small, lower-case letters. i think its more beautiful, more regular, simple and clear.

WF On the subject of democratic texts, what do you think about Beuys?

hdv i have a lot of respect for the work of beuys, but i am not influenced by him. i like the work of richard long very much, although he hasn't influenced me either. what i liked from the beginning in long's work was his feeling for poetry. for several years in the 'seventies, i had on the wall above my work table a little poster from an amsterdam gallery with a photograph by long of a brook with a beech branch hanging over it – just a poetic picture. i like the poetry in richard long's work.

WF You mention poetry quite frequently, yet I'm not sure whether there are many other contemporary artists who would use that word.

hdv in 1972 i wrote a manifesto. many people think it is a poem and perhaps it is that too, but i wrote it as a manifesto: 'my poetry is the world'. it came out of my becoming aware – after working for a while with concrete poetry – that i didn't have to formulate things in letters any more. i can't say what is poetry but i still think about the poetic experience. this manifesto was also to do with unity: 'my poetry is the world. i read it every day, i re-read it every day, i see it every day, i eat it every day, i sleep it every day.' the original was written in english. i like english very much because it's an open language. german is much more fixed grammatically. 'the world is my chance. it changes me every day. my chance is my poetry.'

eschenau, northern bavaria, april 1999

rosa canina
1994

80 x 76 cm

Chris Drury

William Furlong Modernism (and post modernism) have, in the main, reflected the preoccupations of urban life, creating an art of the city. Clearly, you see yourself as doing something else: the source of your work springs from elsewhere, and you have remarked that the strength in your work derives from a deeply personal relationship to the landscape.

Chris Drury You talk about most art coming from cities: I think you can say that art from cities is about ideas. My work is also about ideas, and I'm interested in a lot of the ideas that come out of contemporary art. But when it comes down to it, I tend to make work from the pit of my stomach, as it were. I don't get anything out of cities in the pit of my stomach, but I do out of the quieter places of the world. I hesitate to say nature, because obviously nature is in the city as well. We ourselves are nature. In fact, as soon as you say nature you're actually talking about culture and you're back into cities. What I'm referring to are places where there are not a lot of people and cars and telephones and stuff, where you feel the wind in your hair, all that kind of thing . . . Places like that do move me, and it's only through being moved that you can actually make something. If for any significant period of time I don't go out into the countryside – I'm trying not to say 'nature' – then the work tends to come out of my head and it gets very introspective and self-

conscious. As soon as you go out, that self-consciousness is kind of shattered, and you're faced with a different reality.

WF I'd like to pursue the distinction between nature and the landscape. What are the essential ingredients that give you that gut feeling you described?

CD There is nowhere you can go on the planet that hasn't been affected by man, and I think that one shouldn't start from the premise of cutting man out because, again, you come back to this thing, that we are nature, and that's actually what interests me. It seems to me that I am able to see my own nature when there are not a lot of distractions, and the real distractions are the preoccupations that go on in your head. That is somehow souped up in a city, or even in a town, or even in this room; and it quietens down if you go out. You don't have to go very far: I can walk for fifteen minutes out here and still be within earshot of traffic sounds. But the further out you go the better it is. It doesn't have to be people-free; I've been to places recently like the Himalayas where, for example, I've been walking with Ladakhi people. The landscape was absolutely amazing, and the people were there all the time, and what is really impressive in that place is the quality of the relationship the people have with their land. You can never take people out of the

equation. First of all, you are there yourself, and then there are other people, so I hesitate to say, I get a kick out of going into wild places. It's not true. I mean, I get a kick out of finding a mushroom in a field, so it can be an experience of something very small as well as of something very big. It is great on top of mountains and I love it, and I like to be alone in places like that – that's brilliant – but I also like to be in other places. It's a whole experience.

WF From what you're saying, it's more to do with an internal consciousness than a physical environment or a physical space ?

CD Yes, it is. I have made a lot of site-specific works because it's a reasonable way of making a living and in those situations I am almost always dealing with small communities and working with other people. Actually it's very hard work, because there's often a lot of heavy lifting – of rocks and stuff, but that contains its own lessons.

WF In what sense is a work that you make site-specific?

CD It has to do with time and place and the way a piece sits in a landscape and what it does. It's made there, it's made of the material that's there and it's made by people who live there. All those elements come into it and it has to find its place within the landscape but also within the culture relative to what those people are.

WF So what is its function as a piece of sculpture in relation to the people who will see it and interact with it and move around it?

CD Its function is different from person to person. Because some of the things I make are structures that you can go into, they are experiences in themselves. They are meditative spaces, I would say, and their function is up to the person who enters them. The function within the community is that it's a cultural object built in their environment that may throw up ideas or feelings.

I've made cloud and wave chambers, which are shelters built of earth, wood or stone with an aperture and sometimes a lens set in them which will project clouds or waves or whatever is around on to the floor so that what is outside is inside. And this seems to alter the experience of actually looking at wave patterns outside. There is one that I made in North Uist in Scotland in which most of the landscape you can see if you look in one direction outside is projected onto a wall – sea, islands, sea, land, sky – but because it goes through several pieces of glass and mirrors and lenses, the image is almost like one from an old movie. You sit in this very dark chamber and as your eyes get accustomed to the light, the image slowly appears on the wall. You can even get someone to go outside and dance up and down, and you still can't believe that this person exists – it's a kind of distance image, it's very strange. What that actually means, I don't know: the experience of the exterior of a work like that is of an object that is considered in terms of how it sits in that

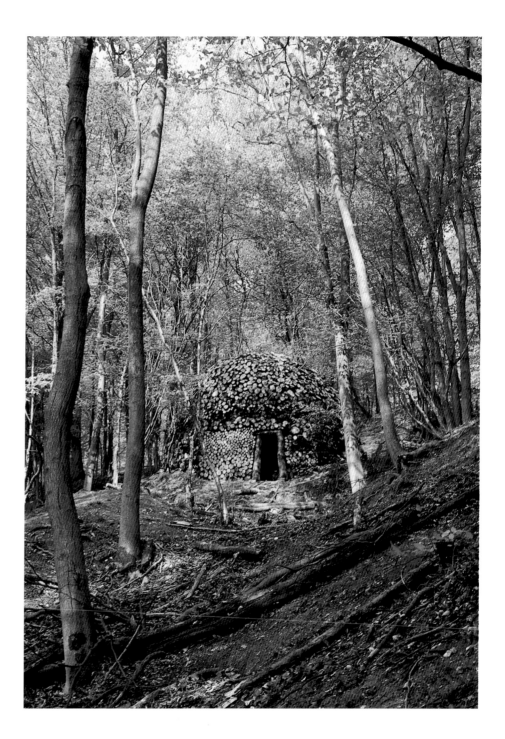

COPPICE CLOUD CHAMBER
1998

sweet chestnut logs,
periscope with lens
Kings Wood, Challock, Kent

73

landscape and how and of what material it has been built, and then you go inside it and you have a different experience again.

WF Is this intervention with mirrors and lenses a new development, compared, perhaps, with structures that are built purely from natural materials, where there's no other element mediating the experience?

CD I started making shelters as camera obscuras in the early 'nineties, to begin with just using an aperture, a hole, which had the advantage of being vandal-proof. Then in 1996 I was building a shelter on the edge of a lake and I wanted to put waves on to the floor, so I needed a periscope with a mirror rather than just a hole in the roof. The only way to do that was with a lens, but it's a very simple arrangement . . . very, very low technology . . . and the lens only cost five quid. I work out how to make the camera obscura with mirrors and lines drawn on a table, and I just make up a box; the one in North Uist was a small, wooden box in which there are three cheap mirrors and a cheap lens, and then the box was set into the wall, so it's a small element in a building made of granite. I've never objected to using man-made materials because, again, man is part of nature. If a bird can make a nest, a man can make metal. It's not a problem for me. I use any material if it's appropriate, whether it's man-made or not. I have made things in cities, but I've always quite liked to use earth materials in cities, simply for the contrast. I guess, though, that one of these days, I'll use something else. Some years ago in Denmark, I used a glass greenhouse and painted on it. So it just depends on what you're doing. The material has to be appropriate to the place. And that's it. It doesn't have to be twigs.

WF To what extent are you bringing materials and ideas and concepts to a site-specific work before you start to formulate it?

CD Well, you always bring yourself to whatever job you do. I visit the site, and the longer I have to sit in the site and think about it and be there, the better. You don't always get the chance. If you've had only a short time to visit a site, then it's important to have a longer time to reflect on what you've seen. And you try out things in your head and then come back, and then you usually make a proposal. Most people commissioning a work want to have some idea of what you're going to do . . . what materials you're going to use, for example. It's not unusual for budgets to be quite restricted, especially when you work for public bodies, so the materials are usually what's around, and that's often stone, because that can normally be got for very little money. So then you have the idea that you've worked on, but over the course of, say three or four months, it can change radically, depending on what's happening to you in your life. For instance, the wave chamber I made at Kielder Reservoir gained its lens only about two weeks before I went up

WAVE CHAMBER
sketch showing operation of mirror and lens
1996

to Northumberland to start the building work. I had wanted to make a chamber to do with waves, and there were rocks on the side of the reservoir that had wave patterns on them. I was going to put those on the floor, but then on a visit to Copenhagen I saw a show of sculptures in containers made by artists from all the major ports in the world, and somebody had put a big telescopic lens in one side of a container and projected the docks upside down on to the wall. It was such a wonderful image that it made me think about using a lens myself, and then I thought, well, rather than stone wave patterns, maybe I can put an image of actual waves on to a floor simply by angling a mirror on the top of the stone beehive hut down at the lake. Because the level of the reservoir goes up and down, the site had to be moved so that the hut could be built right on the edge of the water. That meant that we had to get the stone to it with a barge, which was absolutely horrendous. But I quite enjoy all that physical challenge, and I worked with a dry-stone waller and a couple of other guys. I actually didn't build the shelter myself in the end because the most difficult thing was getting the stone on and off the barge, so for two weeks I was humping stone on and off the barge in five-foot waves.

WF That physical engagement with the process of making is clearly an important aspect of your practice.

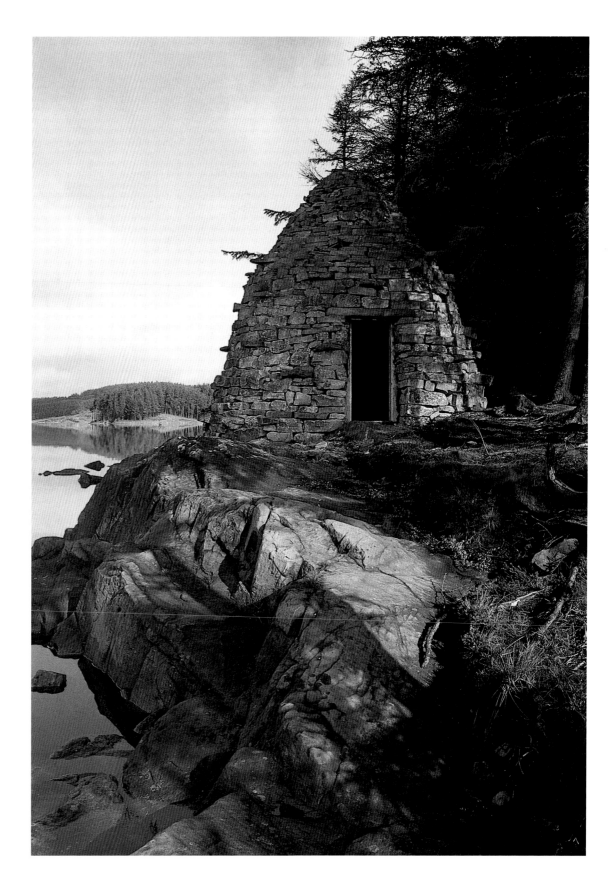

WAVE CHAMBER
1996

dry-stone with mirror and lens
in steel periscope
Kielder Reservoir, Northumberland, England

CD It is a part of the work and, you know, lifting stones for three weeks in all kinds of weather makes you feel very firmly planted on the ground. That piece works well, because the image is constantly changing, depending on the light, and even if you can't see anything, because rain is hitting the mirror (which happens when the wind blows in a certain direction), the stone chamber echoes to the sound of waves crashing against the rocks outside.

WF You are, in a sense, magnifying or intensifying nature through the use of the lens and the mirror and the way in which the chamber amplifies the sound. Is part of your intention to communicate your consciousness of the place to those who witness the work?

CD Yes. And all the time it's pushed back on to the person who's in it, you know, because people's reactions are different. So it is an interactive kind of thing: people have to be involved; it's not just nature or altering nature, it's how you react. I don't think people do go in there and think about things – they actually sit there and experience it. A lot of the cloud chambers, where you've got clouds floating past you, are very still, meditative places. In fact, it's an illusion of stillness, because there is no such thing as stillness. Stillness comes from within. You can go into one of those places and still be worried about your mortgage and all that, so it's only an illusion, and I have to be clear about that. The stillness comes from the person, the viewer, and if that person doesn't have stillness, then it won't make any difference. But I think it does make you stop for a minute and reflect.

WF How would you describe the content of some of the pieces we've been talking about?

CD What always interests me is this business of inside and outside – inside human nature and outside it and how one talks to the other, if you like. That has probably been my main concern. And also the idea that nature is really culture. When you're out in the countryside, culture, or our view of nature, determines how you see what's in front of you. So you never see a thing as it is, you always see it in the way that you've been programmed to see it. And you can't get away from that, ever. But it's interesting to recognise that fact, and in that respect I feel that there's a cultural element to my work; it's not just about moving stones or whatever around, it's about place and history and my own history. There's always this veil between you and what you're actually seeing, the whole history of human interaction with the world. And the only exception is when you're so tired or shattered or it's just such an amazing moment that all that stops in your head. And then somehow something dissolves. But it doesn't last very long.

WF I can't think of artists before, let's say, the last twenty to thirty years who have actually used nature in this way. You've derived some sense of a practice and a relationship to contemporary culture through a very direct engagement with nature which has involved you in spending a lot of time out in the landscape, interacting with it, and making works of the materials of which it is made. In the main, the works don't travel back with you. You make them, you photograph them, so the photographic image becomes the work. What do you think distinguishes a practice like yours from the way in which artists quoted from nature in the past?

CD Well, if you're a painter of nature, in order to paint it you have to subtract yourself from it. You have to stand back and view it, or view the angle. And you take yourself out of it, really, in order to view it. The difference is that I guess since the 1960s artists have been putting themselves into it. And that's part of the equation.

WF But what has allowed that to happen? Why has that come about?

CD It's probably an element that has been around for thousands of years, that our culture has divided itself from nature, and said 'we're different'. I think this art movement is part of a much wider understanding that we're *not* separate. We're a part of nature. I couldn't have said that consciously when I started to work, but I could probably say it now. That there is this growing consciousness that we're a part of it.

WF Could one perhaps draw parallels between a practice such as yours, and the practices of more ancient cultures, in terms of using materials that are found, and perfecting them and building with them and changing them?

CD It's interesting to discover what other cultures have done and what they are still doing, but I'm a twentieth-century person and I'm not a Native American. That is not, of course, to say that a Native American is not a twentieth-century man. I'm simply dealing with what's around me in the present. What I observe in other cultures may be a part of the way I look at things – those cultures that are visible now are very interesting. In Ladakh, as I said before, you see people still living gently with their land and actually, you know, where there are people, they have a very positive effect on that desert landscape. I do take it into account, but I don't make work about it, really. People think that I do, but I don't.

WF I was referring more to the possibility that what you do articulates a relationship between you and the environment you are in and the ideas that arise out of being there, in much the same way as an urban-dwelling artist would make work articulating a relationship to that environment.

CD Yes. I read recently that Don Judd said that the main source for his work is nature. I think a lot of city artists will say that. I don't know how true it is and I don't know what they mean, but I think they're talking about a deeper kind of connection to nature which is there in a city if you can tap it. If you are making

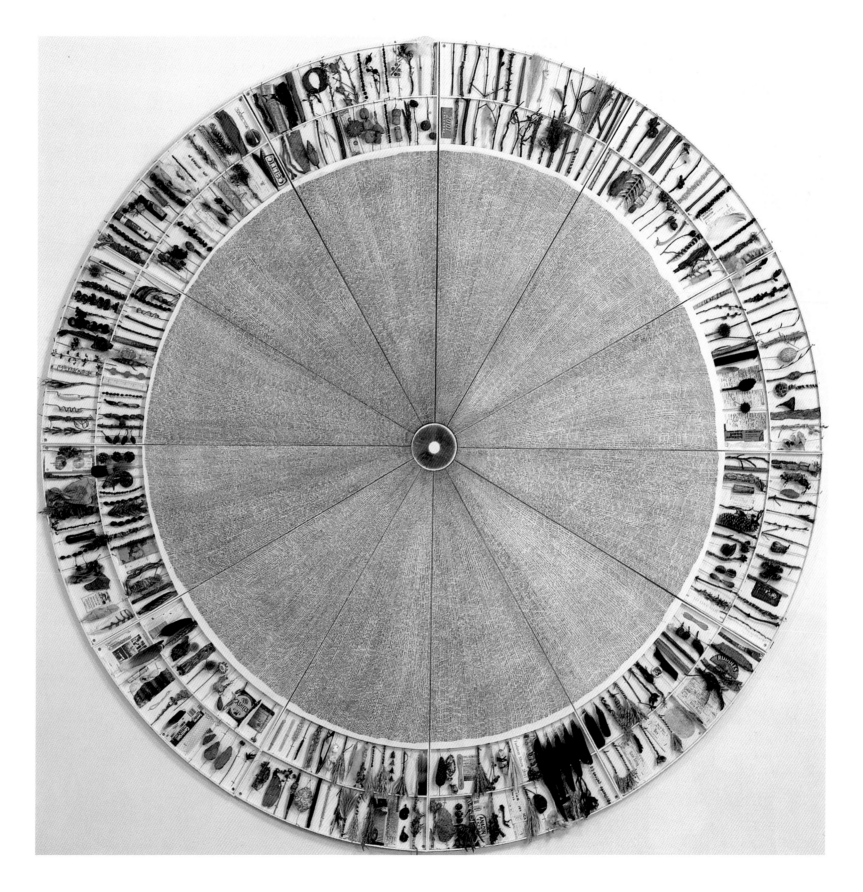

MUSHROOM WHEEL
17th September 2000
–16th September 2001

365 found objects, one for each day of the year on the two outer circumferences. Handwritten diary entries in lines radiating from the central mushroom spore print on paper, mounted on board in 12 segments. 257 cm diameter.

Detail of top overleaf, detail of centre on p.28.

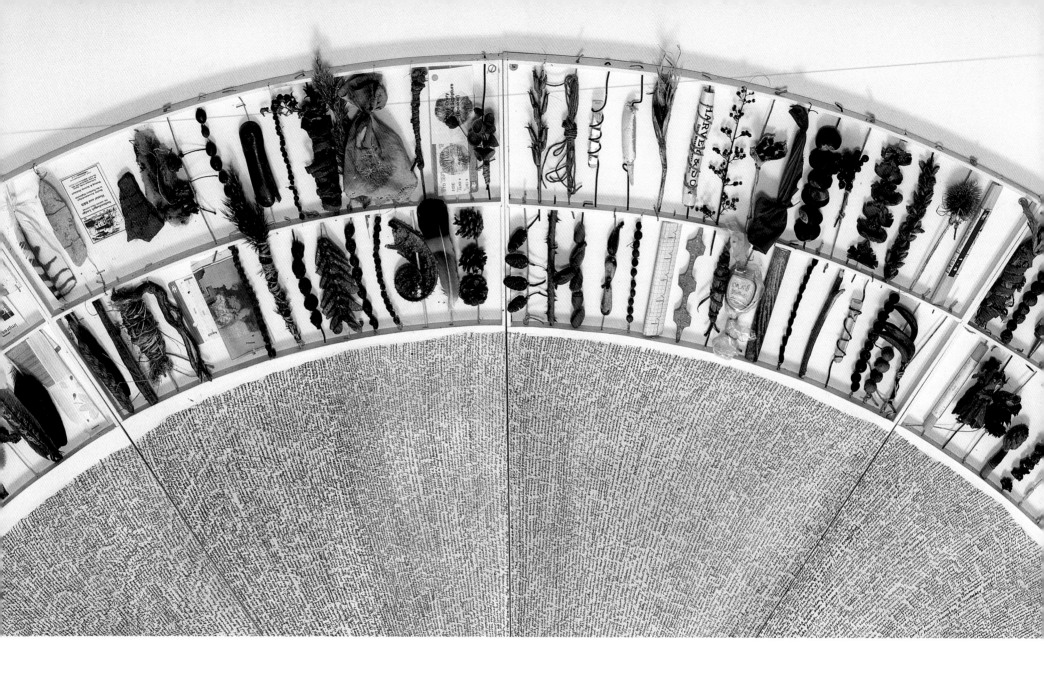

'In July 2000, Kazuo Yamawaki from Nagoya City Art Museum in Japan contacted me about exhibiting the Medicine Wheel I had made in 1983. This calendar work, made of 365 natural objects strung between bamboo spokes with plant papers and a mushroom spore print in the centre, is in Leeds City Art Gallery. Eighteen years on, it is in a fragile state and not really fit to travel. However, the request rekindled my interest, and I began to think about making another one.

'Eighteen years have passed, and my life has changed radically, so I thought it might be interesting to change the format a bit. In 1982, I was living in a cottage in Kent and not travelling much; now I live in a town, have a very hectic schedule and travel all

over the world. I was interested to see how such a work would reflect this. In the event, I did not travel abroad a great deal during this year. In fact, most of it was spent in Sussex, with only one trip to Texas in April. Of course, with the events of 11th September, the world was changing, but this is a work about where the inner world touches outer everyday reality.

'To make this inner world visible, I kept a diary during the year. This forms the largest area of the work, hand-written in the centre and radiating out from the mushroom spore print. I tried to keep the diary simple, as a few words repeated worked best. The objects are listed at the ends of the radiating lines. In reality, I don't expect anyone to spend long reading at all – it's fairly

illegible anyway. The point was that this dense circle of words visually reflects the complex and layered events of a personal year.

'As I kept a diary, I collected objects, noted them in the diary and kept them in a box. The only restriction on the selection of objects was size: the objects had to fit between the struts. The size allowance was in fact slightly smaller than in the original Medicine Wheel, and, as before, my family were able to choose objects. Once a month I would string the objects and edit and transcribe the diary.'

Chris Drury, 2002

very abstract work, then I guess that is the level you work at, and you're working straight with your own nature, which *is* nature.

WF Unlike post modernist art, your works don't appear to have irony: you talk about a gut feeling, and the kayaks and other objects you make are very much made with an aesthetic or a sensibility that *represents* the object. As works, they are not standing back making a comment on the object. Would you agree that irony is absent in your work?

CD I wouldn't have said there was a great deal of irony in the work, although I can be quite ironical as a human being. A few years ago I had to look back over my work because of a book I was putting together and when I started to look at everything that I'd made over the previous seventeen years or so, it was just boggling, and so diverse that I thought, how on earth can I make sense of this? The more I continue to work, the more the work has gone out and become fractured and very different, whereas someone like Richard Long has repeated the same things. My work has become very complex, but then, thinking about something like chaos theory, perhaps that's how I've worked, and underlying all the complexity is a kind of unity so that what appears to be very fractured and different is in fact unified in a whole. I tried to put it in a diagram. It started with the Medicine Wheel in 1983, which was really the beginning of what I've done ever since, and out of that came different categories of work. It started me off on making shelters and baskets, and then the shelters led to cloud chambers, and the baskets and the large, woven works I've made outside led me to the dewpond works [temporary interventions in dewponds on the Sussex Downs, for example, cutting patterns in turf or treading patterns in pondweed]. I've made woven maps, weaving ideas of landscape. And then there are the found objects. That's what the Medicine Wheel is about. And they've become found moments, like the cairns that I have made in the course of long walks in remote places.

WF The works such as the cairns register a particular experience in a particular location . . .

CD Yes, they're nothing to do with sculptures or interventions, they're just saying, 'this is an extraordinary place'. Grab a few rocks, put them up before the moment's gone and photograph it. And then, there are found words. In the same way that you find a place or an object, there are some words that you pick out which seem to have particular resonance, and despite their meaning seem to be always there, and I've used those words in works.

WF When you go to places some of which are very remote, in, say, the West of Ireland, Mexico or Sweden, you commit yourself to a period of time when you're outside walking, camping, relating very specifically to the surroundings that you're in. You make works that are temporary and you might photograph them. So what is it that comes back to the studio? We're in your studio now, and I can see objects that are made here. What is the relationship between the two things?

CD Well, sometimes there are direct objects, like the stick bundles. Two here are sticks from a cholla cactus, wound around with yucca and red willow; one of them is quite meticulously made, in that the yucca is plaited on to the stick, and in the other it is just wrapped round. The first was a stick put straight into the rucksack with some yucca and then made back here, and the second was made right there in the place and then stuck in the rucksack, and so there's a difference between them. And the other two were made on the move in Ireland: one is a stick woven round with some wool picked directly off the ground, stained with the blue dye that marked the sheep, and the other is a bone with a stone stuck in it and some wool at the base. Those were made in the location. That particular colour, the blue-green, is very reminiscent of that place, where there's a lot of copper in the ground. These things are direct works, a bit like the cairns. They're made very directly and very simply with not a lot of thought in them. They're souvenirs, if you like. The more I go on, though, the more I find that those works have an intangible value. The main thing you bring back is how the experience has changed you inside. That comes out in a very indirect way through other works that you make. Those later works will not necessarily be at all to do with a specific time and place, but the whole of the activity of being out there in those places enters you at a different level. When I was out in Ladakh for a month I made virtually nothing and didn't want to make anything, because it was such an extraordinary place.

WF So your work comes directly or in an intangible way from what's seeped in, so to speak.

CD Yes . . . I would say so. It's a very obtuse way of going about it, not very practical, because you never know how it's going to come out.

WF Is travel to other locations an essential ingredient?

CD I've done it less and less, actually, because I get progressively less time for it. But if a certain period of time has elapsed and I haven't gone and simply walked, I feel I have to go and do something – not necessarily a huge walk, but if you're putting out, making stuff all the time, you've got to put something back in. I'm really fortunate to be invited to extraordinary places to go and make work. These are wonderful experiences in themselves, but there tends to be a lot of pressure to make an object. That is a pity, really, because the process is probably the most valuable thing in those commissions. The way that making work with people changes you and changes the people probably has more importance in some ways than the actual objects left behind.

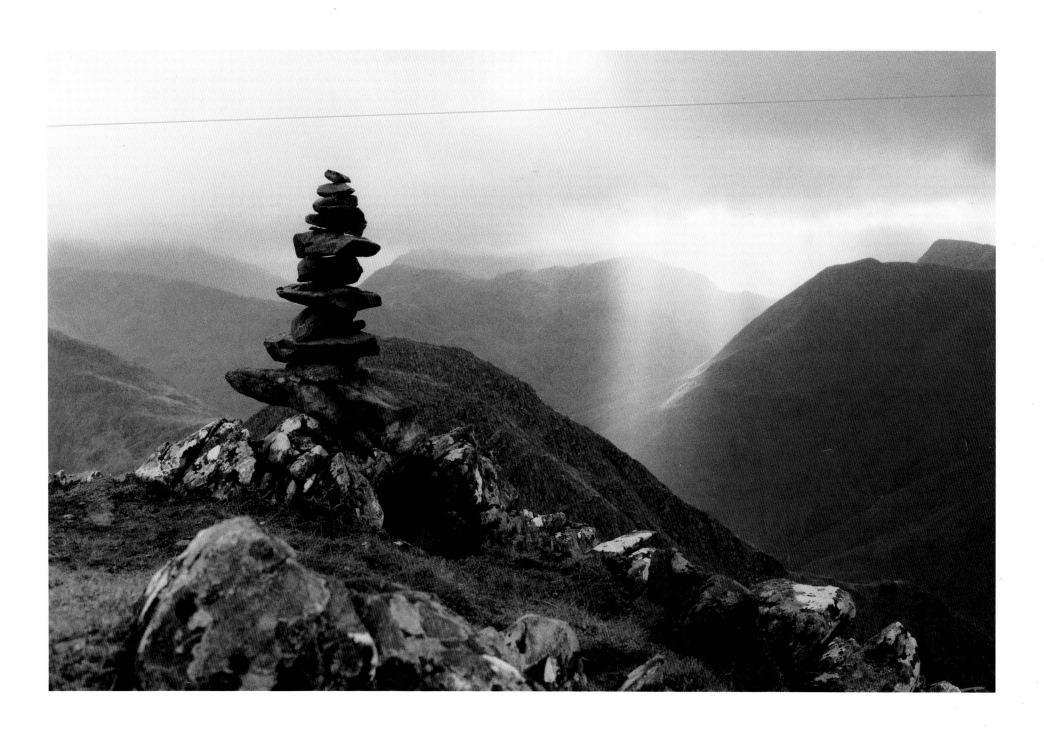

FIVE SISTERS OF KINTAIL CAIRN
1994

Scottish Highlands

WF Is that collaboration a really important dimension to the work?

CD Yes, it is. I've collaborated with other artists on projects. I did one in Ireland with Alfio Bonnano, and that was wonderful. There were also local people helping us, and they were better than us, really. We actually felt a bit redundant. Why were we getting paid so much money and these guys were hardly getting paid anything? But then we did put a lot of ideas into it, and they were saying, 'Well I could do this', and that's great. But also if it were possible to take away the object's making, to think about how these people interact with the land and to make something at a slower pace so that the process becomes as important as the thing that you make, then something would be made that is between people, which is an extraordinary thing. Often you don't get the time to do that, and the emphasis on the commissions is a real problem. 'We want an object at the end', you know, which is fine because you do need a focus, but often time is very short and there's no money and you have to rush and do it.

WF You're saying that the value of the activity is in the process, particularly when it is collaborative with other people, perhaps more so than the artefact that remains?

CD I think so; also, then, they take it on as theirs. The one in North Uist, actually, was really hard work. I had one dry-stone dyker from Skye working with me. Very few of the locals actually realised what we were doing and some of them came and got involved and helped, but there was very heavy rock-lifting which not everybody could do, and then slowly as we got to roof level, people heard about what was going on and came out. And carpenters came and helped lay the roof, and then more people came. Half the community turned up for the opening. There was whisky and bagpipes and suddenly it was there, and they kind of owned it. Even though a few people had made it, the whole community thought, 'this is us, we've made this', and that was good.

WF I remember talking to Richard Long about his walks into fairly remote locations and making works there, such as circles or lines of stone, which he then photographed. I asked him whether there was any sense in which he thought of the site as being a place to which people should go in order to witness the work and experience it, and he said, 'Definitely not'. He ruled it out as being in no sense relevant to the experience. The photograph was the thing. Now what you've just described is a work being made collaboratively with a community. Would you want people from the city, from the art world, from any other world, if it comes to that, to come to the location to see the work? Otherwise, the only people who actually witness the work are those in the local community where it's being constructed. Would you want a coach full of London people to come and spend a few hours looking at it?

CD Well, not necessarily a coachload. But word has got around about these pieces that I've made. People do go out to find them. And I've made postcards and I have a website, both of which actually tell you how you can get there. People from around here who have heard about it have gone off to Kielder to see that work. And from time to time I get postcards from people who've been there. So, yes, I would advise people to go and see these things. In no way could that work communicate itself through a photograph because it's an experience, and nothing you could bring to a gallery would get anywhere near what the thing is about. The drawing of the Kielder work, for example, tells you how the piece was made, not how it feels. And it's always different in different weather conditions. I always say, 'Go there!'

WF You are operating outside the agendas of the art world. By making works that have a particular resonance in a localities outside the art world of galleries and museums, you've separated yourself from the official and commercial circuits.

CD I haven't done that purposely. That world just hasn't always been available to me. For long periods I have had no dealer or agent and I've not always had that market or showplace. I do make photographs of things that I've made quickly in nature and knocked down, and some of them are made into photoworks. It's actually more interesting to me to deal with people in the real world and to make work. The shelter in North Uist came about because I was approached by somebody from Lochmaddy who wrote to me and said 'Would you like to come up for a month and make an exhibition in the local gallery here?' And I wrote back and said that I wouldn't really want to do that because I'd just end up storing all the works in my attic. I suggested that it would be much better for me and for them if I went and made something that actually stayed there, and people got involved in making it. And they immediately said, 'yes, let's do that'. Altogether it was a great experience.

WF You have consciously decided to make works that have a resonance in a particular place, and that wouldn't be possible within a gallery.

CD I can and do make installations in galleries. But I quite like things that actually have to deal with weather and that have a time span too. For example, things of stone will last, but things made of sticks and mud won't: they have a year's life, perhaps.

WF You mean that the processes of living and decay within a natural setting are quite different from the situation in the rarified context of the art gallery?

CD Yes. Even if the ephemeral works, like the large woven works that I've made, are never shown in galleries, as photographs they do get into books and magazines, so that the *image* of them is clear in people's minds. I make a work and

LADAKH I
1997

Map of Ladakh
interwoven with paper
rubbed with earth
collected in Ladakh
watercolour, charcoal
122 x 122 x 10.5 cm

Opposite
MANI STONE
LADAKH
1997

Map of Ladakh
interwoven with paper
rubbed with earth
collected in Ladakh and
surrounded by rubbed
inscriptions from a *mani*
stone
61 x 76 x 3.5 cm

'I brought back from
Ladakh a photograph of a
mani stone, a type of
ancient stone pillar that
stands at the entrance to
villages there. On my
return, I made an
enlarged photocopy of
the inscriptions on the
stone, copied them in
plaster, then made a
rubbing of them with
earth from Ladakh.'

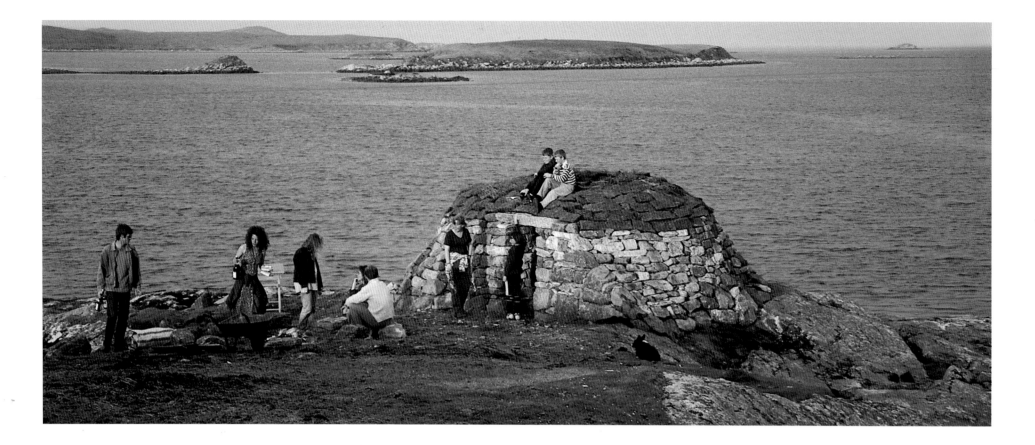

HUT OF THE SHADOW/BOTH NAM FAILEAS
1997

dry-stone walls, timber and turf roof,
mirrors, lens
Lochmaddy, North Uist, Western Isles, Scotland

get paid and interact with the community and that's fine, and then the work and the image are in the world. It's not that I don't want to show work in a gallery. I don't object to doing that, but I work with the resources that are available. Some people have said that you shouldn't bring nature into a gallery, but why not? We *are* nature, we have to touch nature, we touch it every single second of the day, we breathe it. As soon as you say that art shouldn't touch nature, you make a division and really it's the divisions that worry me. So it's OK to touch nature, but of course the degree to which you do so is crucial.

WF This is a matter of integrity: when you are working in any environment you seem to bring to what you do a certain sympathy towards the materials that you deal with and the experience that you are part of. You're not heavy-handed or trying to impose yourself.

CD And there again, you know, talking about the 'site-specific' issue: the work has to sit within the landscape while *not* imposing itself. For the work I made in Ireland with Alfio Bonnano the brief was to make a shelter that people could live in. There needed to be enough room for a bed and a chair, and it had to keep the rain out, almost like a kind of monk's cell. It is such an incredible environment that I felt that to make something that stuck out would immediately detract from the beauty of the place, so the work in a sense had to be invisible; and it was. When I went back some time later, we had a job finding it!

WF There has been a lot of concern about the role of site-specific sculpture, certainly in urban locations, to the point that you could be forgiven for thinking that there should be no such art anymore. But when I went to the sculpture project in Münster [Skulptur Projekte Münster], I saw a number of works that brought back

POISON PIE
2000

Spore print and
handwritten text in white
ink on black card listing all
the British poisonous
fungi and their effects on
the body
89.5 x 89.5 cm

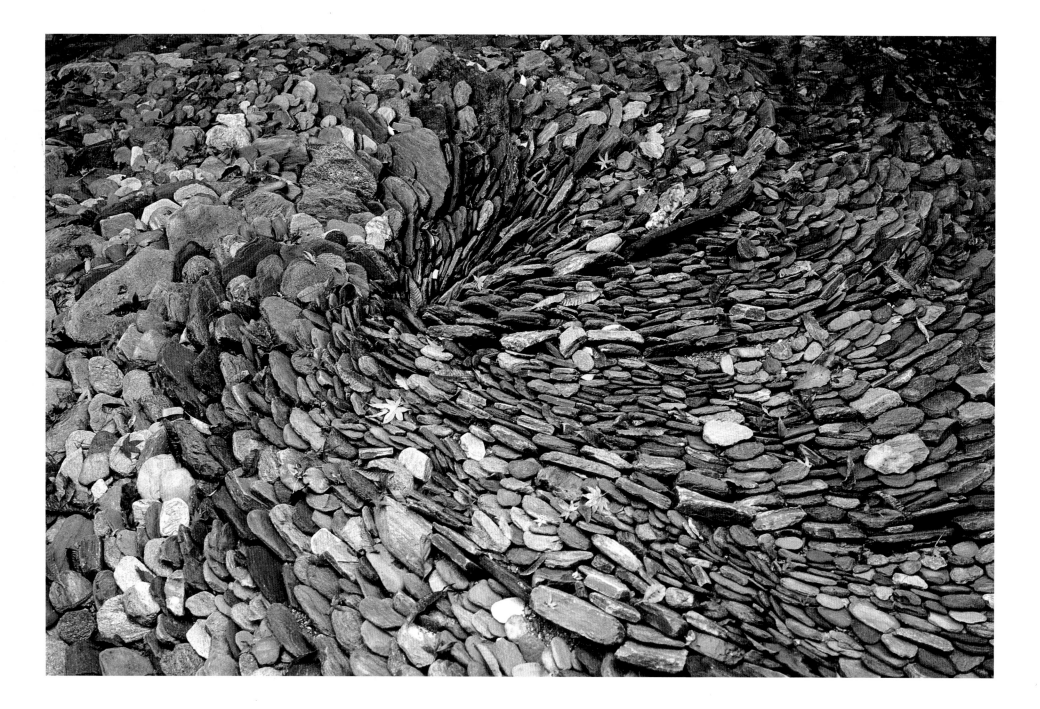

STONE WHIRLPOOL
(detail)
1996

Okawa-mura, Kochi Prefecture, Japan

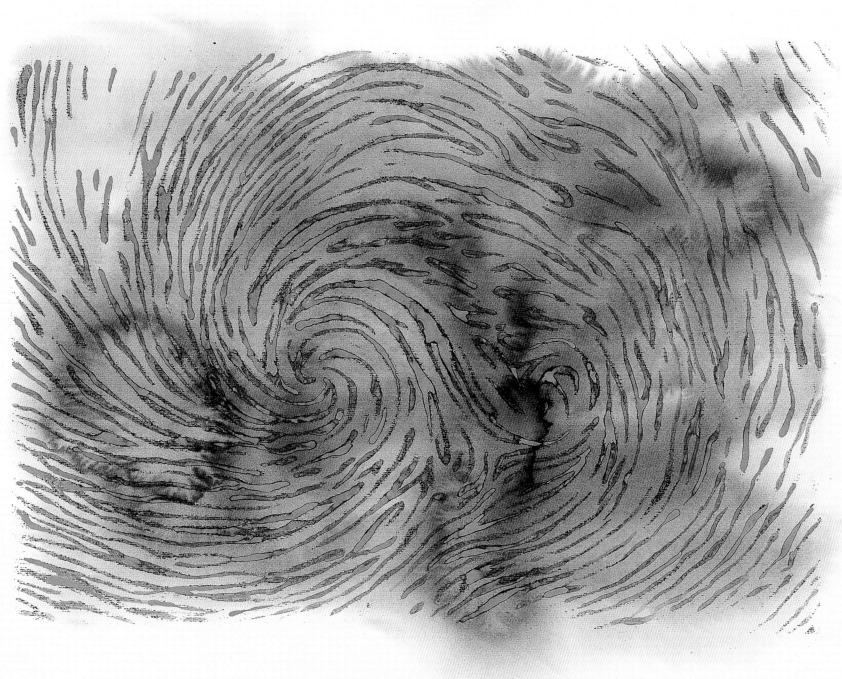

HEART RIVER
1999

blood and river mud on paper, pattern from a cross section through a human heart
56 x 76 cm

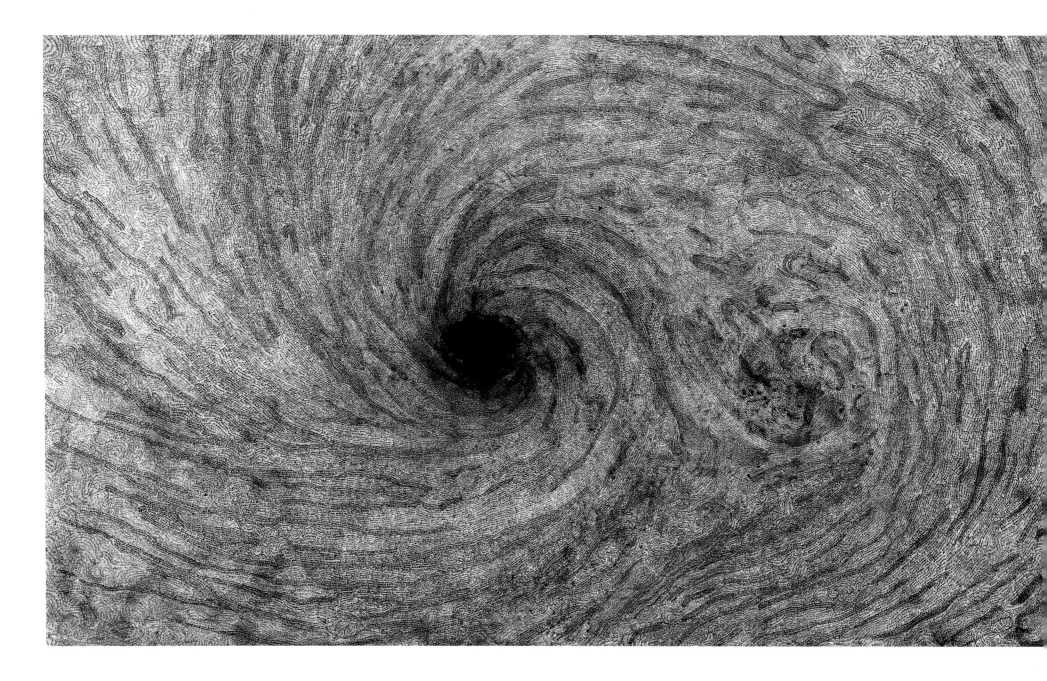

EDGE OF CHAOS
2000

ink cap spore print and handwritten words in ink
on canvas-backed paper impregnated with peat and ink
(The words list the winds and ocean currents of the world.)
140 x 470 cm (in two parts)

this possibility in a very powerful way. But I suppose the underlying criticism has been of the imposition of objects in places, where people wanted them or not, and whether or not they had any function. Now more interactive ideas seem to be emerging. Perhaps you could describe the process of making one of these site-specific works, from outset to completion (if there is a point at which it's completed).

CD The Kielder reservoir piece is a stone beehive hut, pointed at the top. It was actually meant to be more rounded, but in the end it needed to be conical. Before the reservoir was there, there was a cliff, which, until 30 years ago, climbers used to scale. The sculpture is built on the very top of the cliff to which the water now rises, and surrounding it are trees, mostly pine and larch. It sits on very big rocks, right on the edge of the water. It has a small door in one side of it, and that's it. I was contacted by an arts organiser in that area and a site visit was organised. Kielder Water is the biggest man-made piece of water in Britain (and one of the largest in Europe), and I was taken to a high point, from where we looked down over it. I identified an interesting area, and this particular site had an extraordinary feel to it. It wasn't quite an island, because it was connected to the mainland by an isthmus, and there were big rocks on the edge of it with trees growing right down to the water. It was very, very beautiful. But it was also going to pose problems because there was no road to it. I wanted to build something there, but I didn't know what and I didn't know how. I went to look at it again and did some drawings. There was a wind, and the sound of the waves lapping on the rocks made me think that I would like to make something to do with waves. The ideas were very general at that point. I almost decided to put blue glass in the top of the shelter so that you got this blue quality inside. I talked to the organisers about how we would get stone there, and they said that it should be possible to transport it by barge. The water is very deep at that point, so you can get the barge right in to the bank. That meant that it was physically possible to do the work. The next time I visited, there was a lot of bad weather – wind and rain – and the idea of waves was in the back of my mind. When I got back home, I wrote down the words 'wave', 'wind' and then 'mind'. None of those things exist materially: a wave is a movement in water, wind is a movement in air, and mind is a movement in thought.

I'd been doing mushroom drawings in which the pattern of the gills is echoed in minutely written lines of text. For the work in Copenhagen, I got hold of a geodesic domed greenhouse and painted the inside with a very dark blue paint, and before it dried I just scratched in the words 'wave' 'wind' 'mind', like a spore pattern radiating from the top of dome, so that the words were written in light. The light from outside came in through the words, and from inside, what was outside – the trees and so on – were visible through the words. In that sense, the piece was connected to Kielder because those words, wave, wind and mind, came out of visiting the site there.

It took three weeks of exhausting physical work with no guarantee of success to make the Kielder piece. Until it was dark inside and the floor was painted white, one really didn't know that it was going to work. So we got to the stage of it being built but not yet having a door. We covered over the door space with a piece of canvas and put a piece of paper on the floor, and at that very moment the sun was shining directly at the point on the lake where the mirror was directed, and even before we had got the canvas in position, the floor looked as though it was covered with thousands of dancing silver coins. It was a very unusual image, and I was struck by its beauty. We sat there, just watching it for about ten minutes, and then the sun moved off slightly and we were left with just the ripple marks.

WF What was outside was transferred to the inside and thus created a different sort of reality.

CD Yes, though what I hadn't anticipated was how the solid floor would be transformed. It looked as though you were standing on liquid, and that was incredibly powerful.

WF How concerned are you with the way that artists are categorised? Do you feel uncomfortable about the idea of being put in the category of artists who work in nature?

CD I don't object because I do work in nature, but none of the categories that exist quite fits, and yet there's a bit of all of them in the work. As soon as you say 'art and nature', it makes some people think of fiddling about with sticks, which is really not what I'm interested in. What I *am* interested in are the underlying things: that man is nature, and the question of how we are to resolve the problem of human beings seeing themselves as separate from nature. Cities are also nature. Nature is not out there, nature is here, every moment of the day.

WF So the objects that you make could equally be made in the city. A set of underlying relationships is being explored in your work and the location is perhaps of secondary importance. Are you concerned, as are conceptual artists, with working out ideas to do with definitions and relationships?

CD Yes. In a sense you can't *not* be a conceptual artist these days, because you have to think about the world and if you don't you're not contributing to the debate in any useful way. But at the same time, in order to make art that's really interesting you have to stop thinking. That's the problem. It's only if you work intuitively that you actually make something that resonates and then maybe you come to some conclusion about it, but you have to not think – I can't describe it in any other way. So I am a conceptual artist in one sense, but in another I am not. It's a paradox.

WF You don't feel drawn towards what one might call 'the modern world' with its media imagery, advertising, TV and fashion?

CD I live in the modern world. And the work is about the world as I find it. That's my nature. I couldn't make anything that wasn't to do with my nature.

WF You've been living in this part of Sussex now for nearly fifteen years.

CD It's mainly by chance that I've ended up here, not necessarily by choice. I often think I'd like to go and live in the west of Ireland, but I couldn't possibly because my children were brought up here and so I have a relationship to this place – you end up staying where you have that kind of relationship. Art and life are about relationships, so I'm here. I can't move.

WF That relates to what you've been saying about the connections between your practice and the places where you make work.

CD Yes, in the world. There's no point in making works unless they have a relationship to the world and not just with the local people, and the way they are getting out seems to be through publications. One has a dialogue with the world, so the more the work gets out, however it does that, the better. Actually, a publication is infinitely more available to many more people than a show in a gallery. And that's fine. It makes it more difficult to make a living, that's all.

WF The first work I saw of yours was the Medicine Wheel, which I remember being very impressed by. I hadn't really seen work of that sort before in which materials are derived and taken from natural locations, natural sources, but put into a structure that isn't merely a kind of wall hanging that a textile artist might make. You seem to be working with an underlying set of symbolic values. Around us here in the studio you have various pieces that you have written about in your book, using whalebone, ram's horns, and so on. Those objects, which have been taken away from the natural locations where they were found, have to live on their own, so to speak, don't they, in terms of acquiring meaning and an aesthetic? How do you expect them to function? You could actually make a gallery exhibition out of these objects, couldn't you?

CD Yes. But I don't set out to find objects. When I did the Medicine Wheel, for instance, which involved picking up one object a day for a year, it would have driven me crazy if I had actually gone out and tried to find an object every single day. So in the end, I had to let objects come to me. Sometimes I just spotted something, but I had other strategies, like inviting somebody to choose a day and find an object.

When I was doing the *Adharc* show in Ireland, I was walking on a beach and there was a whalebone. I picked it up and later placed it on a cairn. If you take

objects that come to you in that way out of the world, it's almost as if they've been handed to you. Then if you put them in a gallery, you are handing them back and saying, 'What's the meaning of this?'

WF But you've done more than just picking them up, haven't you, with the whalebone and the horns? You inscribed the whalebone and rubbed ochre into it.

CD Yes, the ochre was from the ground; it was there, and I just rubbed it in. I've always put a bit of me in these things, or I've wrapped something round something else. Or with the horns for *Adharc*, I cast them in Irish peat, because that's what I was dealing with at that time.

WF Are there any artists working at the moment or recently that are of particular importance to you?

CD I've stepped back from thinking about art, but I meet artists who are on the same kind of track that I'm on, and I like some of them and their work. I like the incredible density that Roger Ackling achieves in his pieces: it's extraordinary. About Beuys, I don't know really; I'm always slightly dubious about him . . .

WF You mentioned Beuys, and I had thought there might be some sort of possible link there.

CD I find his work intensely irritating, mainly because of the kind of aura he built up around himself. I'm very glad that he was around and that he did what he did, but there's something about the work that is too self-obsessed.

WF It's difficult to separate the body of work from the persona. Now that Beuys is not there, the work has to speak for itself.

I am looking at an image of one of your cairns with a fire in it, which has a slightly haunting presence. It prompted me to make a connection with Brancusi.

CD I like Brancusi's work. But this image of the cairn is a moment that has gone and all you've got is the photograph. A Brancusi sculpture is an object that is still there. In some ways objects are really more powerful, although sometimes you can be left with images that are very powerful. But the difference between an image and an object is that an object continues to talk and changes the way it talks to you because it's tangible, whereas an image is frozen in time. It can be no more than that particular image.

WF Other things that are transitory and that you've valued are process and collaboration. After these temporal aspects, the artefact is all that's left, as evidence maybe, or by-product.

CD Yes all that experience goes: you know that you won't go down in posterity, but so what? That's not necessarily important. Maybe it's important to the ego,

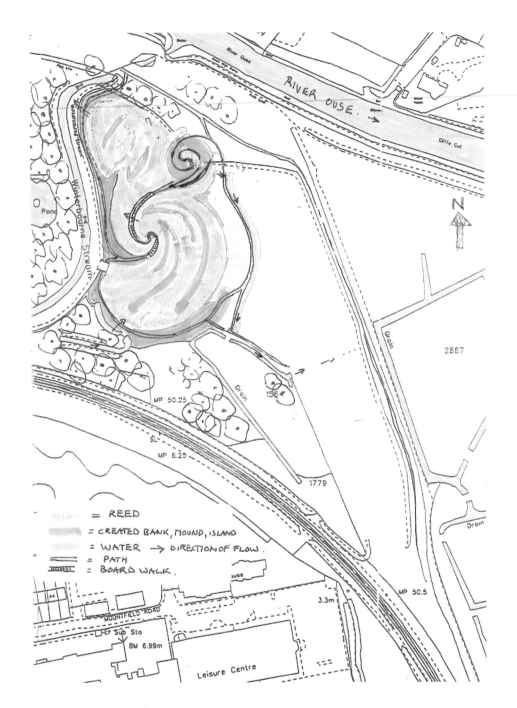

but I'm sure that the human race develops in very subtle ways and it isn't necessarily anything to do with our desire for posterity.

Lewes, East Sussex, England, September 1997

Since this interview took place, more opportunities for showing works in museum and galleries have opened up, and this has allowed me to make more wall works. Much of what I have been doing recently looks at the inner human being and at the body as a microcosm of landscape. This is work that has more to do with thought and idea than with material, place and form.

For example, *Edge of Chaos* [pp.88-89], a work on paper made from densely handwritten text, listing all the names of winds and ocean currents in the world, follows patterns taken from the human heart and from redwood bark. This is a piece which emerged after I had been working on the Lewes Reedbed Project, which is soon to be constructed. It, too, takes its pattern from a cross section of the human heart. It will take three years to grow, on five acres of land, and will be visible in its entirety only from the vantage point of a nearby hill. It will make a significant contribution to biodiversity in this particular stretch of landscape. So the work that is physically large is about something very small, and the one which is small and on paper is about something very large, linking us to systems of wind and water on the planet, and to the very formations of galaxies and the universe.

The process of this work (several months of painstaking repetitive writing in a studio) is internal and meditative. It complements, extends and contrasts with the physical, site-specific works outside. Other works in this series are mushroom drawings, map works, echocardiogram print works and earth wave drawings.

Chris Drury, March 2002

HEART OF REEDS

2000

plan and aerial visualisation
Lewes, East Sussex

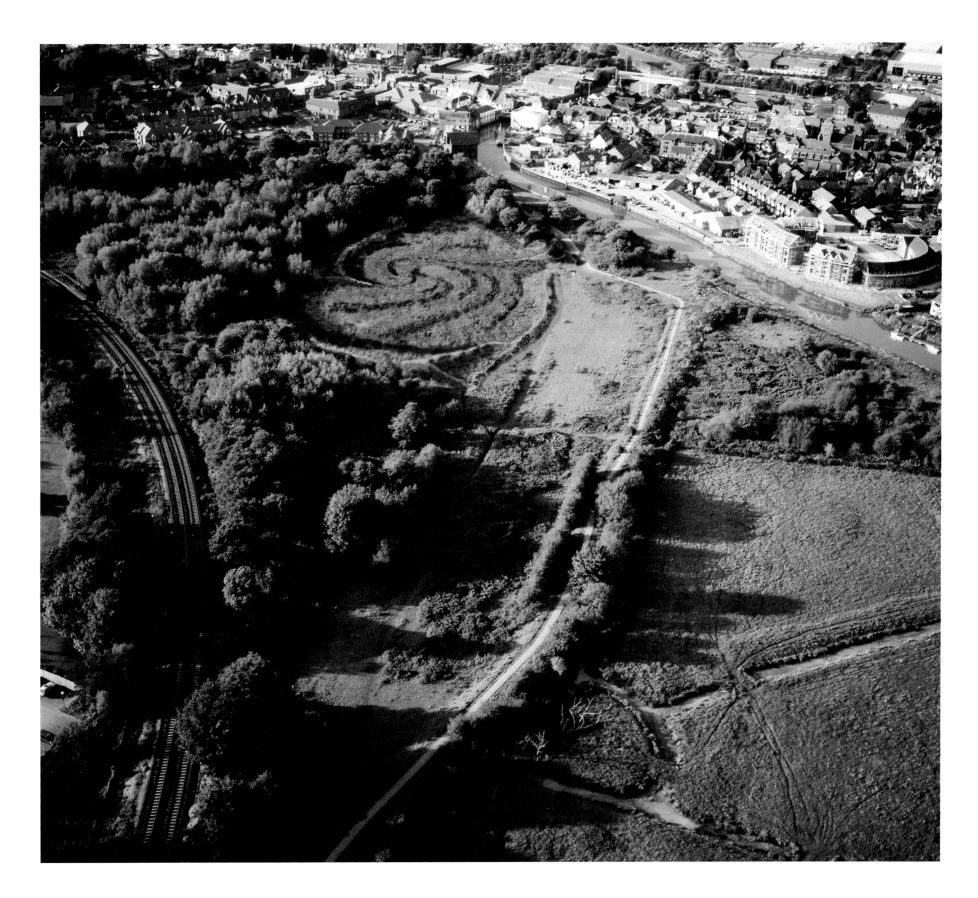

Nikolaus Lang

William Furlong In much of European culture, the urban tends to be seen as having a presence and the natural as representing an absence. Yet you have consistently immersed yourself in the reality of nature, and one of the primary themes in your work seems to be the balance and tensions between nature and cullture.

Nikolaus Lang I think it may in my case be based on my own, very subjective experience. After going through academies and schools. I found myself in London. It was 1968, and so all my friends became big revolutionaries. I was the traitor because I was still working. I was so unsure about this that I stopped working, and then (now I'm coming to your point) I started again, as if from the beginning. I was finding my feet like a child, looking into nature in a very subjective, very naïve way. And then it became less naïve, because I grew up a little bit. I have tried to find a balance, so I am quite aware that my work helped me a lot to jump from one stone to another, to exist, to live . . . to find a way.

I was very, very lucky to go to Camberwell. By comparison with the place where I was brought up, London was much more easy-going, more human, much less conventional, so you had a bigger chance as an individual. And I enjoyed London incredibly. I came without a word of English (my English is still not so

PETER IN THE SKY
Imaginary Figuration No.6
1987

Cross section of coloured sand deposits, polyvinyl acetate on calico and gauze, framework of sticks.
Maslin Sand Quarry (Adelaide), South Australia
210 x 340 x 28 cm

Sand relief taken from a 50-metre deep quarry lying some 30 kilometres to the south of Adelaide. Lang first cleaned the sand face, then hardened the surface of a particular area by spraying it with glue. Small squares of calico were stuck to it and then a scaffold of sticks attached to the calico. After drying, the whole thing, including a thin layer of sand strata, was lifted away. It took three weeks 'to separate landscape from landscape'.

Overleaf
Work in progress at the sand quarry

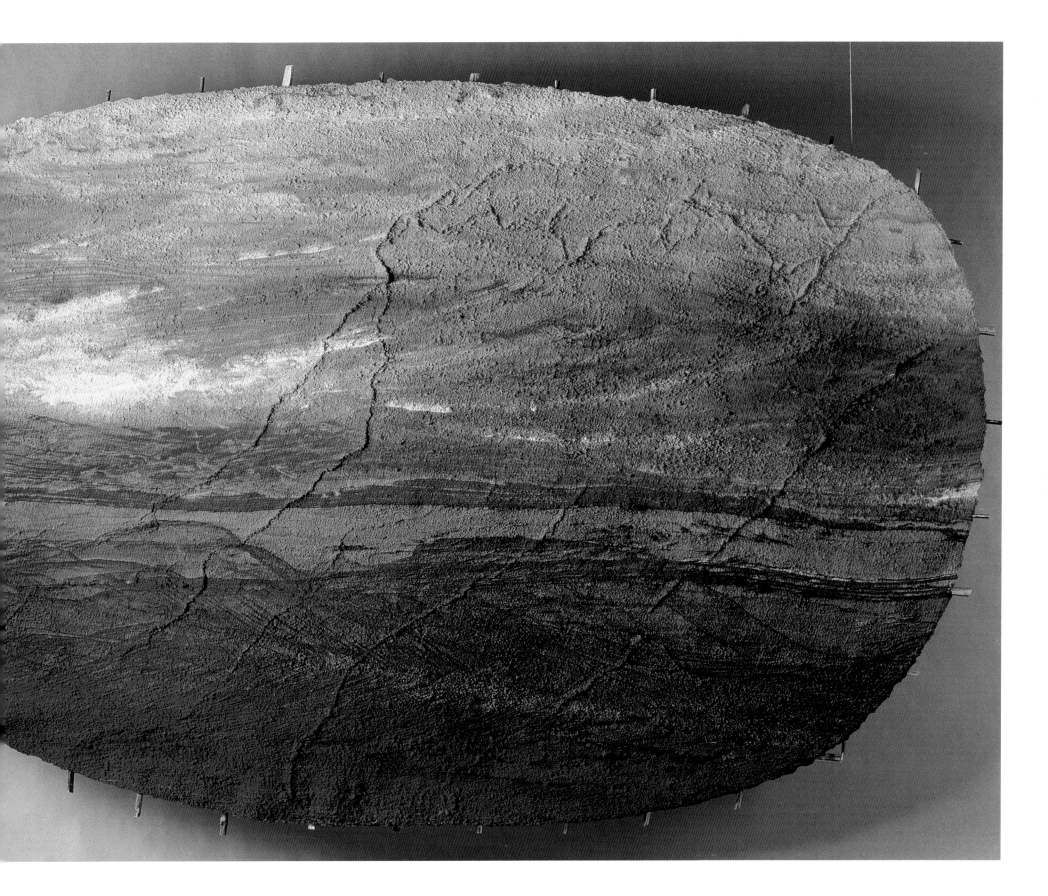

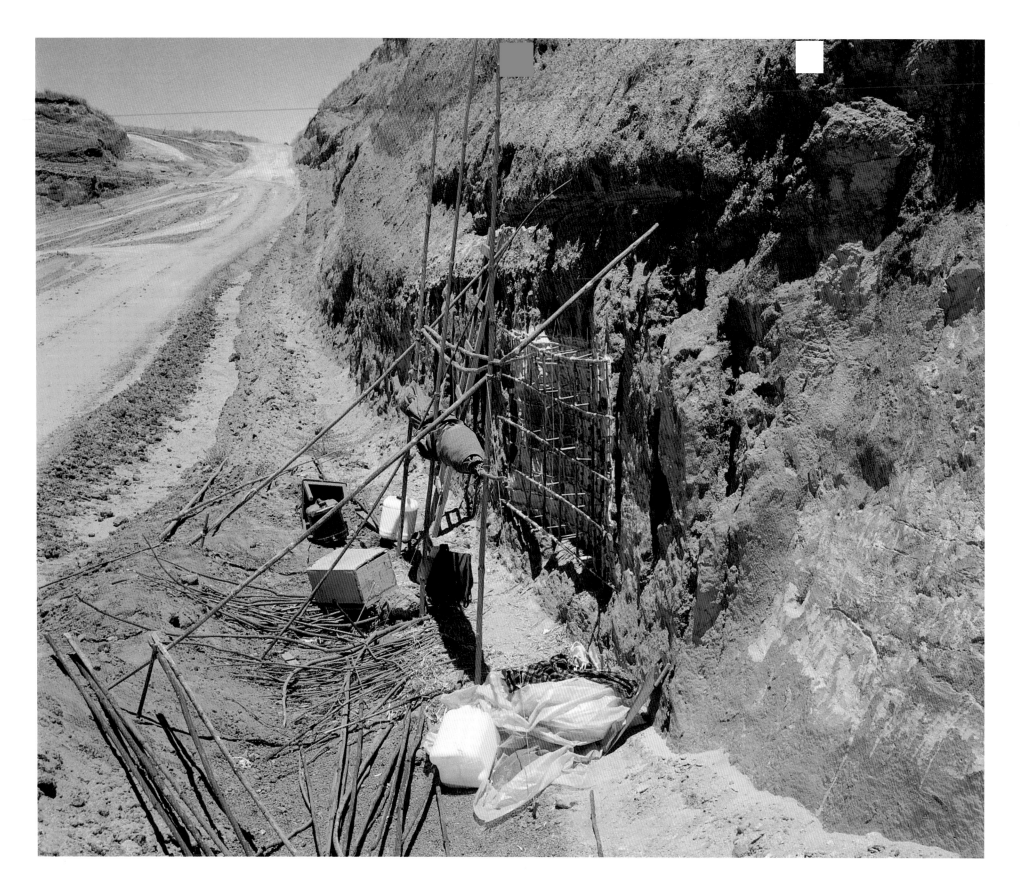

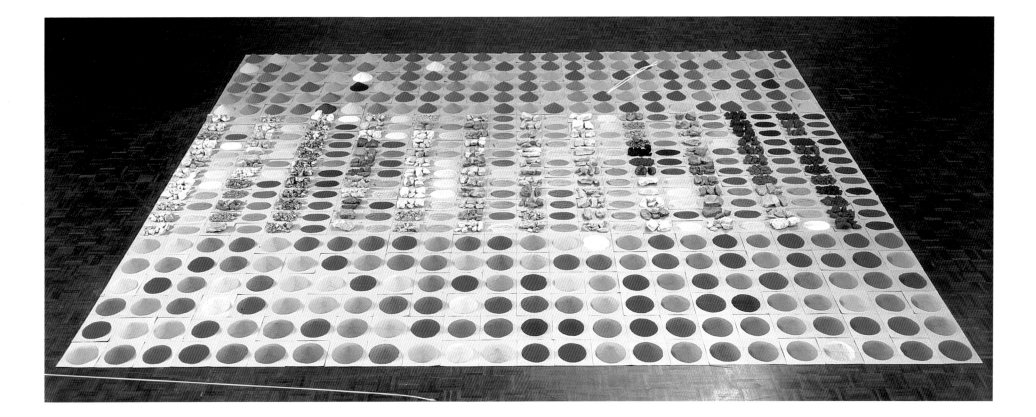

COLOUR FIELD – OCHRE AND SAND
1987

Ochre (coloured clays) and sand (coloured sands) on paper.
Maslin Beach and Maslin Beach Sand Quarry (Adelaide).
The field is divided into three sections of equal size.
The raw ochres with the corresponding pulverised pigments are
displayed in the middle; the sand samples are
distributed equally on either side in conical heaps.

504 x 600 x 6 cm

An ancient Aboriginal tradition inspired Lang's work with ochre and sand in the Flinders Ranges. Certain tribal groups would each year travel for many weeks covering hundreds of kilometres on foot, following the trail of the emu ancestor from the time of the Creation Story to collect ochre from a particular location. The ochre was then used throughout the year for painting the face and body, at initiations and other ceremonies, for rock paintings, for decorating weapons, as medicine and for barter against tools, weapons and the much coveted drug pitcheri. The red material

passed for the holy blood of Dreamtime heroes, a symbol for re-incarnation and life.

By the late 19th century, the white settlers whose grazing land was being traversed were already resisting these ritual journeys. Bloody clashes ensued, and by 1920 the ochre expeditions had died out.

Lang was interested by the idea of what it must have been like for the Aborigines to make such a trip and to transport this heavy colour material on their heads. He met no-full-blooded

Aborigines in this area, and people of Aboriginal descent have long since become detached from traditions such as the ochre processions. Lang's undertaking, 'paid for with a good deal of sweat and thirst' and earning him a few plastic bags of the deep red material which was once so valued, thus took on something of the quality of a pilgrimage.

good), but it didn't matter, because it was an open situation for me. I was already living with Celia [later his wife] and I stopped my so-called academic work and started again, right from the beginning. I had a red bicycle, and we were living in Wimbledon, so I discovered Wimbledon Common and Richmond Park for myself. That was a sort of escape, and it saved me. I started to look at the flora and fauna, I looked into the story of myxomatosis, I went to the library and read a little bit of poetry about Richmond Park and its history and its connection with a German king, George II, who never learnt English, and his grandson, who had bouts of mental illness, and so on. And I also explored Cornwall. So I put myself into so-called nature and looked around and sniffed around and all my senses started to be open . . .

WF Yet here we are sitting in the foothills of the Alps near Oberammergau, which is where you were brought up, with all the traditions and folklore and histories and close-knitness.

NL Culture-wise, I think the village that I come from is a particular case, because it has two aspects. There is the wood-carving background and the passion play background. These cultural and religious aspects generally form part of the Bavarian identity – at least, trying to hang on to them and all the traditions does. I see it as a kind of nostalgic, even pseudo-identity that has very little to do with our present-day reality. Things are changing faster than we can adapt. I remember very well saying to a friend of ours in London, if we go on treating nature like we do, it will end in a catastrophe. Today, I wouldn't say this. It's not that things have got better, but we can't stop change. It just happens like that, like a watch going, going, going.

WF Although you decided to go and live in London in the 1960s, you seemed very quickly to become interested in spending time in Richmond Park, watching what was happening in a more natural setting. You also began visiting the Museum of Mankind and looking at Aboriginal artefacts and culture.

NL Otherness exists, there's no doubt. But the strange thing is that you can also see it from another angle and say, oh, it's always the same.

I always enjoyed travelling, experiencing other outlooks. Genetically, anyway, a man or a woman from Africa or no matter where is very similar to us. I spent time in Japan. I was always on the move. And I was always interested. I found out that the way in which we take our Western dominance for granted is very, very questionable.

While I was at Camberwell, I found a little booklet at the library. It described an anthropologist, a traveller, who had spent three months with an Aboriginal group. The description of this trip fascinated me so much that I started to follow up information about Australia, concentrating on Aboriginal people and their culture. In 1979, I was invited to the Biennale in Sydney. In 1975, I had spent a year in the Villa Romana in Florence on a scholarship, and it was in Tuscany that I started to discover and to collect colours, colours from nature, earth colours for

WEEPING RAINBOW AT MOANA
1986

Cross section of ochre deposits (coloured clays),
polyvinyl acetate on calico, framework of sticks,
made at Ochre Point, Moana (Adelaide).
93 x 360 x 13 cm

myself. I wasn't a painter, and I brought earth colours to another continent, from Italy. These were the colours of Lascaux [site of prehistoric cave paintings in France], of Etruscan wall paintings, of murals from the Renaissance to the Rococo. I tore some reproductions of these paintings out of books and magazines and pinned them on the wall, and in front of them was the material source. The colours of Tuscany were presented or offered to me, so to speak. And I had in mind to do the same thing in Australia, by collecting earth colours there, and so to connect with Aboriginal painting. It was only a very simple idea: material and visualisations from different places and different people and different cultures. That was the first piece of work I ever exhibited in Australia. It's now in the collection of the National Gallery in Canberra.

WF When you have worked in Australia, you have used materials, like the ochre and the bones . . .

NL Yes, but not only nature stuff, I also included relics and remnants of the Land-taking Time, as I call it, when the white man took the land. Sometimes he pushed into quite desert-like areas, and he was pushed out again by nature, and he left all his tools, ploughs and agricultural machinery behind.

WF You are looking at the impact of change and the way that one culture dominates another, at the traces of transition, of domination and subjugation. Perhaps what distinguishes this work is your engagement with this kind of history and mythology. It's not merely a question of finding things and reconstructing the past. You are deeply engaged in this history.

NL Yes. Life is like a training to survive. I'm fascinated by different styles of living, and I think the more variety of cultures there is, the prouder we can be as human beings. But it seems that all the minority groups are just fading away. The industrialised nations are so dominant that other ways of life are simply swept away. In Australia, I have always tried not to be somebody who points at other people's mistakes. This wasn't my idea at all. But I was interested in the interactions and confrontation which are basically the same all over the world, completely exchangeable. Of course, the typical situation there, with the specific context, is very different to the situation here, but in the end it's all human.

WF You are concerned with the relationship between culture and nature . . .

NL There is no single definition of nature, there are many, many, many, and there can be incredible misunderstandings in the way that we see nature. Since we invented sophisticated technology there is also a tendency to exclude ourselves from nature. It is a very strange thing: now we hide behind technology, and at the same time we are becoming very sentimental, extremely sentimental about nature, although our once-natural ability to be part of it is fading away. And I don't know what will be left or what will follow. Is the idea behind keeping a forest just preserving it and loving it and walking in it on a Sunday afternoon, or is it a way of saying, this is an essential part of life, and I have a lot of respect for it?

We are only part of the whole. I am not saying anything new and I don't know about any particular philosophies, but I think it is very subjective to call a culture primitive, and that kind of comment usually has a negative feeling about it. For instance, saying that a culture is 'back in the Stone Age' is very ill-considered, absolutely crazy in fact, because the day will maybe come when someone looking at our situation will say, 'Look at this, it was the "Oil Age" '. It's very subjective.

WF You have made work in which you relate in profound ways to the way of life of people who in the past have inhabited parts of Australia or lived in places near where you live in Germany.

NL There was a show in Hamburg in the early 'seventies called *Spurensicherung*, which is very difficult to translate [loosely: forensic detection]. At the time, I was involved in a complex work: I was following up the lives of a family of brothers and sisters who originally came from this house. When the oldest son married, he got this farmhouse and the surrounding land, and the others had to move out. When I was a pupil at the wood-carving school in Oberammergau, I used to come out here to visit a friend in Bayersoien, and through him I got to know some of the other brothers and sisters, who were treated as complete outsiders by the villagers here. They built themselves little houses and wooden huts to live in, in meadows belonging to this farm, but quite a long way off. After my time in Japan, I came back to follow up their lives where they had lived them, surrounded by nature. At the moment I'm still thinking of preserving one of their little huts. The idea is to hardly touch it, and to try to make a little place to remember the lifestyle of people who were actually of the lowest standing in the social hierarchy of the early twentieth century. I know that it has to do with poverty, or something close to poverty – maybe I could call it simplicity, but then again, this is difficult to define and is often seen only in a negative way. My concept is to create the smallest museum in Bavaria and to make it a memorial to poverty.

WF It's a history that has been forgotten.

NL We have forgotten how to work land, how to produce carrots or potatoes. Mass production means that you pay almost nothing for vegetables that would have to cost far, far more if they were raised by hand. The same goes for meat. Same with all these products.

WF Was there a physical outcome of the research on these people?

NL I followed it up, and the finished work was called *For the Götte Brothers and Sisters*. I collected . . . I followed my interests. There was a little bit of geology with fossils, so I looked back – there was a time aspect in it. I looked into the vegetation,

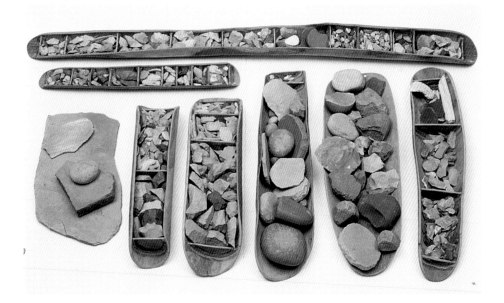

from CULTURE HEAP
1986-91

Above: prehistoric stone implements found throughout the Flinders Ranges, South Australia; blades, points, scrapers, drills, burins, choppers, cores, hammerstones, mill and grinding stones, etc.

Below: two stone slabs each bearing 35 imprints of jellyfish, *Ediacara fauna*, 600 million years old, found in the Elder Range, South Australia
75 x 35.5 cm

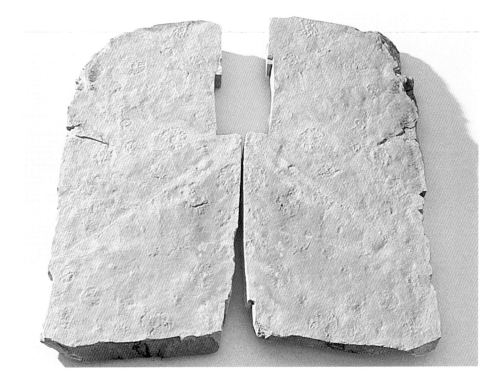

and I looked into the animal world and I looked into building aspects, so I criss-crossed from nature to culture and from culture to nature. If we think about nature and then describe its opposite, it tends to be the technological side of our existence, which is what makes us so powerful. But I believe in bringing everything under one heading. It's all nature. Even a car. In one sense, of course, it's not nature, but it was only by observing nature that we were able to develop the car. And when you think about the beginning of tools, this was an absolutely fantastic move: creating something that enabled you to create something else. You could, for example, make a tool to polish a piece of wood, or to cut or plane a piece of wood, or to sharpen something to a point.

WF Very practical things . . .

NL It all has to do with food. We developed ways to produce food rather than hunting and collecting it. This was the revolutionary step that led to where we find ourselves today.

WF As an artist, you have given nature, the otherness we were talking about, a form: you've articulated things that don't come with a language. Like Aboriginal culture, it's not written down, and the ideas are not the same as those we are familiar with. For example, there's no concept of territory (which a Western outlook would bring), so in a way, your work seems to want to give a voice to this other way of thinking and feeling.

NL Yes. This is my experience. I found a culture like the Japanese culture very complex, very interesting, very artistic, very innovative, very creative, very barbarous. By being somewhere else I learnt to find my position as an artist within that context. Then it becomes possible to discover art outside what is normally considered art. When African art or Pacific art suddenly began to be seen as more than just something exotic in a collection, it was artists who first declared it art and opened up the attitudes of the general public in the Western world. The criteria applied to art today are no longer restricted to a canvas with an illusion applied to it. In 1996, I spent some time in the north west of Australia, and I was confronted with visualisations, so-called rock art – paintings on rocks, on natural surfaces – and they were absolutely fascinating and amazing because they are all about life, all about other views, other completely different views. They bear witness to a way of life that has almost disappeared all over the world. They open up a window for us to a time that we all came from but which today is generally considered as primitive and uncivilised.

WF The form of the works that you made in Australia seem to me to indicate an interesting methodology and process. You're quite ordered in the way that you draw together materials in terms of indexing, sorting, classifying. I'm thinking of the bones, the seeds, the coloured earths, the animal skins . . .

PETER'S STORY
1986-89

14. Dressing axe blanks,
Hookina Creek, Flinders Ranges
1987

Opposite
PETER'S STORY
1986-89

20. Chair, string made of human hair, emu's leg, kangaroo's head,
fox-cub with two heads (one added by Lang), two lizards beneath a billycan,
the animals all mummified and coated in red ochre.
Prehistoric campsite at Lake Torrens (a dry salt pan), Flinders Ranges
1987

NL This is a very museum-like method, a pseudo-scientific method, but I'm not a scientist. In fact, by doing it I question the whole concept of the museum, which is about ordering and cataloguing and numbering things. My approach is not what I learnt to do at art school. I'm sometimes quite jealous of conventional fine artists, who create something of their own in a classical way, by applying colour to a canvas. I try to make work that is as dispassionate and objective and cool as possible, but of course it's not cool as the subjective element is always there. My art is often made up of a mixture of materials and methods, texts, drawings, photos, found objects, performances, etc.

My interest in prehistoric stone tools is not to find them and collect them and number them. I'm interested in using them, in trying them out, in understanding their possibilities as tools, in understanding theory and practice. So, in many cases, or whenever I had the opportunity, I knapped my own stone tools and used them on wood, bone, animal hides, meat, stone . . .

WF A lot of the things that you've used operate at that interface between man and nature. The tool is an example, but I was also very interested in the way in which you had used, for instance, dingo skins, animals that had been knocked down by cars . . .

NL . . . or the skin of an animal shot as a trophy. I used the materials I found. It's the cheapest and easiest way, and, of course, it is amazing. It has something to do with the climate in Australia that you find mummified animals lying in cave-like or protected situations. I think all materials are worth using to visualise or to fix something.

WF In *For the Götte Brothers and Sisters*, you gathered evidence rather as an archaeologist might: it's similar to the way you described your work in Australia. There was even a piece in which you researched a story about an Aborigine who was killed.

NL Peter's story is about mistaken identity, about an Aborigine who was wrongly accused of killing a white shepherd in the Outback in South Australia in the mid nineteenth century. He was marched down to the nearest courthouse, which was in Melrose, tried to escape on the way, was shot at and badly wounded, then thrown into gaol to await trial, and when it was too late, he was identified as Peter and was not the suspect the whites were after at all. He died of his wounds in Melrose. So I followed the route from where he was captured by the police to the courthouse 300 kilometres to the south. This tragic story and the walk over this stretch of land were the core to which I linked my interest in the fate of the unfortunate Peter. The outcome was a series of 32 photographs.

I tried to visualise what it would have been like for me in other people's situations. I made one piece for which I copied something which was itself a copy. The well-known Australian anthropologist Norman Tindale, who produced plaster

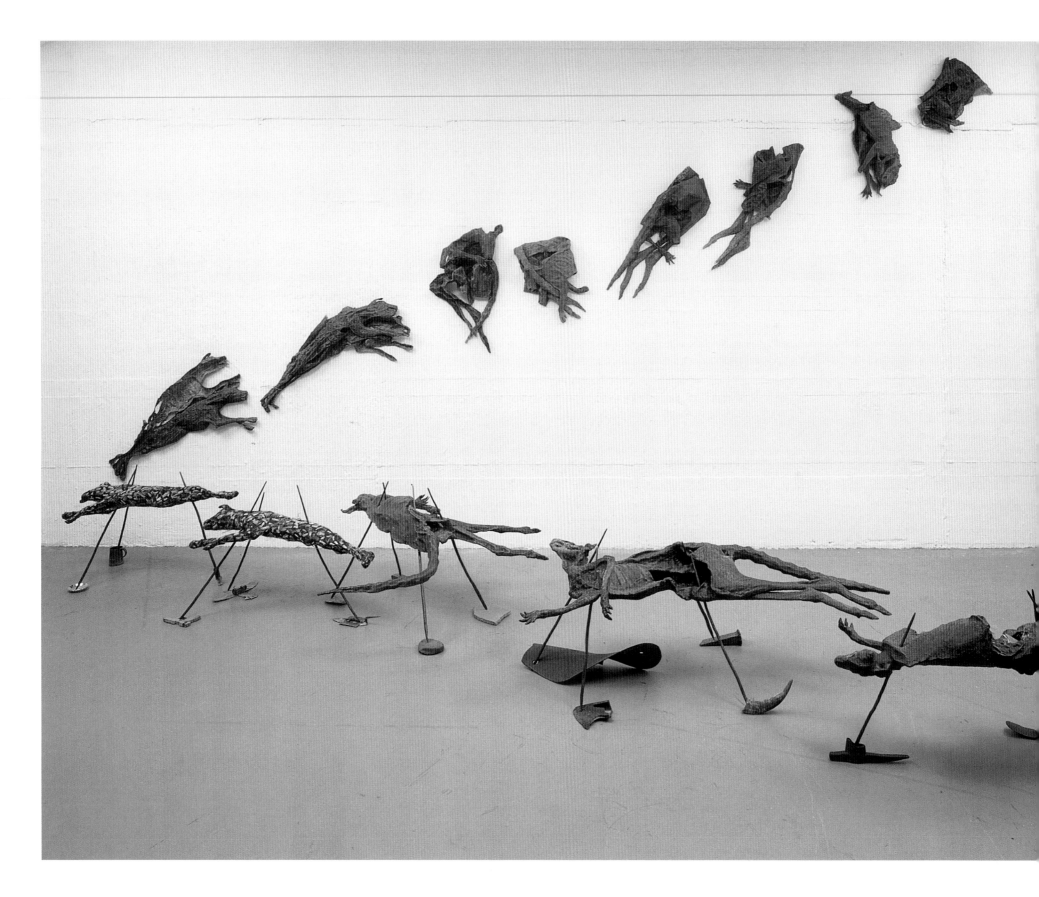

HUNTING AND BEING HUNTED
1987-1988

Two mummified dingoes, seagrass-ball fibre, polyvinyl acetate, bitumen, emu feathers, wooden pistol, tin toy plane, cross, trowel, religious picture, gold plate, pewter tankard, two bottle necks, wooden sticks

Three mummified kangaroos (carcases found in Yourambulla Range, Warrakimbo Homestead, Flinders Ranges), seagrass-ball fibre, polyvinyl acetate, bitumen, emu feathers, three miners' picks, plough blade, plough share, cow horn, four stone tools, wool samples, wooden sticks

four casts of two mummified dingoes, and six casts of three mummified kangaroos, hemp fibre, polyvinyl acetate, ochre

Dingoes are dogs that were domesticated by the Aborigines and trained to hunt kangaroos; they have since returned to the wild. In an attempt to keep the dingoes in the desert areas, the so-called Dog Fence was erected in Australia from west to east. On this fence, Lang found two dead animals, which had been poisoned and hung up as trophies. He mummified the carcases then tarred and feathered them and coated them with ochre. (Their stretched fleeing forms have been compared by one writer to Scythian bronze reliefs.) Mummifed kangaroos, discovered beneath a rock overhang and among ruined buildings in the Flinders Ranges, were prepared with layers of bitumen and plant fibre. From all the mummified animals, two dingoes and three kangaroos, Lang cast two paper-thin skins apiece using hemp and glue. The animal carcases take on a new, almost surreal identity. Supported on stilts, one kangaroo is standing on Aboriginal millstones, a second on implements used by European miners, a third on objects derived from farming: cow-horn, iron wedge and ploughshare. Three stilts supporting one of the dingoes are resting on a wooden toy pistol on the left, on the right on a tin toy plane and at the back on a brick-layer's trowel and a prayer book with a crucifix. The stilts supporting the other dingo are resting on a gold saucer, in a pewter tankard and in two bottle necks stuck one inside the other. Of the three kangaroos, one is stuffed with emu feathers, a second with sheep's wool and a third with wool samples – a reference to sheep breeding and the fact that animals introduced by the Europeans deny the living space to the indigenous species. Each year around a million kangaroos are shot. On the floor the kangaroos are pursuing the dogs; on the wall, the dingoes are hunting the marsupials.

casts of Aboriginal people and had the idea of making busts, pieces of sculpture, to give substance to his notion that certain types were typical of certain areas, so he had an old woman and an old man and a young boy and a child from different tribes. Later on, he even produced a catalogue, and you could order, say, one Aranda warrior, finished to the point of being coloured with yellow-brown oil paint. I found the original cast in the storeroom of the Adelaide Museum and I asked one of the curators working there whether he would allow me to take a cast of one of the busts to use in a piece of work I intended to make. I was given permission on condition that I gave a pledge to observe the laws of the tribe. The act of making a cast made me realise certain things about the original: that it was actually a very bad piece of sculpture because Tindale had brought from the field a negative cast made with the subject in a lying position, and then he had put it upright, like a bust, so the shoulders were wrongly positioned in relation to the neck, and the neck was wrong in relation to the head: everything was wrong. And of course you can't make a negative with open eyes. So the eyes of this Aboriginal youth were closed, but Tindale opened them, or the plasterer opened them, and he repaired some areas around the neck, and so on. So I made seven negative paper casts and seven positive plaster casts of the head and my idea was to cast my own closed eyes and cut his opened eyes out and replace them with my closed eyes. By doing this I was trying to find my own position in this question, 'what about my view and our views of other people and what about their view of me and us?'

WF The casts would have been made originally as objects of curiosity . . .

NL I'm not trying to point at somebody, to be a teacher. I think Tindale was an absolutely fantastic anthropologist, and every human makes mistakes or hurts other people by doing certain things, but I accept Tindale anyway as a man of integrity. Today it would be absolutely impossible to go out in the field and take casts of Aboriginal people – of course, it would be politically absolutely incorrect. If some artist now had the idea of making a cast, there'd be nothing essentially wrong with it, but he would be immediately criticised, I guarantee you that.

WF It would be seen to fit in, wouldn't it, with the European repression of Australian Aboriginal life?

NL In this case it concerned English dominance, although I think the problem of domination is not a national problem, but a human problem. This is what I learned there. And the tragic aspect of history, this fatal impact, is something that we have to face up to and deal with. It is not only the Australians who need to do this, but all of us, wherever we live in the world. In the case of Australia, I think it is too easy to have a National Sorry Day and to write S O R R Y in the sky with the vapour trail of a plane. If the Germans were to do the same thing in the sky over the Reichstag, to ease their guilt over the slaughter of the Jews, the world would be outraged.

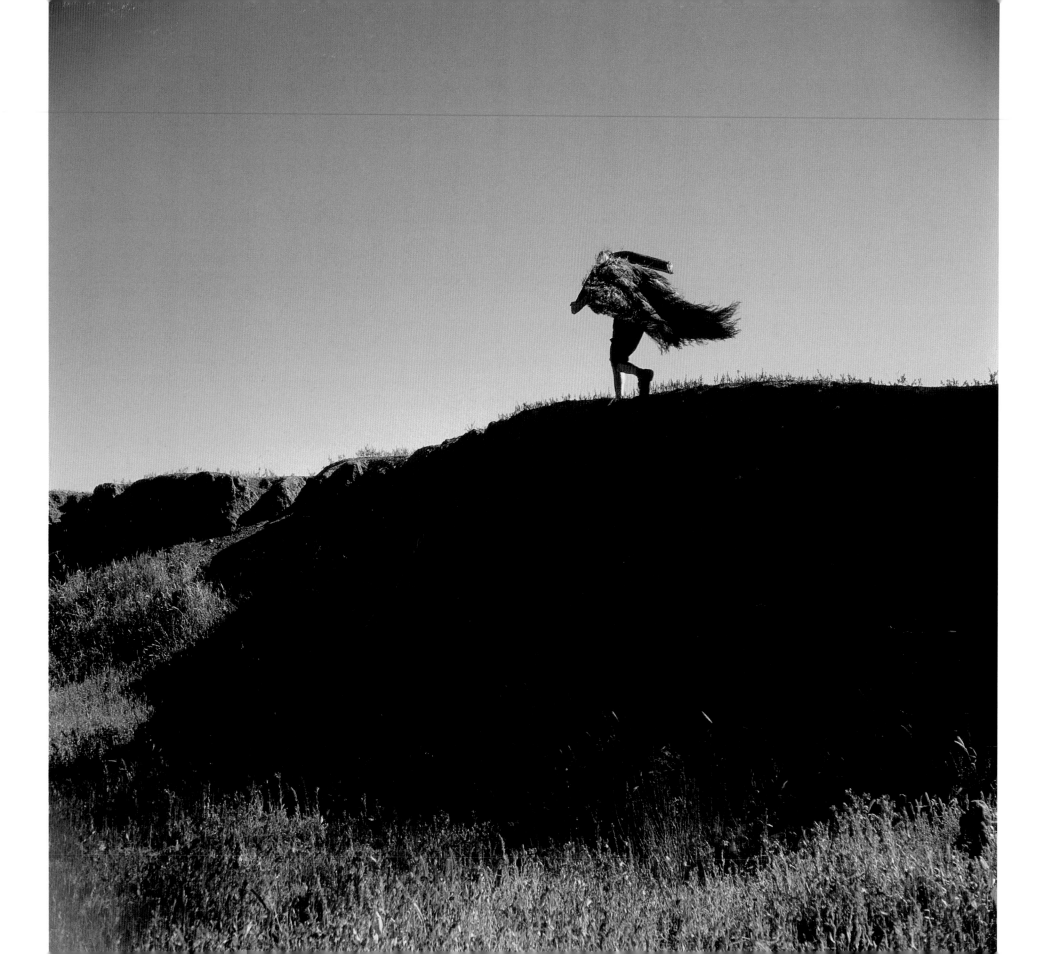

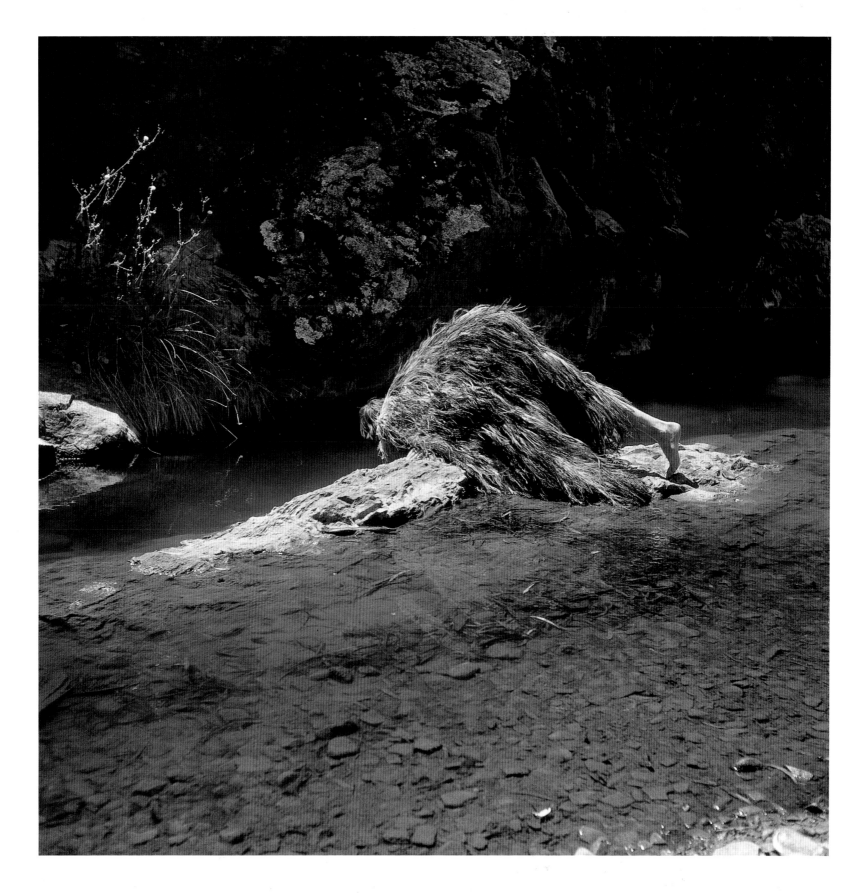

Opposite
PETER'S STORY
1986-89

25. Figure carrying
boomerang
Glass's Gorge,
Flinders Ranges

Right
PETER'S STORY
1986-89

26. Figure at waterhole
Frome Creek,
Flinders Ranges

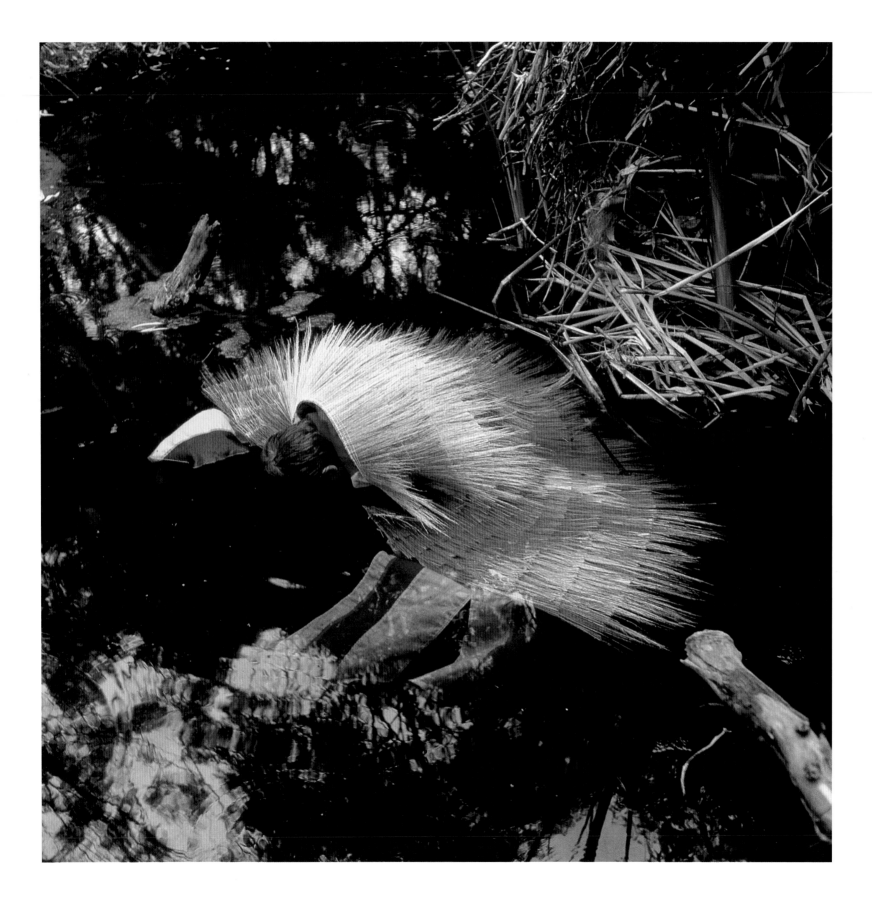

PETER'S STORY
1986-89

27. Plunging into hot
radioactive water
Paralana Hot Spring,
Flinders Ranges

PETER'S STORY
1986-89

28. After the bush fire
Wilpena Creek,
Flinders Ranges

WF When you go to a country as different as Australia, there is perhaps a distance which allows you to make these observations more easily than you would if you were working in Europe. But would you agree that these issues are close to home? That they are the same in Serbia or Bosnia?

NL Yes, in the end these things are quite interchangeable because we are too preoccupied with our own sense of well-being. You could argue that people didn't know better in the Victorian era in England, or in the same period in Germany. Opinions were so influenced by imperialism that people had the attitude of feeling superior to these naked men, who were seen as having no religion, nothing, while industrialisation and the knowledge of realistic and systematic thinking was sweeping through Europe. But to claim superiority in this way is completely subjective, because there is only existence, just life, how you live, and there are many, many, many different structures for existence.

In Stone Age cultures, a large part of people's existence had to do with following in the ways of their forefathers, and that tended not to lead to innovative change. This was a very, very static way of living, but strong, because the experience of how to exist was passed down from generation to generation. The religious or spiritual aspects and the natural aspect were completely intertwined, like the weaving of a basket. Nature was the base, and they understood themselves as part of it, in spite of having sharp stone points on their spears; these were simply tools to produce animal protein. Incredibly, the Aborigines had hardly any tools, owned nothing, not even a house or a roof; they were naked, had no cover, and lived from hand to mouth. So no cupboards with food in them, they just lived in the moment. This is a concept, a life concept, for which I have deep respect.

WF But it was unsustainable, I suppose, as European settlers gradually eroded the edges of that culture, and didn't recognise its validity or respect its structures.

NL I believe that more or less the opposite of a Stone Age structure is a Neolithic one. We are Neolithic people, we are inventive, we question everything we do, and this drives us further. And when the two cultures meet, of necessity, they clash and it goes without saying that the static one loses. We were very critical of the way that Aborigines lived. We believed that such people could jump from their philosophy to our philosophy, or from their reality into our reality. This is impossible: it would be the same thing if some alien came to us and told us that we had to change completely to its way of life.

WF Isn't there an inevitability that a culture such as the Aboriginal culture will be destroyed by white, European dominance?

NL Well, the word 'eroded' is already negative; it carries negative undertones. I would say that your question in itself could be regarded by some as politically incorrect. My view is that a culture subject to such pressures is bound to change; it

Above: Red Gorge, Flinders Ranges
Right: work in progress at Red Gorge for *Brain Ship* (finished sculpture shown overleaf)

Red Gorge, Flinders Ranges, has the biggest concentration of prehistoric stone engravings so far discovered in Australia. Lang found an open-ended passage, which can only be crawled through. The walls and floor had been smoothed and covered with engravings which he found when feeling along them with his fingertips; they depict turtles, geckos, owls, lizards, also animal paws and human hands. Sometimes there is an older, abstract pattern among them. On the slabs by the entrance and exit are circles, points, spirals and what are perhaps sun signs.

Lang suspected that this was an abandoned native cult site – only emus and kangaroos still come here – and decided to cast the narrow passage three dimensionally. For this he used paper pulp, a mixture of cotton fibres and rain water. Pressed on to the rock walls, it dries quickly and produces extremely fine, delicately exact casts. The work in the low corridor was painstaking and took a week, at extremely high temperatures. In his studio the artist fitted the numbered sections together. The cavity produced a form like a paper kite or air-ship and was strengthened with bamboo. The inside is now outside; the engravings have resulted in fine reliefs.

In order to dedicate this supposed cult-site to the memory of the Aborigines, Lang hung twenty-two paper casts of a prehistoric skull and called the structure Brain Ship – a fragile memorial to a people who have all but disappeared.

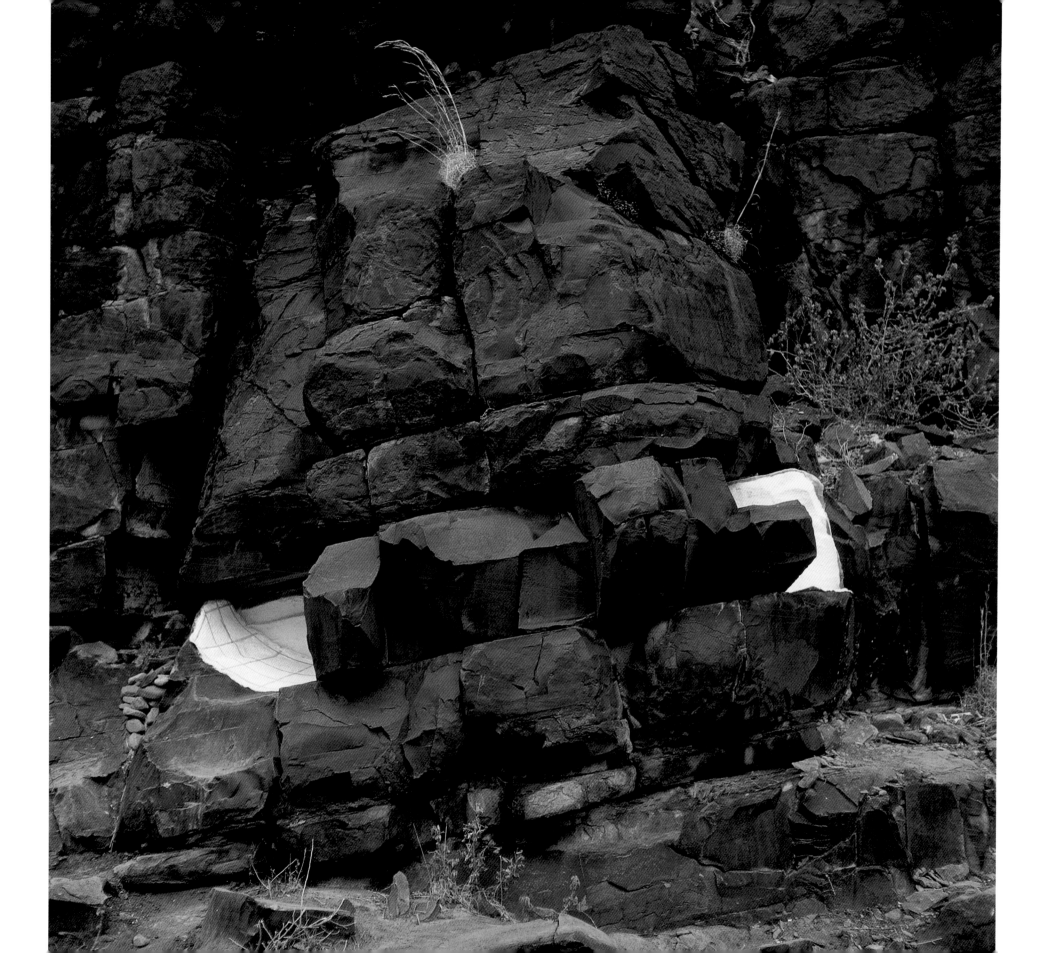

BRAIN SHIP
1987-90

Cotton paper pulp, gauze, bamboo, spruce sticks
70 x 280 x 65 cm

will change to something completely different. If you look at the situation world-wide, our time is one of an incredible mixture of genetic materials, so perhaps it helps the human race to exist longer if they mix in such a way. Maybe, I don't know. Nature does not ask whether it is successful or not.

WF Since the first European settlers arrived in Australia, the cultural terrain has been completely redrawn. You are looking at the impact of that re-mapping, aren't you?

NL When I plan a big project covering at least two years, I have to find the finances, and there is a lot of logistical stuff to organise, and so on, and I spend about four months of one dry season preparing. Each time I confront myself with a question. For example, what is currently interesting me is the whole Aboriginal contemporary art scene. Again, European interference is very strongly observable. You can see it, you can feel it, it's there, but I'm not interested in pointing a finger, I simply follow my own interest. I try to tune into this completely different, Aboriginal point of view and then attempt to follow it up.

WF And when you are undertaking a project, in practical terms, where do you start, what do you actually do?

NL First of all, my method is always, more or less, to throw myself into a certain cultural situation or to go to a certain place, and then I have to experience it, and then come to understand more because I work with my hands.

WF Do you live in the Outback when you go there?

NL I divide my time between the city and the Outback, though I spend more time by far in the Outback. I like Sydney and I like other towns as well, but really the strongest aspect is the Outback because this is a part of nature which is still not a broken nature, simply because it is too vast and often too hostile for us to completely re-form it. There is an attitude inherent in Western culture that nature is there for us: to be used, to be ploughed over, to be dug into to get all the resources out. Discovering this possibility of using things was, I think, neither positive nor negative because every living thing on this planet uses something.

WF But you take into account other aspects of nature than the uses it has, such as the associations of the site, its magical properties, the importance of places to the Aborigines.

NL I definitely do not hold any esoteric beliefs, and I don't try to be a nature apostle, because this is very questionable. I am aware of the very tragic situation of the Aboriginal people, but to be a missionary is also very, very difficult – you have to be a fantastic human being not to misuse knowledge or even belief. For me, coming from a Catholic background, all the aspects about belief are in some way very questionable.

There's hardly any infrastructure in the part of Australia I want to re-visit, the Kimberley, there's just a track going through an area the size of Poland, right through the middle, which is impassable in the wet season. I know how hot it is there. I know how difficult it is to get things, so with the experience of having been there for three months, I will try to build a structure in which I can operate. My dream is to have a four-wheel drive, to create a workshop on wheels, so that I can go from A to B and even push into the bush, walking, and experiencing land, people, plants, animals. I will use what I find on the way and dig into it sideways, so to speak. I was able to spend time with an Aboriginal elder in 1995; we worked together for three months. He taught me a lot. He talked to me of his experience and view of life, of his beliefs, his aims, his hopes for his people and I found this extremely interesting. I feel privileged to have known him. I try not to organise every last detail of a project, but I have to be absolutely independent. I do need the right tools, but that is all.

WF When you say 'a workshop on wheels', that implies that you will be making things, what things?

NL On the way, maybe, I'm spontaneous. If I like one particular situation or a place, I may stay there for a while. I could decide to spend all four months there. But I also have many, many ideas, and I have to compress all these ideas, and reality will tear me back anyway. You know, everything is difficult there, so it takes more time. But I take my tools, my materials. Sometimes, for example, I take a lot of pigments that I have collected over the years, and I maybe use the colours in different ways. It's a sort of workshop travelling trip.

WF When you make works on that sort of a journey, what happens? How are they retained? Do you take photographs of them, or do you keep them to reconstruct when you come back?

NL It depends. Sometimes I collect material, sometimes I play around and use the camera to fix an image or I make a drawing or I make a print or I make a piece of sculpture. I'm absolutely open.

WF But you will bring some of that material back and make an exhibition with it?

NL Yes, perhaps, but I never make the objects for that purpose. Tragically enough, we have to end up in a museum or a collection or whatever, but I have hardly ever followed up an invitation to work specifically for an exhibition. Usually I do something and then I offer it, so it does end in an exhibition. I would be happy if I could find a place in Australia and I'm happy to find possibilities here. I'm quite sure that if I can bundle up my energies and my strengths, I will bring something back. So I do take something away.

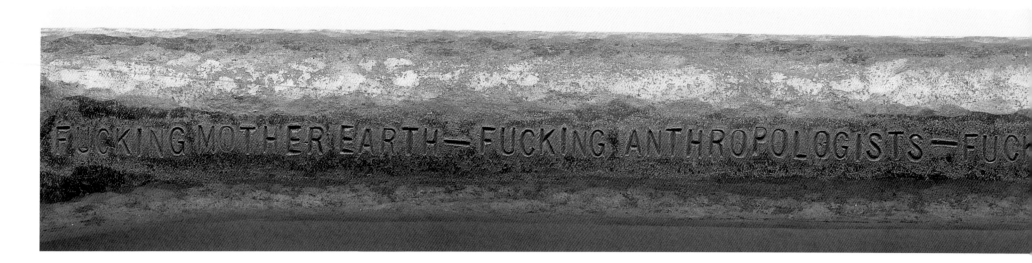

WF You first went to Australia in the 'seventies and then again in the 'eighties and 'nineties.

NL Altogether I have spent about six or seven years in Australia.

WF Have your methods or areas of focus changed during that period?

NL I jump forwards, backwards, sideways. Sometimes I make quite classical sculptures or two dimensional visualisations such as works on paper using natural pigments. I try to be absolutely open. If I'm able to be open, then maybe the results will be good.

But I'm also not alone. It is not really very wise to make trips like these completely on your own. If you go into the bush alone, and something happens to you, you are lost. But, if you have another human being with you, you have a better chance of avoiding disaster. I'm quite OK on my own, but I like to communicate. I like to be open towards the Aboriginal people, but without wishing to be an art adviser, an art dealer, a missionary. You know, I don't wish to be a dominant individual. But the very moment you appear on the Aboriginal scene as a white person, you are already interfering, you can't really avoid it.

WF The act of living in that part of Australia is absolutely essential for you to make this work.

NL This turns me on: the experience, the smell, the heat, the sandstorm, a good waterhole, the call of the birds, the animals, the people out there . . . for me, this spells life. I'm not based on theory.

WF I was wondering how important your relationship to the place where you were brought up, to Oberammergau, to this close-knit village society, is in what you decided to pursue?

NL In the 'sixties, I hid. I thought, I'll never say that I come from Oberammergau, not even that I'm German. In London, some people realised that I spoke German, but there is some dialect in the way I speak so they thought I might be Austrian. But I had to learn to accept my background, you know, this heavy rucksack full of conventions and traditions. I used to be a wood carver. If I could show you what I have done! You know, it's very difficult to become an artist with that reality behind you.

WF You trained as a conventional woodcarver?

NL More or less, yes. I learned how to carve very realistic figures of animals or human beings or whatever. The Oberammergauers were renowned for their production of sacred and profane woodcarvings, which were sold all over the world.

WF That craftsmanship comes out in a number of works I've seen that you made in Australia.

NL Yes, but craftsmanship does not necessarily have anything to do with art.

WF It's to do with making, though

NL The making, the craftsmanship, is meaningless if there is no soul or secret in the work itself. In my childhood, 300 families in my village lived from woodcarving and even at that time, I would say that the finished products in many cases were not art, not even really craft any more, but a means to an end. Today the craftsmanship of woodcarving has declined dramatically. The religious context has lost its meaning and credibility to a large degree. Also woodcarving machines have taken over and the cheaper products from Italy and other countries have put many woodcarvers in Oberammergau out of business. Of course, an object being made with a machine doesn't necessarily mean that it isn't art. However anything is made, I believe that its quintessence has to manifest itself for it to be what we call art.

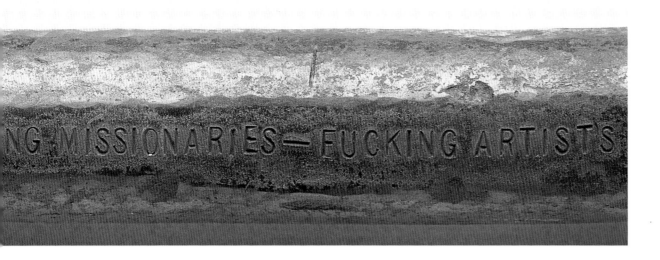

from CULTURE HEAP
1986-91

Detail of hand-forged iron wrench used for fixing drill rods in drilling for
water, incised with expressions used by a militant Aborigine in
conversation with Lang.
1987

70 cm

WF You explore but also celebrate cultures that haven't had a voice.

NL Yes: 'voiceless' cultures became a huge source of inspiration for countless artists in the twentieth century, whether we are talking about the visual, oral or performing arts. There's always a tendency to look back, of course, and to point to things that have already happened. And this process makes sense, I think, only if you work towards the openness in front of us, or the emptiness in front of us. Then, looking back can help us to understand what lies ahead.

WF You don't accept the view that open spaces, natural spaces are empty spaces?

NL They're not empty. What I am pointing to is the attitude of the English at the time when they arrived with the First Fleet in 1788. They justified taking possession of Australia by using Latin, by calling it *Terra Nullius*, or The Empty Land. To an empty land you can open the door and the windows. And you can plant your national symbol and feel justified in taking it over by claiming that it is empty. But, of course it wasn't empty. Hitler invented another excuse to expand to the East, which was that Germany needed resources and land to sustain its own people. In both cases it was a matter of saying that one's own existence was more important and more worthwhile than that of others. A lot of people have ideas of expansion in all sorts of direction. But expansion always means stepping on somebody's toes. The Aboriginals themselves came from somewhere else to the continent we now call Australia. I don't know what drives human beings, what has always driven human beings to go further and further and further. We know a little bit about the very early *Homo erectus*, who was around before *Homo sapiens* arrived. The theory is now that we came from one place, Africa, and then we moved into Asia and even to New Guinea, and that it was the Aboriginals who touched Australia first. I'm speaking about theory, about so-called science, what we know today, but

maybe tomorrow we'll find that the story is quite different. That is quite possible. Gradually we are piecing more and more parts of the puzzle together, but it's very, very complex, understanding where we come from.

WF Time seems to be a very important ingredient in your work.

NL Yes. I look to the past to try to make sense out of the present. David Mowaljarlai, my Aboriginal elder friend, who had never attended a philosophy class in his life, said something that impressed me greatly: 'There is no past, present or future'. That means that any attempt to capture the moment is an illusion. But we still try to do it. David also said, 'In space, there is no beginning and no end'. Many of my artistic efforts are attempts to come to terms with time and space.

In some places nature is so strong – as it is in the desert or at the two poles – that it is hard for humans to survive, but with our technology we find ways to overcome the problems. Back in the Middle Ages, I believe, thousands of Eskimo people moved deep into the ice fields and found ways to exist there. If it's worthwhile to go to the North Pole to get the resources, we will do it.

WF Is your excitement at going to the Flinders Range in the Outback, where it's extremely hot and hard and tough, to do with its wildness, its remoteness?

NL Yes, I admit this. It's a bit like a sport thing, or an adventure thing. I think you can see that with this feeling of emptiness that people have today, and with all the free time and the sense of lost identity, there are trips and trekking and adventure holidays to almost anywhere including the Australian Outback.

You know, you have to be quite fit to exist in a town. You have to know the ins and outs and how to go from A to B, and how to confront that person and this person, and in the Outback it's very similar . . . you still have to do the right thing. In my case remembering street names or certain people's names or arranging things

TERRA NULLIUS
1987

Stone tools and implements found in the landscape referred to by early colonists as *Terra Nullius* – no man's land, which had in reality been populated by Aborigines for tens of thousands of years.

in a town, I find much harder. All that is heavier for me than if you put me on the edge of a desert, and say, 'Oh Nikolaus, I'm terribly sorry, but I must leave you here'.

WF It's to do with time, too, isn't it? The timescale in a city is very rapid. In a desert, maybe, it's much slower.

NL Not necessarily. If you're using tools, especially a modern tool like a car, you can just slip through the desert. You can live with the brakes on in a town, and you can live with the brakes on in the Outback.

I believe that there is a tendency at the moment to idealise, to imagine their belief systems and mythologies were a means of securing life. My reconstitution such as in *Peter's Story* or as in my 1979 *Australian Diary* or in the *Culture Heap* is my way of looking back and then confronting myself with the question of survival, whereby I hope I avoid the sentimental view that every human being from a 'nature-culture' lived in total harmony with nature, in which every aspect of life was balanced. There are many examples where this was not so, such as when the moas in New Zealand and the mega fauna in Australia became extinct through over-hunting. But enough hunters and gatherers guaranteed their existence by doing the 'right things', otherwise we wouldn't be here today. Among anthropologists and sociologists there are two theories about this, one being that the aggression of human beings was the key to survival, the other that it was the balance between aggression and lack of aggression that guaranteed their continued existence. One of the Aborigines' survival methods, for example, was to burn the land. They had knowledge of fire and ways of making fires that changed the territory and maybe even altered the climate and, of course, changed animal life. It created a completely new biotope.

The Aborigines' firing of the land was multi-functional. It made the land transparent for hunting. It drove animals out to be hunted and provoked new growth – the land was fertilised by the ash, and the new plant life attracted animals back into the area. So this was not only destructive, but also productive. But over-used or misused, it could lead to catastrophe. The Aborigines were clever. Nearly all of their tools that I have seen had not just one function, but several. They had very few household belongings. The man had a bunch of spears, and maybe a boomerang sticking in his hair belt, some stone knives hidden in his hair (using it like a pocket) – that was all he carried. And the female carried children – either she was pregnant or she carried a small child or had a bigger child with her, and she very often had a digging stick or a bark container which was also a shovel – it could be used to scoop up water, to bathe the baby, to carry a newborn baby, to transport materials, to winnow seeds, and so on. They were usually on the move, at least some of the people I found out about were. But Australia is so big: whatever you say about Aborigines may have happened in one place, but not necessarily in another. There were huge cultural differences between groups. But basically, they guaranteed their

from CULTURE HEAP
1986-1991

CAPE OF DRIED GRASS OVER UNION JACK

Draped in a grass cape or a cloak made of emu feathers, Lang took photographs of himself (by deploying an automatic shutter release) trying out what the indigenous people have now almost forgotten: making stone and wood tools, bark containers and digging sticks, gathering roots, wild fruits and seeds, and so on.

In an analogy to the station scrap yards in the Australian Outback, where disused and worn out items from all the phases of settlement are jumbled together, Nikolaus Lang stacked things in his *Culture Heap* which he had found, transformed, or made himself as simulations. *Culture Heap*, which echoes the 18th-century 'cabinet of curiosities', contains objects that reflect his admiration for the ingenious survival methods of the Aborigines, but also the courage and inventiveness of the early colonists, informed by ironic reference to Lang's own more recent occupation of the Outback as a German artist.

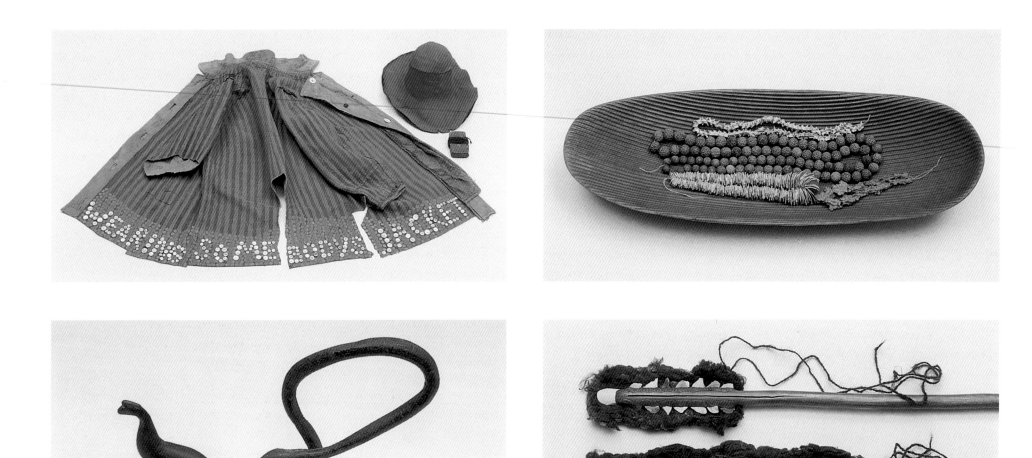

from CULTURE HEAP
1986-1991

WEARING SOMEBODY'S JACKET

A jackeroo's belongings: a Catholic prayer book tied up with string made of human hair, a leather jacket and hat. Lang turned the leather jacket inside out, patched it up, added stripes of red ochre and sewed on mother-of-pearl buttons.

EMU AND SNAKE

Two Aboriginal wood carvings, mounted on iron coils. Emu: 15 x 10 x 28 cm; snake 25 x 11 x 38 cm.

COOLAMON (made with stone tools by Lang)

A fluted wooden implement of a sort used by women. River-gum wood coated with ochre. 66 x 24 x 10 cm. Contents: threaded stones of the quandong fruit; threaded fragments of emu egg shells from prehistoric camp sites; threaded vertebrae of King Brown snake; threaded 'natural glass' fragments resulting from lightning strikes in sand.

TWO DEATH SPEARS, ONE HUNTING SPEAR (made with stone tools by Lang)

'Death spears', one with eucalyptus hardwood tip set with opal flakes in resin and grass tree shaft (112 cm), the other with stone and porcelain flakes set in resin (215 cm); 'hunting spear' made from coolabah root with stone point set in resin (112 cm); all with sheep's wool and string made of human hair.

existence with the most economical effort and the most reduced toolkit, and this is a huge cultural achievement. It would be wrong to talk negatively of this as 'Stone Age'. It's very, very clever. They were so much part of nature, they were able to get the most out of their tools and the opportunities that presented themselves – weather-wise, water-wise – and all this life training they went through meant that they lived so closely with nature that they were able to survive. Whether they were aware of this is another matter. Anyway until the white man came, they had no-one else to compare themselves with. If we took on their way of surviving, tried to live as they did, we would fade away after three, four weeks, and just disappear.

WF That complexity, that intelligence of adaptation is what really interests you?

NL Yes, it interests me because we see their lifestyle in the same way that we see poor people today, that is to say, as restricted and primitive. And I don't think this is very wise.

If you look at the cultural landscape around where I live, here in Bavaria, all the fields and the forests were planted, the fields were ploughed and the grass was sown and harvested by hand. Even today, there's still a lot of handwork carried out round here. And this is a place where I have space, and space I was able to afford. Because when I took over this house I worked for one and a half years on it to bring it up to this standard for my family. I work in the garden, I do carpentry, it's all work with my hands, but it's a complete hobby. I enjoy working with my body, and I get tremendous pleasure out of planting, putting in seeds, harvesting radishes or lettuce or beans or peas or whatever. Then I know about a plant. Or if I collect apples . . . I used to produce a lot of cider, for example. But if I were counting money, I would stop immediately and concentrate on my art and try to sell it. But I can't help using the resources that surround me. You know there are berries: redcurrants and black-currants and . . .

WF But your engagement with nature here is almost part of your life in the way that the art is. It's not separate.

NL Yes, if I lived in a town, I wouldn't have the opportunity to grow berries or vegetables, but here I have and I take it. I think it also helps me to understand other lifestyles; everyone has to do something, either with his hands or with his brain, or preferably with both.

I was trained as a sculptor. And the sculptor uses his hands or used to, anyway, to materialise his ideas, feelings, visions. Nowadays sculpture is no longer concerned only with a tangible object, and the understanding of it has opened up so much that even a conceptual piece is included in the same category.

Wherever there are people, there is culture, whether they happen to live rural or urban lives. But for many people today living in towns and cities clearly has advantages over living in the country. At the moment, I'm quite optimistic. I try not to fall into the trap of declaring that 'if we go on like this we will cut our base away, we will poison everything,' and so on . . . Our existence here on this planet will leave some scars, some changes. It's just like a watch, like a piece of machinery. And I don't think it's the first time that a culture has glided into a situation where it jeopardises its own existence. This possibility is ever-present, so we just have to adjust and simply try to navigate our way through, but in the end I have hope, I'm quite optimistic because we are not standing still. If the moment comes when we stop moving, then it will be very sad, but that hasn't happened yet. There are a lot of people who question our dominance and question how we act. When the ideology of Eastern Europe broke down, we took a deep breath and said we always knew that our system was the right one, but it's absolutely clear to me that a system is not static, that we have to work on it all the time, and if we are unable to adjust, then we get into difficulties.

WF Well there has to be some kind of mutual understanding between different sorts of belief systems, otherwise we see examples of what happened in Europe in the 'forties or what has happened to the indigenous cultures in Australia.

NL You can go much further back than that, you know – to the historical exchanges between France and England and Spain and England, but we hope that Europe has learned, and that Germany in particular has learned from the catastrophes of the twentieth century. I think we have learnt our lesson in one way, but in another, we haven't learnt at all. So, speaking about my own country – we were split into two so that we would be weakened, and then two ideological directions were im-planted, and the result was the Cold War. This conflict ended with the fall of the Berlin Wall, but re-unification has led to new problems within this country as a whole. And we have now arrived at the point we were discussing previously – domination. I think that West Germany is often very insensitive in the way it deals with East Germany. Our attitude is one of superiority.

WF Did your family live in this area for a long time before the war?

NL I was born in 1941, so I experienced the war as a tiny child. I remember very well the Americans coming to liberate us. My father was Bürgermeister [mayor] in Oberammergau at the time, and after the war he became Bürgermeister again. But I have to mention that he was a member of the party during the Third Reich, and I come from the generation that had difficulties in handling this background – I still have these difficulties in some way. But again, we have to be absolutely open, there is nothing to hide. I tried to hide my background, the fact that I come from Oberammergau – that was wrong.

Bad Bayersoien, Bavaria, Germany, November 1997

VARRIOOTA'S DAYDREAMS AFTER HIS ESCAPE NEAR AROONA HOMESTEAD
1987-1988

Print on paper from inked river-gum tree-trunk showing insect borings, in total, twelve sheets 192 x 375 cm
two paper pulp casts of river-gum tree-trunk showing insect borings
cotton paper pulp, gauze, glue, pine laths, each 350 x 55 x 65 cm

Varrioota was one of the suspects in the murder of 1856 (*Peter's Story*) who was apprehended but managed to escape.
Beneath the bark of a massive fallen red river gum tree are the labyrinthine tracks of insect larvae.
Lang inked in these patterns and then printed them on to paper.

Opposite: work in progress at Hookina Creek, Flinders Ranges

In 1998 Nikolaus Lang went to the Flinders Ranges in South Australia again, in an attempt to take up where he had left off in the Kimberly in 1996. Sadly, his working partner in 1996, the Aboriginal elder David Mowaljarlai, had died in 1997. The project they had embarked on came to nothing. He experimented with making prints of animals that had been run over in the Outback. He then travelled to Victoria to meet up with an Aboriginal woman artist, Dorrie Gibson, with whom he started on a series of collaborative works on paper. They went together to Dorrie's homeland in northern Queensland, where they eventually became the guests of Diane Cilento at Karnak. It was here that they completed their venture, together with other members of Dorrie's family. In 1999, Lang returned once more to the Flinders Ranges and made *Roadkill,* a vast work on paper. In 2000, he completed another *Roadkill* in the Flinders Ranges and also visited Dorrie again in Victoria. In 2001, he had an exhibition in Adelaide where the collaborative works with Dorrie and other artists were shown, together with the *Roadkill 2000.* He intends to return to Australia again in 2002.

ROADKILL
(detail)
1999

Along the edges of tens of thousands of kilometres of road in Australia are strewn the corpses of thousands of animals ranging from kangaroos and dingoes to snakes and lizards. During the night they are killed unintentionally; during the day some drivers chase and kill for sport. In the searing heat of the Australian deserts; Nikolaus Lang drove long distances over a period of months in a jeep collecting the carcasses of freshly killed animals, which he first sprayed with ochre (collected in the Flinders Ranges), then hurled at long, strong sheets of paper fixed to a wall improvised out of lengths of chipboard. The resulting imprints resurrect the animals in a strange, almost magical way, looking, as one commentator put it, like 'photographed souls which, after leaving the body, become momentarily visible . . . with Lang the medium allowing them one last burst of vitality'. The spirit of shamanistic ritual shimmers in the role Lang has prescribed for himself. The act of thowing the animals was a deliberate strategy to avoid imposing decorative order.

Whole work: 330 x 3150 cm

Richard Long

William Furlong Much of modernist art originates in the city, yet you have consistently chosen the non-urban context, or non-urban spaces to work in and to make your art. Are you drawn to these 'other' spaces because they are free of the references and resonance of the urban context?

Richard Long The work I did as a young artist emerged partly out of a desire to make sculpture in new ways. I knew that there was a romantic tradition of describing landscape in beautiful images, you know, paintings, all that stuff. My ambition was to take on the idea of landscape art in a new way. So some of my early works were to do with hollowing out the ground, creating negative space, like making a cave (although I never did that). It was partly a matter of exploring formal ideas about how to make sculpture in new ways, in grass or with water, and then I had the idea of walking in a field near London to make a work of art (*A Line Made by Walking*, 1967). I then decided to use a bigger landscape, to make a ten-mile walk across Exmoor in a straight line. There was physical and intellectual energy involved in making art on this scale. I was attracted, as you say, to the big, empty space of Exmoor, because it was the best place to do a straight, ten-mile walk and also because I like moorland. Those places had a nice spirit to them. It was a pleasure to make art in them. So it was never some didactic impulse to make art that was

specifically not urban, it was more that if I wanted to make a walk to bring time and space into a work of art, then the landscape was the best place to do it. And, by nature and inclination, I chose the places that I love to be in.

WF Where there is an absence of urban culture?

RL Oh yes. My art isn't about urban culture. It is about simple things like footprints, straight lines, time, space, miles, all those things which would be really difficult to work with in a city. So it never entered my head that the city was an appropriate place to make my work. I mean, in a way, I didn't give these issues any thought. You know, it seemed a right and natural thing to do, particularly to go to places like Exmoor and Dartmoor, which are really abstract, empty. The fact that they're just rolling moorland, that they're almost plateau-like, was very useful, especially for the early works. I was very conscious, then, that it gave me the opportunity to make a type of art by walking in a completely new and original way, particularly those early, formal, ritualised walks: walking in straight lines or perfect circles, measuring time. Obviously time exists in life for everyone, but I was able to use time in a very particular, precise, formal way in those early works. It was necessary to do those things. I think there are moments when you have a new opportunity to do

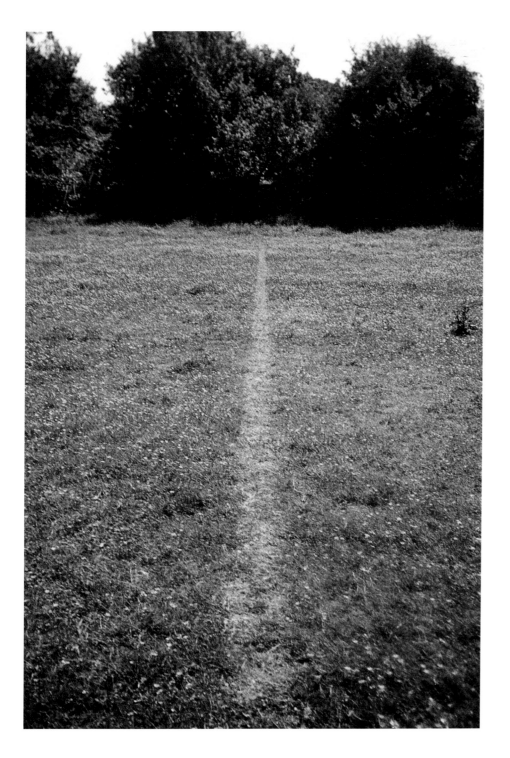

A LINE MADE BY WALKING

ENGLAND 1967

something, and that's partly what those early works were about. Later, in the text works, I had the freedom to use words more, to be more literate, to be more complex. A landscape place like Dartmoor provided me with the opportunity to realise my ideas. It was sort of a combination: carrying out a good idea in a beautiful place.

WF So it wasn't so much the space, as what you did in the space?

RL Yes. It was about, maybe, just making the walk and then making the work of art by drawing a straight line on the map. When I said before that I had been aware of the romantic tradition both in photography and in landscape painting, it was to explain that I felt I had an opportunity to get away from that and to make art in a way which wasn't about celebrating the beauty of the landscape, but which explored completely different issues. I suppose you could say that I was an artist in the landscape, which was different from being a long-distance walker or a landscape photographer or an explorer. So it was very particular.

WF You mentioned your interest in developing the idea of landscape. Historically, the ways in which artists have related to nature has been quite varied: there's Gainsborough's depiction of nature as a sort of inventory of ownership, there's Turner's idea of the untameable force of nature, then there's the park, which is a quotation from nature, then there's nature as a means of exploring historical, structural interests, and when it becomes just the material – I'm thinking of impressionism, and so on. Against this background, how do you locate yourself?

RL I could also say there's nature in other cultures. There's nature in Aboriginal art, and there is nature in the tradition of Japanese Zen poetry and the walking poets. There's nature in all cultures. What I think I was trying to do partly was to set all those things aside. Those are all interesting aspects of landscape art, which existed in history, but I was able to go on in a different way. It wasn't about ownership, or any of those other things you mentioned. I suppose it was a way to work in the arena of the landscape as a modernist, in the avant-garde tradition, though I didn't think in those terms at the time. In the mid 'sixties, there were a lot of interesting ideas floating around. I was a young artist with concentrations of real interest but also blind spots of ignorance. I remember seeing Yoko Ono – she did a performance at St Martin's, although I knew nothing about Fluxus art. I was also very interested in some lectures by John Cage which were about chance and time and also humour. So maybe my work partly came out of that radical re-think of everything, which was so characteristic of the 'sixties. That was the general cultural background that I was in as a young artist.

WF And conceptual art, which you were central to at that time.

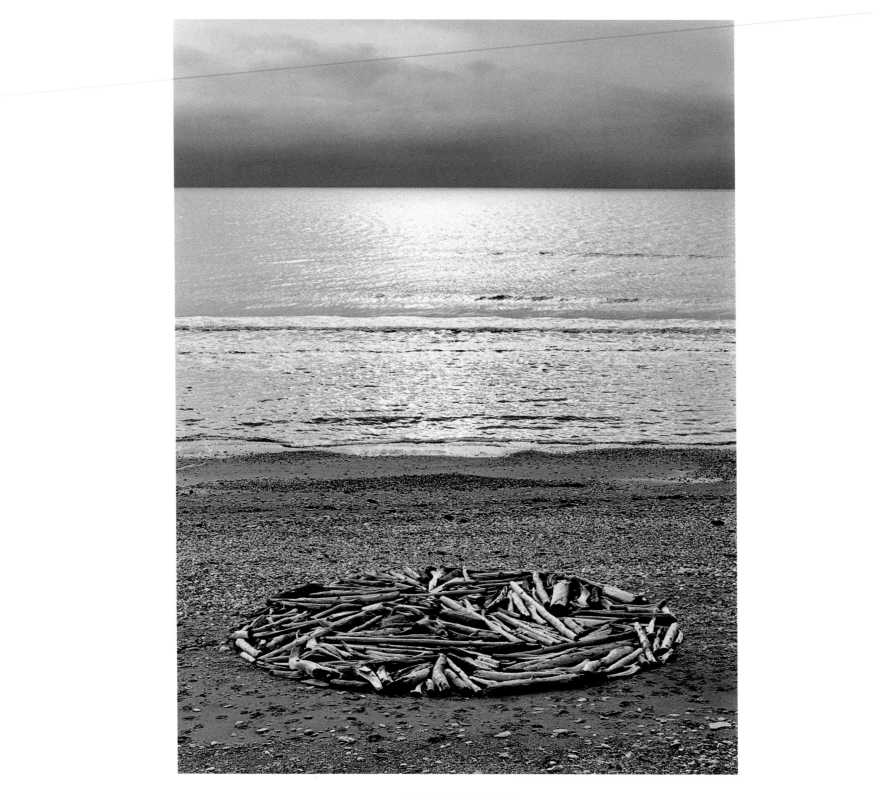

A CIRCLE IN ALASKA

BERING STRAIT DRIFTWOOD ON THE ARCTIC CIRCLE 1977

THE SAME THING
AT A DIFFERENT TIME
AT A DIFFERENT PLACE

A STONE BROUGHT FROM SOMEWHERE ON A PAST WALK
PLACED ON THE SUMMIT OF SNOWDON FOR A TIME DURING A FIVE DAY WALK IN NORTH WALES
AND CARRIED DOWN TO BE LEFT SOMEWHERE ON A FUTURE WALK

WINTER 1997

RL Yes, around '66, '67, though I wasn't actually aware of the term 'conceptual art'. Certainly John Cage was interesting because of the ideas, which, with hindsight, I suppose, were all part of the conceptual thing.

WF You mentioned Aboriginal art and the relationship of Aboriginals to natural environments. It seems that there are artists who pick up on the function that the landscape has for Aboriginal cultures. You have walked through a lot of landscapes that presumably have invisible associations and functions. Is it important for you to pick up on those references?

RL Not exactly. It would be presumptuous and inappropriate for me to pretend an Aboriginal sensibility. The Outback is their cultural territory, and maybe Dartmoor is mine, in a completely different way. So I can admire and be aware of different cultural landscapes, although they would not necessarily form the content of my work.

WF You don't do any research into them?

RL No. But, obviously I have an interest because we all share the same nature. I've said many times that nature is universal. One of the nicest experiences of my life was a big show in Paris a few years ago called *Magiciens de la terre*. It was very moving to see how many cultures all round the world still, for example, work on the floor with natural materials. I found myself close to a lot of art from completely different cultures, like Navaho sand paintings. In some ways I feel closer to a lot of the artists in that show than to so-called landscape artists like Cézanne or Constable or Turner, who, for me, exist more in the tradition of painting than in the tradition of nature, or the landscape.

WF So you would look to that route for a feeling of affinity rather than any group of modernist artists?

RL Yes. I think some of that stuff is very profound. It has a spiritual dimension which interests me. I mean, if I had to look for a strong spiritual dimension in historical art, I might look to Jackson Pollock, or Malevich. I can pick out things that I like in the tradition of art history, but it's not necessarily to do with landscape, it's the spirit of it, connecting with something more primitive.

WF There is a sense in which your work doesn't really use irony in the way that a great deal of modernism does. It's very much a direct response.

RL Well I thought irony was all to do with post modernism, but I think it's quite difficult and mysterious to talk about that, because some good art does have a kind

of an irony to it – Duchamp is a good example. But I think it's just that art is often a kind of antidote to normal life, the other way of doing things. I'm not playing a game. It's serious. But humour does come into it just as it comes into life. So it's not deadly serious. I'm not entrenched in dogmatic positions like some artists.

Another thing to say about my work which I was half aware of at the time but I can talk about better with hindsight, is that my early work was contemporary with so-called American 'land art'. That was about claiming the land on a monumental scale, it was all about using heavy machinery, the ownership of land, and it needed lots of money and all that. But I had a completely different philosophy. Now, on the one hand you have those artists who make monuments in the landscape and then on the other you have the very politically correct idea that one should not do any-thing in the landscape except leave footprints and take photographs, do nothing but record it. But I think that my work occupies a really fertile territory between those two extremes. I make art which makes fairly transient sculptures. I can pour water, I can move stones around, to use time, space, distance. I can make a sculp-ture 164 miles long simply by walking across Ireland and putting a stone on the road at every mile, but it's not monumental. I can throw a stone around a ring of mountains and return the stone to the place where I found it. So I would like to think that my work explores a lot of interesting ideas where I'm walking around the world and moving a few of its materials around, leaving traces, but in a discreet, intelligent way. That is neither making nothing at all nor building monuments.

WF The issues you're dealing with are often complex : time, scale, your relationship to the environment, your physical presence and how distance is measured between things.

RL Yes, it's endless. It's complex only in that it's like an on-going dialogue with the territory that I have chosen to work in, which is the landscape. So, for example, in the last couple of years, I've made a few walks which are a kind of metaphor for the world of particle physics. If you think that the fundamental nature of reality com-prises matter, time, space, things appearing, disappearing, reappearing, positions in space, density, I can use all of those elements in my walks. A walk can measure time and space, I can make stones move around, leave them in different places, exchange them, scatter them, bring them together. A walk can easily articulate all those fundamental aspects of time and matter.

WF Does that suggest that your work is, in that respect, metaphorical, or is this a reading after the event?

RL I think some works are metaphorical, not all of them. Again, having done lots of really straight, formal works which weren't metaphorical, maybe, as I've done the ground work, I now have a kind of freedom to make a few works which are metaphorical or that can be read metaphorically. The works that I've been de-scribing can also be read straight. What I like about the way I work is that even though on one level it's extremely simple (for example, just walking and carrying a stone in my pocket), it nevertheless has rich connotations and interpretations or metaphorical allusions.

WF The way you've made work and the means you have used over the last thirty years have remained remarkably consistent, but each time you make a new work, even if it's a walk or a circle, do you find it a completely new, exciting experience?

RL Yes. I think that each work works on at least two levels. It is what it is, you know, what it looks like and the interest of its idea. But then there are also the accumulated ideas of all the work over the years that give it an extra meaning, and that's also a feature of my work. Somebody might see a work of mine on Dartmoor from last week, but then to know that I've covered Dartmoor with different walks for different reasons in different seasons and at different times of my life is also part of the knowledge of that work, or it can be. So, it has a complexity . . . I think that repetition actually represents complexity sometimes, or richness. It's not just repetition. If I had walked a straight line once in 1967 and left it at that, on its own it would have been an interesting work, but the fact that I've walked in straight lines in different landscapes of the world for different reasons to realise different ideas about measurement or time, or whatever, sort of builds. So the idea that one thing leads to another is really important in art. I mean, I could talk endlessly about the cosmic variation contained in all this, I could repeat circles all my life and they would all be different because every place in the world is different. Every stone in the world is different. Or I could make a million of my River Avon mud works and they'd all be different in the way that snowflakes are all different . . .

WF . . . or fingerprints?

RL Exactly. So tied up with sameness in my work is the idea of the cosmic variation that is part of life, and also that sort of fractal expansion and repetition: one foot-step and a thousand-mile walk. For me originality is not just inventing some new idiosyncratic shape all the time. It's not about that kind of aesthetic invention, it's much more fundamental and philosophical.

WF You're using forms that are universal: the circle, the spiral and the line have appeared from pre-history.

RL Yes. That's right. I think that gives my work power and accessibility and, as you say, universality. I mean, they're just stronger than if I were inventing my own forms. So one thing about my work is that the form can stay the same, like a circle, but the content can change, endlessly.

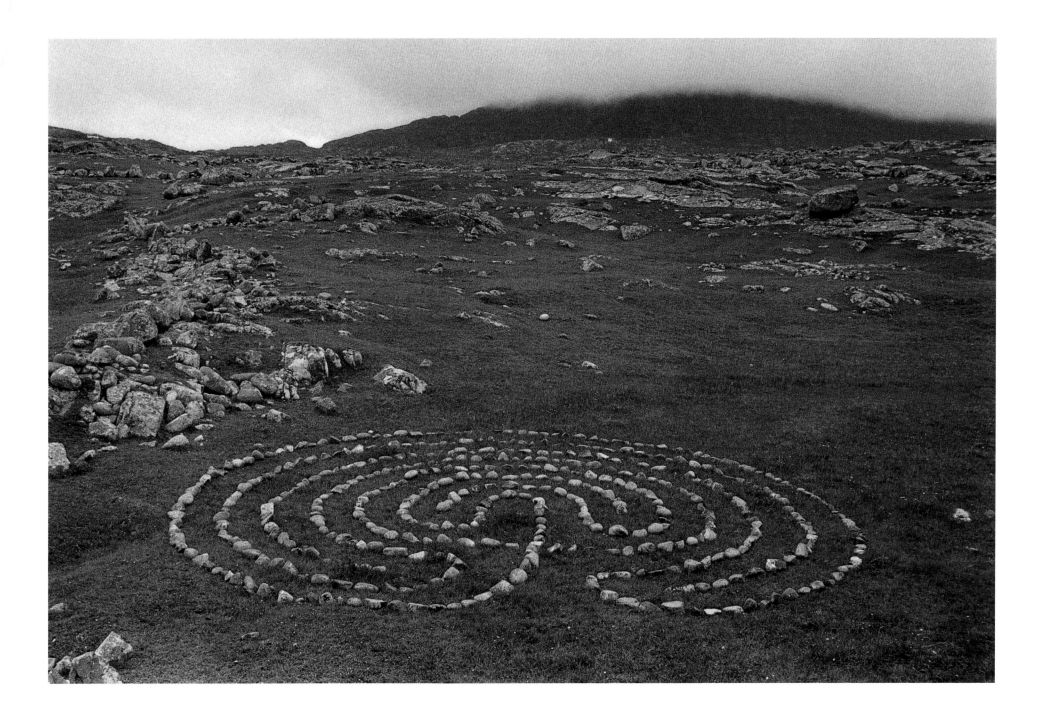

CONNEMARA SCULPTURE

IRELAND 1971

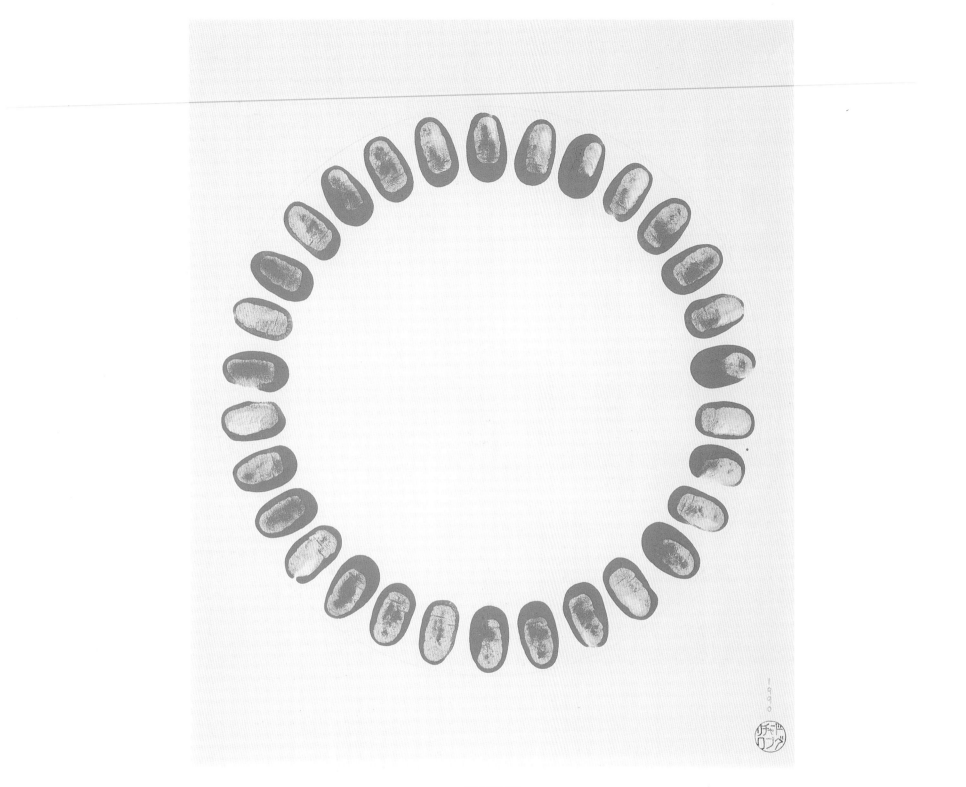

UNTITLED
1990

River Avon mud on card
36.8 x 31.7 cm

WF It's interesting as a statement of practice in the context of modernism where the emphasis has always been on novelty and innovation and change, which is almost to do with the pace of a city. Every day is completely new and fresh, you've got to come up with something new. But you've put yourself slightly outside that.

RL Well, I can be original in a different way. I'm always using stones, I'm always using circles, and yet I would still say that all my ideas are different. So I could make a hundred walks and they'd all be for a different reason or following a different idea. To that extent, it's a kind of freedom for the idea to be original and not the shape or medium of it.

WF You quite rightly point out that the whole world isn't like New York and London. There is another context with a different timescale . . .

RL . . . which most people aren't familiar with. Like I said, I consider myself a realist, not a romantic escaping to the wilderness. So, I would say the wilderness is a great arena for me to realise my modernist ideas about art.

WF Does the term 'wilderness' embody the idea of wildness too, of something that is untamed, that to a very large extent hasn't been interfered with by man?

RL Yes, to the extent that it's just a part of the world that's not been urbanised. It's probably wrong to think that any part of the planet is untouched by people or cultures or civilisations, it's just not always apparent. So no matter where I go in the world, I will never feel as though I'm on the moon, because there's nowhere that hasn't had people living in it. There are just different ways of living in the world, and the people in Alaska or in the middle of Australia are just living in the world in a different way from people in cities. They are using their natural environment.

WF Your relationship to those environments, though, is clearly a key factor in the making of the work. You talked about your physical ability to walk so many miles per day, and so on.

RL Right.

WF But it's also to do with you coming up against a hostile environment, maybe, so there's perhaps a sense of survival, endurance?

RL Well, occasionally. If I go somewhere that I've never been to before and I don't really have much knowledge of it – which is quite often a good reason for going to a place – I'll have experiences or encounter situations that are unfamiliar, not exactly in a dangerous way, but just in a way that sharpens the senses. Even going to Scotland, I can run into blizzards or get wiped out by torrential rain or high winds. So, I don't think of those things as dangerous, but just as interesting features of normal world life that sometimes I can even use in my work.

WF So, it's not to do with battling against natural forces?

RL No, no, no . . . I think that's a very romantic idea. Though occasionally, with some of my walking works, say, when I walk for twenty-four hours continuously, or, make a long-distance walk in some mountains, there's a kind of pleasure in having that sort of challenge . . . to know that I can go into a different physical zone – a rhythmic mode of life that is different and dynamic and satisfying and relaxing. The wilderness is able to offer the opportunity to live differently from the way you live in a city, and I actually find this more interesting.

WF When you take photographs, then, when you're engaged in living in this way, what you bring back is an articulation of the process, the pleasure, the experience.

RL Well, it's a residue. I've often said that sometimes a sculpture that I've made along the way is a sort of celebration of that place, of me being there at that time in that state of mind – perhaps very exhausted or quite relaxed or happy or whatever. It's a record of that moment in my life when I've stopped there to make that particular work, and then, I should say, the photograph is a record of that moment that's later brought back into another context as one way of communicating that.

WF How would that differ from a tourist's photograph of that spot?

RL Well it might not differ, but I'm an artist. Whatever merit my work might have would be to do with my sensibility and intelligence as an artist, and maybe that I take a photograph for different reasons than a tourist would take one. But, you know, photographs are one of the most democratic of twentieth-century art forms. Photographs don't have the kind of status of other artworks. Great photographs have been taken in all walks of life – the right person in the crowd when there's an assassination, or a cosmonaut, an astronomer, taking a unique photograph, or a sports photographer. Different types of people can take great photographs for different reasons. I'm just in the category of an artist taking a photograph for my own reasons.

WF So it's very specifically an artist's work rather than documentation of the site.

RL Yes, I think it probably is. The photograph is usually a record of a sculpture that then becomes a work of art in a different way, because I put it in a frame and I write a caption under it and show it in an art gallery or a book or something, so it just becomes art because I'm an artist.

WF But it's part of an embodiment of a practice and a relationship to the space – it's quite a complicated set of things that are going into that photograph.

RL Well, I try to get it in focus and I suppose in a way I've always tried to take my

photographs in the spirit of the work and of the place, but not just for the beauty of the photograph.

WF What do you mean, the beauty of the place? How do you use beauty in this context?

RL Well, to make a sculpture, whether it's in a landscape or a gallery, is just to make a beautiful, powerful image – I don't know quite how else to explain it – so beauty is definitely an element in my work. I suppose what I mean by beauty is that it's like an image that has an emotional power. So maybe beauty's the wrong word, but it's a kind of . . . it's something to do with emotion, which I think is what art is.

WF Hard to put into words.

RL It is, actually – that's probably why I make it into a work. I also think there's the beauty of ideas as well as physical beauty, and the best art is always a combination of both.

WF There was a reference in your book *Mirage* to you making 'new works from stone and mud directly in response to the space'.

RL That's really no different from my normal practice. Often when I go to a place to do a show, I've never seen the space before and so if it's a big space I can do a big, beautiful, grand work, and then, because it's easy for the way I work, it's more practical to get stones from the locality than from elsewhere. So in the case of the Palermo show, I got local mud and stones – Sicily is in any case a very stony land-scape. But, underneath all that is the fact that I'm not a studio artist and that because I use very simple natural materials that are not industrialised, they're not prefabricated, it's easy for me to find stones or mud or water to make my mud works, or what I need to make any of my sculptures, more or less anywhere.

WF You say you're not a studio artist, but you have a studio. What happens there?

RL Well, it's just my house, where I design my catalogues and write my letters and just do all my office stuff like answering mail and . . . designing books and everything.

WF Don't you formulate new works in the studio?

RL No, not at all. Normally I have an idea about a future walk when I'm actually on a walk. Or I might . . . oh it's daft, but, because I do a lot of cycling (I don't have a car), I kind of sort my life out and come up with what I might do for a new show, or something, when I'm cycling into Bristol for my shopping. So no, I don't sit down in front of a blank piece of paper and meditate. It's more when I'm out and about that I have my thoughts.

WF But they're not recorded, obviously, you wait until you get to the new context and then make the work.

RL I'll always have a general idea about what I want to do, whether it's for an exhibition or on a walk. But then the particular conditions can change that, you know, when I get there, or I might find things along the way that I could not have known about, so I like to think that I'm fairly flexible in the way that I make art and open to the conditions of different spaces and places.

WF So, all the work is made outside or beyond the studio.

RL Yes. I suppose the only category of works that comes close to being made in a studio are the little mud works, where I dip the paper into a bath of muddy water and hang it up on the washing line.

WF What happens to them? Are they works that are then shown and presented?

RL Yes. I suppose they're a smaller version and a more domestic form of the water works that I make in the landscape – by pouring water from my water bottle along a road or down a rockface. So, at one end of the scale are the water works in the landscape, and then there are the big mud works in the exhibitions which are made directly on the walls with my muddy hand. And then the smallest scale of that category of work is the mud drawings. For these, I dip pages into muddy water and which I then allow to run off. One aspect of these that I like is that the image is not made by me touching the paper, it's actually made by nature, by the wateriness of the mud, its viscosity, and gravity. So they have the great merit of that cosmic variation that I was talking about before. I could make a million and they'd all be different.

WF The long list of your exhibitions is also a list of localities where you have both made and shown works. So those localities are, in a sense, the studio.

RL A lot of my work takes place in public in the art world of museums and galleries. I've always been interested in making work in public places, as a complement to making work out in the landscape in remote parts of the world, which could dis-appear, and will probably be seen by very few people, or be anonymous, or be unrecognisable as art in that place.

WF When you have a major museum show, presumably it is a combination of new works and works borrowed from collections?

RL Yes, that's often a good way to do it, because it gives a historical dimension, but it also offers me an opportunity to make new works at that particular place. I can show a photograph of a walk I might have done in Tierra del Fuego alongside a circle of stones there in the gallery, so people can see that the outside world is

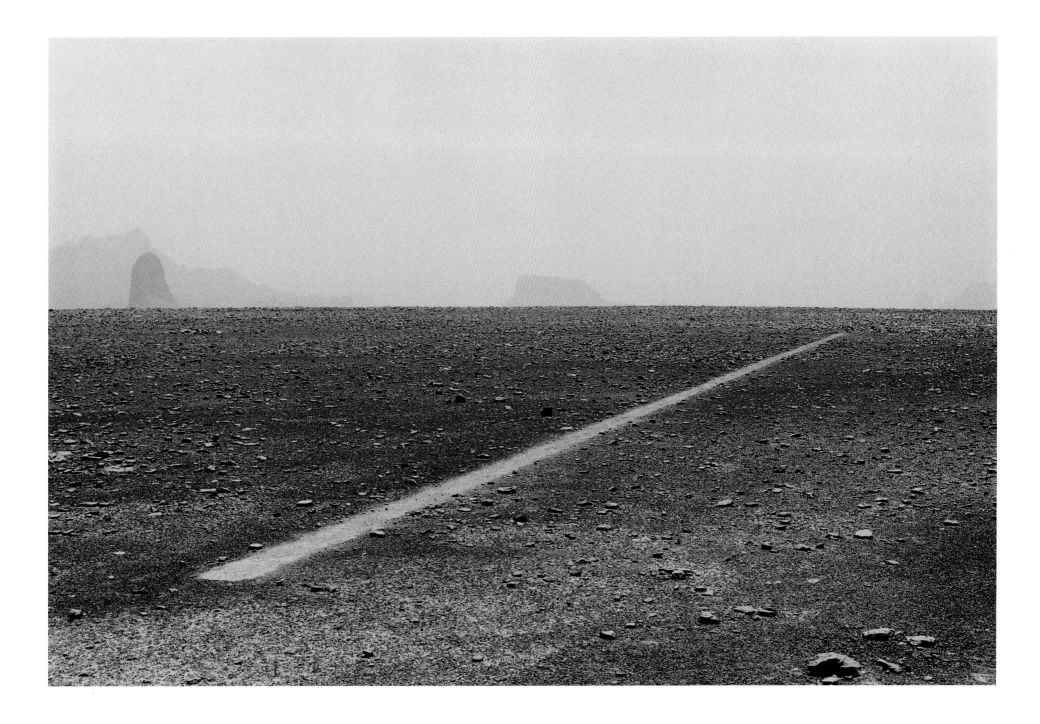

DUSTY BOOTS LINE

THE SAHARA 1988

my territory to make art in, not just galleries. People see a real circle of mud on the wall in front of them or a real circle of stones on the floor, and then the maps and texts and photographs can bring [all these] other works from around the world into the same place for people to know about imaginatively.

WF We have talked in the past about the fact that you felt it would be highly inappropriate to designate one of your sites in nature as a work. From time to time I imagine people invite you to do that?

RL Well, actually no, not so much, though occasionally somebody might want to know where a particular work is. But you're right to suggest that it's a very important aspect of my work that the locations of the sculptures, even though they're obviously real (just as real as, say, the Tate Gallery) are also anonymous. It's not part of the idea of the work for them to become famous sites, to be visited by lots of people. In fact, the whole point of a sculpture could be its isolation, or tranquility or silence. So I'm happy to have this way of showing those works through photographs or maps. Anyone looking at a map work can find that place, so in that sense it's just as public as a room in the Tate Gallery, because that place exists out there in the world.

WF Does the idea of site-specific sculpture have any resonance for you?

RL I suppose theoretically, technically, all those works were site-specific, like the daisies on the Downs here in Bristol, or walking the line in the field. I mean, they were all specific to the place I made that work in. But the term 'site-specific' is for me just something that's an academic, art-world piece of jargon.

WF Are your works located out of doors publicly very often?

RL Only occasionally. I don't have any really dogmatic views about my art practice. So once in a while an interesting opportunity comes along where it's been a good idea to make a work which is outside and in a public situation, like the Tokyo Forum, which has a quite a big work of mine in a public space. From time to time an artist may do something that's not very typical. Occasionally I have to take a risk, or do something stupid or make a mistake, you know, do something that's a little bit out of kilter with what I usually do. But in general, I would have to say that I'm not interested in public commissions or city art. Cities have their own type of beauty, you know . . . they don't need art to beautify them, not in my opinion, anyway. I think it's perfectly OK for many artists to want to do that. It's just not my choice.

WF Rachel Whiteread's Holocaust Monument for Vienna is an example of making art for a city, but also of making art with a particular purpose, with a particular brief to remember a certain set of issues.

UNTITLED
1989

River Avon mud on paper
three out of five parts, each 50 x 39.4 cm

FAST HAND CIRCLE

ANGLES GALLERY, LOS ANGELES, 1990

RL I can see that could be a good function of art. I actually did do something of the kind in Switzerland some years ago. It was the 700th anniversary of their parliament and I made *Seven Hundred Stones for Seven Hundred Years* – seven piles of stones at different places around the lake where the Swiss parliament first originated. That was an example of a sculpture on a walking route also having a commemorative, historical and social function. But I suppose I only do that kind of work if it suits the way that I work anyway.

WF Are the materials you use always derived from natural sources? You haven't made works using manufactured products or manufactured materials. Or might you do so?

RL Well, I did once make some water drawings on a synthetic base, but they weren't that interesting really. I did them so that they could be rolled up and kept, but strangely enough I discovered that they weren't as interesting as the water drawings that I just poured straight on the floor, like the one I did in Sao Paolo. I guess the lesson I learnt was that it's really in the spirit of my work that a lot of it has to be temporary, that I can't go out of my way to make it permanent if it's not appropriate. Having said that, somebody asked me recently whether I feel sad at the end of a big exhibition when the mud works are destroyed, and, you know, sometimes when they are big, successful mud works, I do regret that a master-piece could be washed off! In a perfect world it would be great if a lot of those works could stay.

WF You could actually make them on temporary panels, on canvases.

RL That's the old problem. Then it would become like a sort of a painting, and because I'm not really interested in painting, it wouldn't be appropriate. The mud works have to be made on proper walls which are part of the building. You can't have one without the other.

WF So the physical circumstances and spaces of the building are germane to what you're doing . . .

RL Yes, I think so. I'm not a painter.

WF It would be an easy way out?

RL Yes, that's right. I don't use the word 'painting'. I call them 'mud works'. The first mud work I made was anyway on the floor, with my hands. And it was only years later that I figured out that I could do the same kind of gestural stuff on a wall, so the mud works actually did start out as sculptures, and then a couple of shows after that, around 1970-71, I made one with my boots, with muddy boots making tracks on a gallery floor, so, it was all just to do with mark-making which was really two-dimensional sculpture, you know, sculpture with no height . . .

RIVER AVON MUD ARC
Work in progress at the Guggenheim Museum, Bilbao, Spain, 2000

1449 STONES AT 1449 FEET

1449 TINNER'S STONES PLACED ON DARTMOOR AT 1449 FEET

ENGLAND 1979

WF With materials by which you have been surrounded all your life . . .

RL Yes.

WF The Bristol context and the Avon and the mud seem to resonate through everything you do.

RL Yes, that's very true. That had a big influence. It still does. And that's where my mud comes from, you know, just a local creek ten minutes away from here.

WF You must have known a lot of artists in the 'sixties and 'seventies, and even now, who, wherever they come from, want to migrate into urban culture, the city, and leave all this behind, but you've stayed with it.

RL Not many artists go on living where they were born. But it just so happens that it's suited me to go on living here, for many reasons. You know, you could go all round the world and not find better mud than in the Avon here. Even though I've made a lot of works around the world in different landscapes, I've probably made more works just walking around the West Country roads and lanes than I have anywhere else. It's my home territory as an artist and it is still a very good one for me. Also, Dartmoor is a sort of prototype landscape for me. It's just always there for me to work in.

What I have always liked about Dartmoor is that it is this big empty place which nevertheless has traces of all these layers of human history, like the tinners or the farmers or whatever. And I suppose after so many years I can also say that it has also traces of my own walks and history on it. So I can't go to Dartmoor now without being aware of a lot of my own history, my walks that have criss-crossed it for thirty years, and that, as I said earlier, becomes part of the cumulative richness of the work. All the old works now inform the new work.

WF And those various layers are implicit now.

RL Yes, that's right. So the work becomes different. The first time I walked in a circle on Dartmoor, it was exciting to think that no-one had ever walked in a perfect circle for those reasons in that place before. It had the energy of being fresh and original and new in the art world and everything. Now that way of being original has gone because I've done all those lines and circles on Dartmoor, so it's different. As you say, I'm now working with my own history.

WF How does this inform your work, do you think?

RL Well I suppose my work is informed by the experience of knowing the place better, but there's also a kind of challenge. I've done all these walks, but they don't repeat themselves in terms of ideas. It's always possible to follow a new idea. I realise also that Dartmoor has fundamentally remained exactly the same, while my life and work have been evolving on it.

WF Do you ever feel that you could continue your practice by not travelling widely, by staying around where you live?

RL Oh yes. I've always had a strong feeling that somehow if the politics of the world were different, if I were forbidden to travel, if there weren't the freedom I have now to go more or less anywhere in the world, I could still be an artist within fifteen miles around Bristol. Once an artist, always an artist.

WF The travelling means that high technology is in a way embodied in your practice, because you couldn't go to the remote places without jumbo jets, and so on.

RL No, absolutely not. My generation of artists was the first to be able to treat the world as one place exactly because we live in an age of jet travel. In 1969, I was able to go to East Africa fairly cheaply, for example, to make a sculpture on the summit of Kilimanjaro. So I've absolutely used that freedom to travel in my work, and I can only do that because I live in the modern world.

WF And there's no conflict there?

RL No, not at all, no. I suppose in the old days artists were different because they made the Grand Tour, or there were explorers or botanists like Darwin. There was a kind of tradition of travel, but in a different way. Maybe they didn't have the idea then of the world as one place, of what Marshall McLuhan called the global village. I think there are elements of that in my work – of the world being one place, but in a good way, in the sense that we are just all one species living in the same place in the universe.

WF Is there any sense of a danger here, that because of all this the natural spaces in the world will turn into giant theme parks that are only there because we've decided to leave them alone?

RL Over the years I've become more aware of such issues and of the fact that somehow I have to take more responsibility, that we all have to be more responsible for what we do in the world. As a young artist I was just completely involved in my work, purely following my ideas and using the world for art. But, as you say, it's a very different world now, from what it was thirty years ago. So to some extent, I like to think that I have changed my art practice and my thinking a little bit to be more careful or responsible or culturally aware. I'm not in favour of being so politically correct as to leave no trace, because I think people from all cultures and histories have always done something in the world, have left their mark. And the human race is founded on movement and cultural migrations. What counts for me is why I do my work and how I do it. So I think that if I make art in a positive way to celebrate the world, in dialogue, it can somehow be good.

WF Defining a human being's relationship to the world?

A LINE IN THE HIMALAYAS

1975

NATURAL FORCES

WALKING WITH THE FORCE OF GRAVITY

IN THE FORCE OF THE WIND

THROUGH THE FORCE OF RIVERS

ALONG MAGNETIC FORCE BY COMPASS

OVER GEOLOGICAL FORCE ON THE STICKLEPATH FAULT

A FOUR DAY WINTER WALK ON DARTMOOR 2002

RL Yes. However much of a mess we make of the natural world, it will always be part of the human condition to have a relationship with our environment, whether it's as a farmer or as an artist or as a poet or . . . as a technologist, or whatever. And I believe that in spite of living in the world of the internet and high technology and super science and everything, water is still more important than technology. The most important themes in my work are water or space, night and day, the tides, or just the wind or whatever . . . these are still the most important fundamental things.

WF Could you ever envisage working with such technology as the internet, which has given everybody virtual access to the whole world?

RL I don't know. I guess I'm not that interested in it, really. All artists make different work, and all art finds its own level, in its own way. So for an electronic or video artist, or something, the internet might be appropriate. But I'm still quite happy putting my art into the world in the ways that I have so far chosen. I still like the fact that a work could be in such a remote place that no-one could see it. In other words, it's like the antidote to the internet. You see, I'm not against the internet, but I just think that we have the freedom to do what we want in the world. That's why I'm very different from Gilbert and George, say, because they have this very simplistic view that art has to be sort of populist, which I think is a really big misunderstanding, and conservative. You know, I think the great thing about art is that it can be anything an artist wants it to be. Whether it's the most obscure, elitist, invisible kind of work or the grand works about sex and humour that Gilbert and George do in huge museum shows all around the world. I don't think it matters. It's just each to his own, really.

WF Are there any artists that you have a particular sympathy with? I had a conversation with Carl Andre a while ago, and the way he was talking about the studio was very close to the way you have been talking – he doesn't have one. He was talking about making works on site, and this being to do with materials.

RL I suppose you could categorise Carl Andre as an urban artist and me as a landscape artist, but, over and above that, there are elements of our work – that sort of very simple, calm, minimalist aesthetic – that are very close in spirit. And he's a very old friend, anyway. So often the artist's work that I admire, that I'm attracted to, is not that which looks superficially like mine. But it's more the artist whose work is close in spirit, in the kind of thinking, in the philosophy. So, for example, I'm not really interested in, say, Andy Goldsworthy, because for me he's a sort of second-generation decorative artist. I can't really learn anything from his work because it's familiar territory to me. It's also about all the virtues of craftsmanship or the decorative use of colour, or of building something technically well, which are absolutely not the things that I'm interested in; they're the opposite of the reasons why Carl Andre is a good artist. His work is not about craftsmanship, it's not about all the ways of construction, it's not decorative, and those are exactly the reasons why I admire Carl's work. We come from an 'idea' generation which has nothing to do with skill or expertise. The physical beauty of Carl's work is the result of elegant and logical thought, like good mathematics.

WF You mentioned that it was just an instinctive choice to make a straight-line walk on Exmoor [in 1968]. One could perhaps deduce that this came out of the freedoms that seemed to prevail in the 'sixties and the kind of things that John Cage did and conceptual art being in the air, but that it also linked in with your background, your history, where you were born.

RL Yes. I think it was those two things coming together. As a child I was always drawing and painting and then when I was about nineteen I started to find a language for myself which combined a lot of my physical childhood pleasures with my love of art. Walking across Exmoor that day in a straight line, you know, satisfied the criterion of doing the right thing for the right reasons and was also a great pleasure. Being able to expand my walks over the years into some of the most beautiful landscapes of our planet was a life-enhancing dimension for me, very different from urban or city experience.

WF With a different pace, a different timescale, a different set of pressures . . .

RL Yes, a different imaginative adrenalin . . . a different rhythm. It's not for everyone, but it just suited me. So I've just made art in the way that suits me.

WF This links back to your history which included experience of and sympathy with that sort of environment, albeit in and around Bristol.

RL Yes. I used to love watching the ships and tides, playing on the towpath, in the gorge or on the Downs. And as a child I knew Dartmoor, because my grandparents lived in Devon, and we would spend holidays with them.

WF I know that when you're invited to go abroad to a museum, you might then make a walk in the locality, but you also, presumably, choose to go to particular locations. How do you select those places?

RL I have travelled for all sorts of different reasons over the years – it could be completely on a hunch, because I just had a feeling that it could be interesting. Recently, I went to Argentina, and it's strange that I'd never been there before because it's always been some vaguely exotic place in my imagination. There were strange spaces, you know, like the pampas, and it has unique types of indigenous animals. So sometimes I can go to a place after it's been in my subconscious for years. When I went to Zambia in the late 'seventies it was partly because I wanted to go to Central Africa as an artist, but also because my brother was working

SOUND CIRCLE

A WALK ON DARTMOOR 1990

CIRCLE IN AFRICA

MULANJE MOUNTAIN
MALAWI 1978

there, so that was like a base, a starting reason, and the contact made it easier to make the trip. So that was a personal reason for going to a place. It led to my doing *Circle in Africa*, on Mulanje Mountain in Malawi in 1978. Or – another example – my friend and fellow walking artist Hamish Fulton might have suggested that we were due for a walk together, so then we'd meet up in the Royal Geographical Society and just get some maps of South America out on the table and have a look with a completely open mind. We found a great landscape just by seeing it on a map of Bolivia, a completely empty area with some dotted shading – labelled 'ROCKY' – crossed only by a railway line with one station in the middle of it: General Perez. Or another example would be that I might have a very precise idea about going to Scotland and walking a circle intersected by lochs, so that I'd be walking around my circle but also walking around the edges of water. So in that example, I travelled to follow an idea. There are many reasons for choosing places.

WF And do you have a next port of call in terms of a place that you feel you definitely want to go to? Do you plan ahead?

RL Actually, I don't plan ahead too much, no, that's one feature of my amateur personality really, I never think more than one or two walks ahead. So at the moment I do have a plan for a long-distance walk next year which I don't want to talk about because I don't believe in talking about things I haven't done yet. And then, on another level, I have a particular idea for doing a walk, probably on Dart-moor, which is a sort of metaphor for the micro-scale of matter. That's just the idea. You know, walking is walking and that stays the same – just as the circles stay the same, but the ideas change along the way, from walk to walk. There's been very little commentary on the ideas behind each particular walk amongst critical commentators on my art. I think there's a lot of things to be said about the different ideas contained in my work, particularly in the walking pieces, which have never really been discussed much.

WF Because all the walks are different, one clearly cannot talk about the general underlying concerns of a walk, but can you give me an example of a recent one and talk about what underpinned it?

RL I did a six-day winter walk on Tierra del Fuego not long ago. That's an example of going to a place which is completely unfamiliar to me, and the places I found along the way I couldn't have imagined beforehand. And then, more recently, I did a walk which was about bringing a stone from somewhere in the world and making a five-day walk in North Wales and leaving the stone on the top of Snowdon for a while, and then taking it down again to be left somewhere else on a future walk. So that was to do with combining in one walk the idea of the past and the future with the present. And connecting two anonymous places to a known place with

one stone. The walk in Tierra del Fuego and the one in North Wales were done for completely different reasons. One is a much freer, wilderness kind of walk, and the other is more idea-based.

WF Have the walks changed in this way over the years? Have they become more purposeful?

RL Well, as I tried to say at the beginning, I was very conscious in the early days of needing, or wanting, to lay down a certain history of making works that were very formal, ritualised, you know, walking in ways which had never been done before, completely different from, say, making a pilgrimage or being an explorer. And then having done that kind of walk, I was able to be freer and make sculptures along the way, and later to show photographs of those sculptures and the beautiful landscapes they were in. But it's interesting . . . I actually still like to go back to those quite formal walks which are about very particular ideas. So I suppose one way to talk about it is that if I go to the Himalayas, the mountains are so grand and epic that the work itself has a kind of adventuresome dimension, which is great . . . but I still also like to do the formal, almost theoretical walks, such as the one I've just described about placing a stone on Snowdon. Another recent one in England involved a meandering walk of twelve days, for 360 miles, in the English country-side, and being on and intersecting an imaginary circle at midday each day. It's like a circle of middays, a text work like a clock. So the walk was really just a question of actually carrying out that particular idea from the beginning to the end, whereas on a walk in the Himalayas, I don't know what's going to happen. As the years have gone on, I still like to make these formal pre-planned walks, like the *Circle of Middays*. It's still necessary to keep those going, you know.

Bristol, England, 1997

Giuseppe Penone

William Furlong Much of modernist art of the late 20th century has tended to spring from the urban context and urban preoccupations. Given your profound relationship with the sources and materials of your work, that is the natural cycle, natural processes, rhythms and the associated materials, where would you locate or situate your practice as an artist?

Giuseppe Penone I think that first we have to be clear about what we mean by 'nature'. Often when we speak about nature we are thinking of something that lies outside the activities of man, and when we define the work of man, it is usually in terms that refer to the urban. The natural retreat is seen as just that, as something else. But in fact in Europe we don't have a nature that is really nature, we have a nature that is a product of man. As far as materials are concerned, there's not such a big difference between a piece of steel and a rock or a tree, if you think about the fact that the form of the landscape and the forests have resulted from thousands of years of work by farmers and other people who have worked on the land for countless generations. The distinction between the two is not so big.

It's maybe worth thinking about impressionism. This was perhaps the most important art movement of the 19th century and it was very much associated with the landscape, but the end of the 19th century was also the time when the industrial revolution was at its height. And now, at the end of the 20th century, a century during which industrial production has grown enormously, the general tendency is to place less and less importance on the urban, on the industrial. Electricity is no longer visible in the landscape but is underground. We are trying to rediscover a space that is empty of that kind of technology. There is a problem with the technological media. I think the problem for the media is different from the problem for art, because with the new media we need to communicate with just one language, and the language of the media is usually determined by the language of mathematics, in other words, with digital codes. You have to translate reality into mathematical terms. But in art, in painting, in sculpture, we can do something different. We can make a language without having to translate it into mathematical terms. So I think art has became one of the rare spaces where man can relate to reality without having to do this in the terms dictated by the media, because you have to consider what the material means to you. This is an opportunity to respond in a way which is perhaps very ancient and which is common to all people and not specific to a particular culture. These days, the global village is a reality; art allows communication in terms that everyone can

understand, which is far simpler than using a specific language. A specific language always introduces the problem of power. The exercise of power is not something that is of interest to art.

WF I'd like to continue to explore the idea of two different spaces, though you have pointed out that you do not believe that there really are two spaces. I'm interested, even so, in the idea that there are different senses of time associated with the urban and the non-urban – the world defined by natural processes operating on a quite different timescale from that of the city. These are processes of life, of growth, of night and day, of seasons and mortality. Much of your work seems to explore those kinds of space and I was wondering whether you think that there are fundamentally two sorts of dynamic operating in the world: one that comes out of a kind of acceleration of time that is associated with the city, which is drawn on by artists who come out of urban realites, and the other spaces which have different dynamics, other processes which are perhaps calmer?

GP The time of nature is our time. I cannot identify a big difference between a man in the town and a man in the country: the thinking may be different, the sense of acceleration may be different, but that's to do with economics or perhaps with language, with communication. That's not a real acceleration in terms of human life. There is still the rhythm of day following night. You may do one thing more quickly and other things more slowly. But I don't believe that there is such a big difference. I don't make this distinction, and I *like* not to make a distinction between man and nature, because man is nature. It is no big problem. Real time is something determined by nature. It's not something different. Our idea of time comes from the changing of the seasons, the growth of plants, from our body, from the earth. This is the basic measure of time.

WF I believe you were born in the village in northern Italy called Garessio in an area that is rich in Neolithic and Roman remains and other archaeological traces, and I wondered whether that had influenced you? When I look at a lot of the pieces you have made that were interventions in nature, it seems that you were not trying to make dramatic changes to physical spaces or physical objects but rather that you were leaving the trace of a human being on those objects. Am I right to think that this socio-cultural heritage is a prevailing influence on what you do?

GP The influence of the landscape is certainly strong, but that is really not the point. When I started work, it was the end of the 'sixties, and at that time social, economic and political systems in Italy and across Europe were changing. Young people and many of the artists of that generation were turning their backs on the old systems. Choosing to work with something that was not a material derived from the prevailing culture, things like stones or trees or leaves, was a way of using something that was not involved in that system. It was also to trying to do something

different from what we already knew about. It was outside the accepted process and outside art as it had so far been defined by art critics. So it was a matter of trying to do *something*; it didn't necessarily have to be art. But art provided the only space in our society that could accept that kind of response or experience. This situation was not created by artists. The work that I and other artists did was something that could have been interesting in the context of poetry or art or botanical investigation or any number of other areas. The basic impulse, the basic challenge was to try to do something that presented an alternative to a culture that we thought was old. This was the reason for the choice of those materials. It was not so much a direct cultural reference.

In Italy whenever you see an archaeological, site it is Roman, there are Roman remains everywhere, but all the culture that was there before the Romans is invisible. The Romans were so strong that they destroyed the other, not least because it was a culture that had another way of thinking, that had another relation with nature. The Romans made roads along the floor of a valley; the people before the Romans built them along the ridge. This is a big difference in thinking. And working in the way I did, I found, I think, a very strong relationship with my little village which on the surface doesn't appear to have any culture. But among the people there, these very simple people, there was perhaps a memory of another culture that was not visible. And you can learn to understand from simple people and also from the work of such people, and from their relation to a natural kind of thinking and working.

WF You mentioned the 1960s when artists challenged the existing formalist procedures by making work that didn't relate to the expectations of galleries and art critics, and artists like yourself found ways of using their own experience, their own histories, their own narratives to make art. Artists such as Richard Long, Joseph Beuys, Mario Merz, Ian Hamilton Finlay and Marcel Broodthaers began to explore a very broad set of ideas. I guess that at the time this was just something in the air, but nevertheless what you were doing was quite radical, that is, making art out of anything, but particularly making art out of first-hand experience – just looking at the materials around you and thinking about the ideas that surrounded you in your context. It was a time of permission to do things away from hierarchies and expectations, and formal conventions.

GP Yes, but I feel there is and was a difference between artists of an older generation who had their own view of reality and this other art from the postwar generation. You mentioned Beuys: basically he had an academic point of view about art. But when you see work like that of Richard Long, it has nothing to do with academic art. It has perhaps something to do with the ideas of Byron, of poetry, of Rimbaud, but it's not to do with some theory about how to make art. At the time, the challenge was not whether something qualified as art, it was how

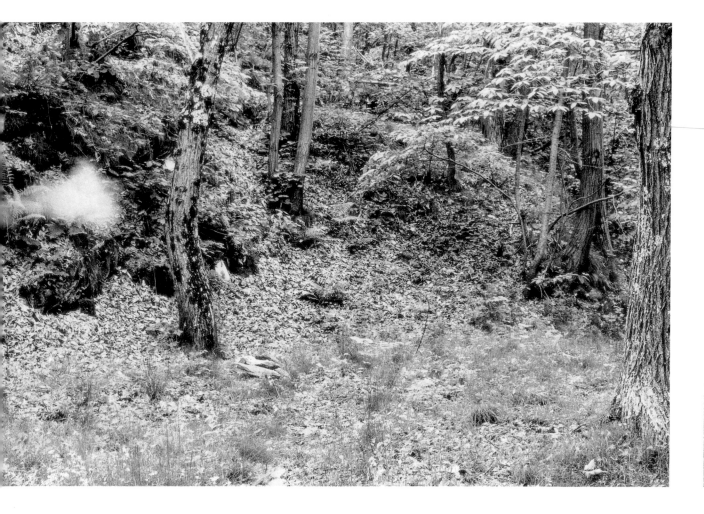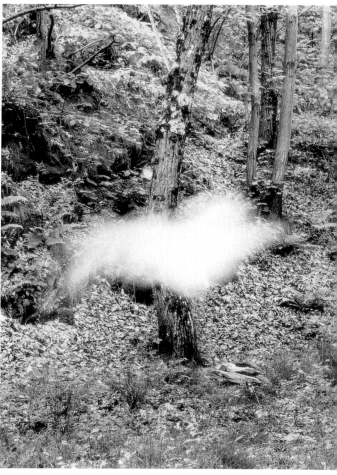

FIRST BREATH
from *To Breathe*
a series of six sets of three photographs and one single image
(studies for the *Soffio* sculptures, one of which is illustrated on p.158)
1977

dust, trees

'Talking about a work of art, or even describing it, is always a kind of
betrayal, because the language of writing and the language of sculpture
are very different. But what I can say is that [this work] draws attention
to the transformations of space that take place when we breathe, or
touch a surface.

'This work is a reminder that every breath we exhale is an introduction of
one body of air into another, and that, in a sense, our innermost being is
identical to and cannot be separated from the world around us.'

Giuseppe Penone 1999

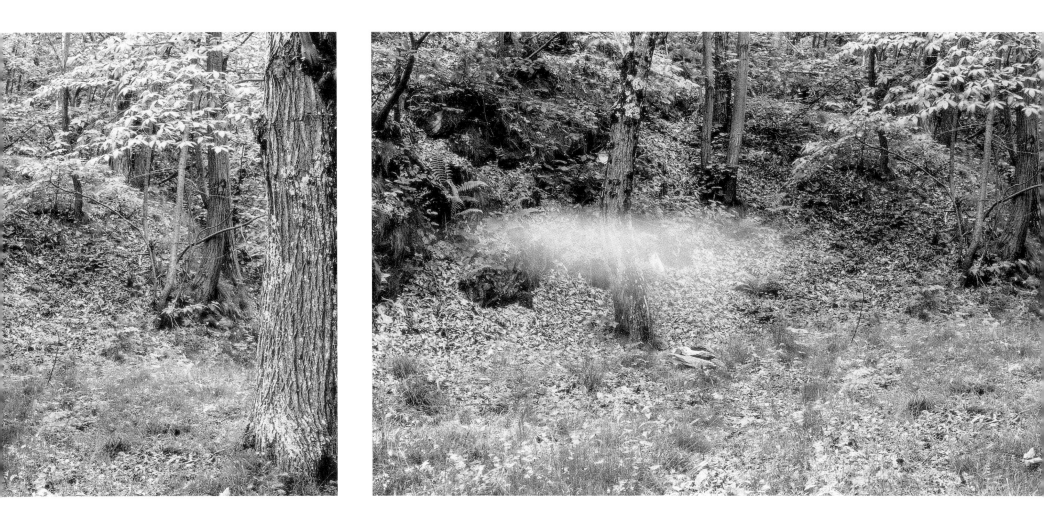

one could do something different. It was trying to change things. Other older artists were perhaps able to wield power more effectively than younger artists.

WF Thinking for a moment about artists in America that used the land like Smithson and Michael Heizer, who carried out enormous interventions in the landscape leaving what some people might see as huge scars, working on a monumental scale, it seems to me that you work has been much more to do with uncovering or retrieval or exposure rather than being a dramatic re-presentation of nature.

GP I think that with the work in nature of American artists, such as Heizer, the problem is the monumentality of the work. It's not so much a problem to do with the art; sometimes you can see forms that are quite close to Malevich or some other form that you recognise, but what is surprising is the *size*. You would need a 'plane to see the piece. What also happened was that the photo became the piece, the piece that was sold in the show, and this, in a way, is a nonsense. There is also a big difference in terms of the kind of nature that surrounded the artists. In the United States there is still nature that is real nature, you can tell that it is not

a product of man, but in Europe every tree that you see has been planted by man and is part of an *organisation* of nature, so it is not possible to think in the same way. Europeans need always to think in terms of history. We cannot forget it and if you have to think in terms of history you think in a different way. If, for example, there are two sculptures in a square, one 300 years old and the other contemporary, the act of looking at them is the same. It is only memory or culture that creates a distinction in your mind between them. Where there is a new view of reality, it is possible to forget history, and perhaps that is necessary sometimes.

WF Do you think about these things when you decide to make a work, or are there other ideas that you have in your mind?

GP This is not what you think about when you make a work. But you have general thoughts in the back of your mind and sometimes this can help you to make a good work. But that is not what you are thinking about all the time. You have to understand that simple fact to be able to make a work because if not, perhaps you will think you have no reason to make it, or perhaps you will make the wrong

work. You have to think about the reality of where you will install the work.

WF So that is an important factor for you, the context where you install the work?

GP Well, the context is more conceptual than physical.

WF What do you mean by the conceptual context?

GP Here is a very simple example. When I make a work on a tree growing in my village, where I go from time to time, that work has a meaning for the people of my village and has a completely different meaning for people in town. This is what I mean by the conceptual context.

When I present a work in a town like Paris, a work that I have made in the village, I know that this work has a different meaning for the people in the town, and there is another kind of response. If I can, I place my work not just in the context of the space but also in the context of the thinking of people and, perhaps, their way of seeing nature. People in the town think nature is something different from man, for example, so if you say it is the same thing, it becomes a dialectical problem, not just a problem of form. It's not just a work about a form in art, it is also a work to do with language; it embodies a dialectic between different conceptions of reality. I believe that every good work of art creates a dialectic.

WF Germano Celant [the critic who coined the term 'Arte Povera' in the late 1960s] made an interesting observation when he said, 'Our culture has separated one way of thinking from another, the human being from nature. I don't believe such a clear distinction can be drawn.' That seems to be what you are saying, that you don't accept that there is this clear distinction. And you've said something else, that 'one of the problems of sculpture is contact, the idea by itself is not enough, it doesn't work; an action is necessary, and this action is transmitted through contact.' Is that a reference to the fact that conceptual art is non-substantial?

GP I say that because people sometimes think that art is a problem of perspective, of how things are seen, but to understand what you see, you need to touch. If you don't walk, you don't have any idea of the distance between two points. It's only afterwards that you have the experience of the space through your body. Then you know what the distance is from seeing it, from your view, and you understand the space and you understand the form, and you understand whether the material is hard or soft, and so on. This is because your eye gradually learns how to see, but the first experience one has as a child is a tactile experience. Education makes us forget part of that, but when you make a sculpture you have to remember it, because if you forget, you will make a work which is based on convention, a convention of view, but it is still a convention. If you make work that is about the reality of the material, then it is not about a convention of view. Using your hands

to make a work is also valuable because you gain a knowledge of the material and sometimes of the process, and that experience and knowledge are not things you can have just by thinking or by looking. If you work just by thinking, just by eye, and you don't have your hand on the material, in time the work becomes very conventional – it may be your very own convention, but it's still conventional. If you can relate to the material, the work will be less conventional, more living: this is my personal thinking about how to make a work.

WF So that physical contact with the materials is an absolute prerequisite and the starting point, maybe?

GP You could say that it is a starting point in my work. The first important work I did was basically about the relation between the tree that was growing and my body. It was not a problem of intelligence, of mind, it was a problem of material and body – one material within one kind of time, that was the tree, and another material with a different timescale, my body, my person. The work was about giving to the material, the tree, my time, or, about me taking on the time of the tree: it was about physical experience. I could have explored the same problem idea through another form, but I think the body was the right one, because it meant that two different living forms were being placed in relation to each other. Man was not more important than the tree. The two elements had equal value.

WF In that work that you have just described, what did you do with the tree?

GP If you were to grasp the trunk of a tree in your hand and if you were able to stay in the same position year after year, the tree would not be able to grow at that point of contact, it would grow around your hand. But you cannot stay there for that long.

WF So you made an artificial hand?

GP The artificial hand related my time to the time of the tree. This was not a normal way for the tree to grow, but it revealed the tree as being almost like clay. You think of it as a hard material, but it is also soft. By intervening in the tree's time, you change conventional ideas about the nature of the material: the tree is thought of as solid, but it's not, it's fluid.

WF You have referred to ideas about hard and soft haven't you? And how in the end there is no such difference: the two are the same thing.

GP Hard and soft. Sculpture, as a form of art, is a language. And you don't have a language if you don't have contrast. And in sculpture, the contrast is between soft and hard. If you look at Renaissance sculpture, you see the body, and there the contrast is not between different materials, because you have the same material. The contrast is between different levels of pressure on the same material and how

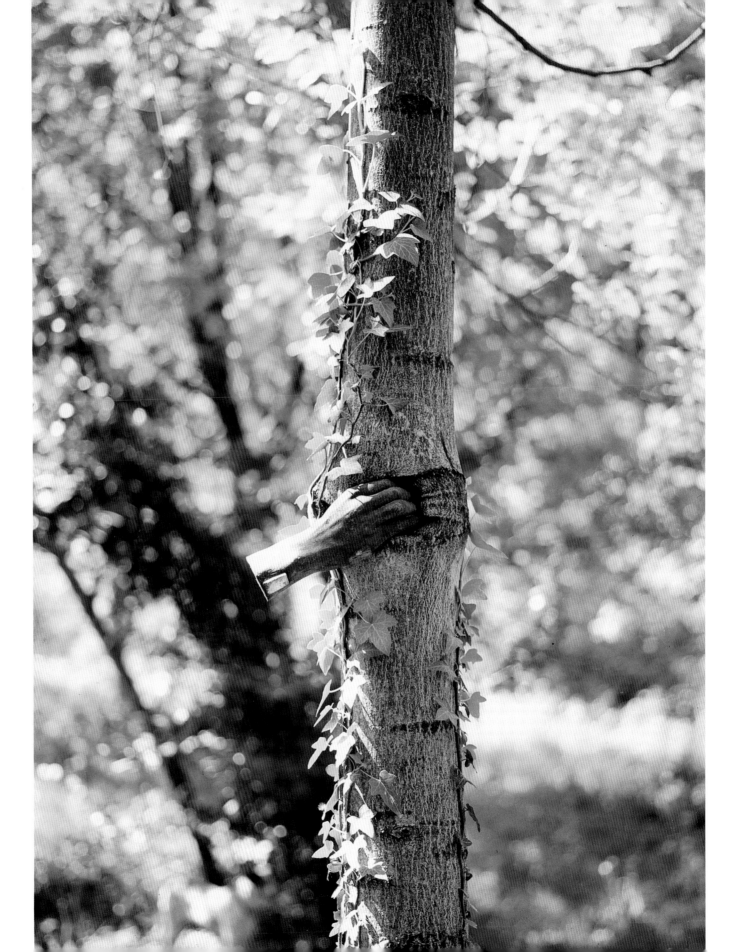

CONTINUERA A CRESCERE TRANNE CHE
IN QUEL PUNTO/IT WILL CONTINUE TO
GROW, EXCEPT AT THIS POINT
1968

Photograph of work in progress

The tree, once it has lost or consumed every trace of
emotional, formal and cultural significance, appears
as a vital, expanding element, proliferating and
growing continuously.

To its energy, another energy is attached – mine. Its
reaction is the work. GP 1968

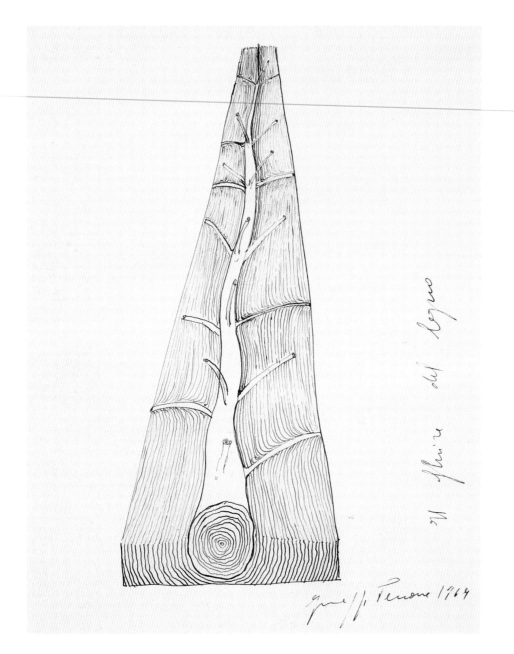

IL FLUIRE DEL LEGNO/THE FLOW OF WOOD
1967

Indian ink on paper
32 x 24 cm

it reacts to these. You might see, for example, the pressure of the hand on the body of a woman, so you have a sense of the pressure being hard and the body being soft. Contrast is the basic element in language and in visual language. That's also how poetry works, isn't it? You say that fire is cold, and that is a contrast and it becomes interesting. If you say that fire is hot, there is no contrast, it's obvious, and it leads nowhere.

When I made the work with the hand, I thought, if I can stop the growth of the tree at the point where my hand touches it, then, when the tree has entirely enveloped the hand after 30 or 40 years, I could come back and, by carving, find the exact point of contact between me and the tree – a memory within its structure. Then I began to think about the fact that timber still contains the form of a tree, and I took a piece of wood and started to open it by carving it, following a growth ring and cutting away all the wood around it. By following the growth ring, I discovered the form of the tree and the knots indicated where I would find a branch. I started carving and cutting away in the middle of the piece of wood and I worked in one direction towards the base of the tree and in the other direction towards the top.

WF Is that sculpture something that can be seen purely as an aesthetic object?

GP When an artist makes a drawing, he is a man who has found something, who wants to show you something that is in the material. When a prehistoric artist made a sculpture, it might have been because he had found a stone that was like an animal and he just decided to do something to make that animal visible. The form already exists, and the artist works to show it: the work itself shows that is related to reality. You can find this in Michelangelo Buonarroti: he says that what he was carving was already in the block, he just opened it up. And Duchamp, too, when he showed the *Pissoir*, he said it was the Madonna. He found something that became visible once he had shown it. Perhaps if he hadn't shown it, we wouldn't see it: that's a basic concept of making sculpture, I think. And I found the tree that was in the block of wood. That is a very traditional way of thinking in sculpture.

WF This piece was made specifically for gallery presentation. Would you ever show it in another setting, outside, for example?

GP No, it wouldn't be possible to show it outside for conservation reasons. Nowadays I am given opportunities to show this work in big spaces. When I made the first one in 1969, it was three metres long. That was not really very big and after I'd made it I felt it was too easy just to see it as an object. I wanted to keep the feeling of the size of a tree in relation to the human body, I didn't want to lose that poetic sense. If it were an object that was easy to install in a house, perhaps I would lose the value of the idea, so I made pieces of seven, eight, twelve metres. Nowadays there are very big spaces everywhere to show in, and they are perfect

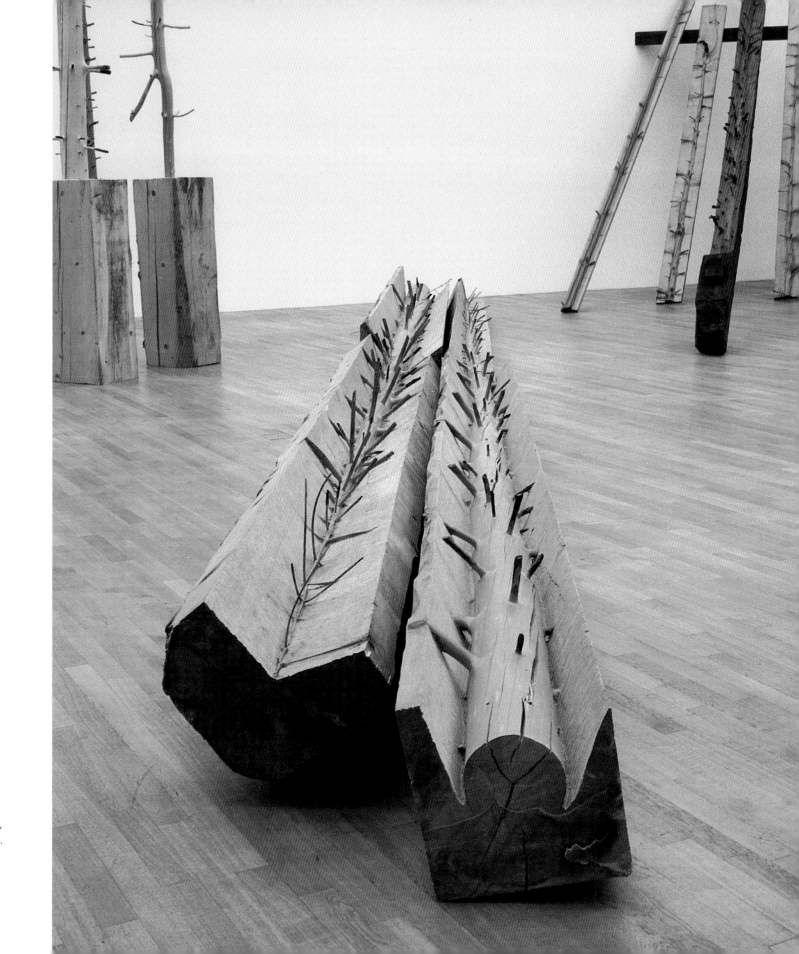

RIPETERE IL BOSCO/
REPEATING THE FOREST
1969-1997

Kunstmuseum Bonn, Germany, 1997

. . . forests, avenues, woods, gardens, parks,
orchards : their trees are sealed inside doors,
tables, floors, planks, beams, boats, carts . . .

GP 1968

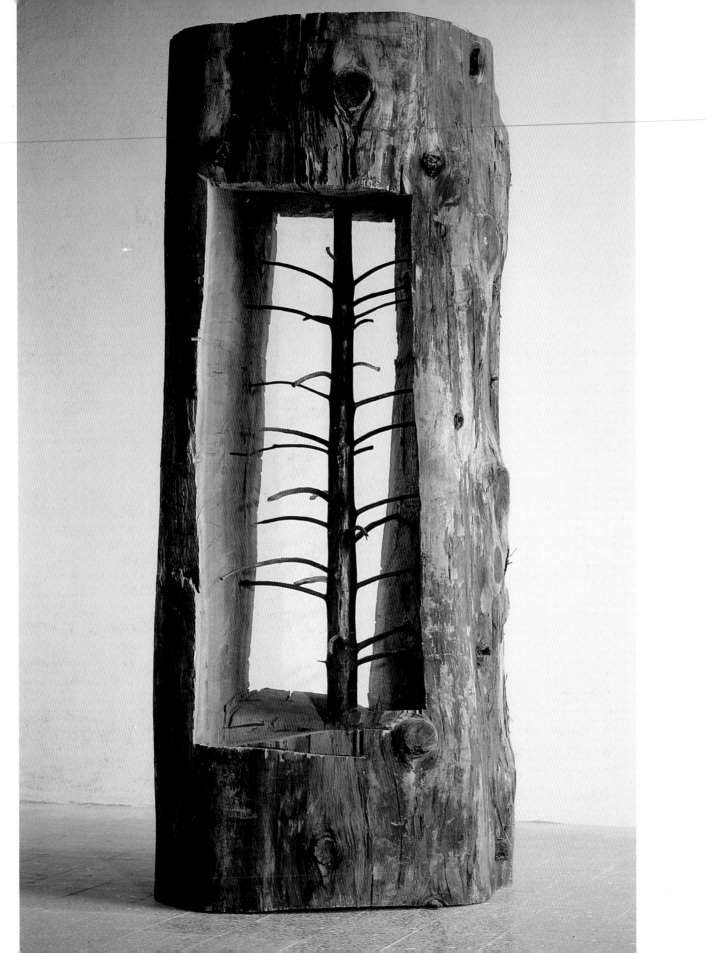

ALBERO-PORTA/TREE DOOR
1993

cedar
250 x 120 x 120 cm

ESSERE FIUME 1, 3, 4/TO BE RIVER 1, 3, 4
1981-97

stones: in each pair, one found in the river, one sculpted
Kunstmuseum Bonn, Germany, 1997

objects for such spaces, but when I made them, I didn't yet know that I had the space to show them. I still don't, necessarily.

The value of the work doesn't change whether it is in a museum or in a street. It's always the same. It doesn't need the context of the space to exist. It's like a stone, it's like a man. It's something that always has its value. Perhaps if it is in a museum all the people will think it is an art object; if it's in the road, perhaps some people won't. But that's an art problem. The work itself doesn't change.

WF You have spoken about making a work in your village that refers to what you've described as lost histories, things that don't mean anything to people unless they are part of that culture. Richard Long makes works in the landscape but he isn't interested in people going to see them. They exist purely to be photographed. Is there any parallel in your work with the idea of working in isolated places where people are absent and then bringing the work back into the art world to be validated?

GP I think that perhaps that kind of work was necessary especially in the 'sixties, because if you made it where there were people, it became like a happening, like a piece of theatre. So you had to do it in an isolated way, because if not, it would lose its power as a sculpture, it would become other things, it would become just another work. When I do that kind of work, I try to do it in a place that is related. Perhaps after they have seen it, people will ask me about it. But for the people in my village it does not seem surprising, because it's part of their culture to do things with trees. For example, they prune them so that they will produce bigger fruit. They are working hand-in-hand with nature, but they are also changing the form of the tree; so for the people of the village, my work is not so strange or astonishing.

WF When you leave the village, you carry with you ideas to do with cultivation and hunting and what I think you called 'lost economies' – fishing and so on,

The river is endowed with a marvellous agility, its course is continuous, insistent, methodical and eternal.

The mass of water tells us that it runs, it flows, it slides, but this is only as far as the eye is concerned; for the earth touched by the river, it is rough, dry, harsh, nervy; it presses down on the earth, stirs it up, flays it.

The grinding of the rocks when the river is in full spate, the continuous scratching of the sand, the perpetual movement of the water over the river bed imprinted by the gradual movements of large rocks, the slow moving around of medium-sized rocks, the faster scattering of pebbles, the rapid flowing of fine sand creating a veritable river within a river.

The river transports the mountain; it is the vehicle of the mountain. The battering, the blows, the violent changes effected by the river hurling smaller stones at larger stones, the water that insinuates itself into the thinnest joints, into cracks, causes fragments of rock to come away so that the mass of stone is slowly made smaller, subjected to an endless working away with small and large impacts, light scraping by sand, rock-splitting blows, gradual wearing away under great pressure, dull blows. You discover why the aim of the river is to reveal the essence, the purest and most secret quality, the most compact quality of every single rock: forms which already exist and are present in all stone, a quality which is in every single rock.

The river reveals the matter and the form that will endure and draws the rock closer to a state of calm. Everything that it produces, whether tiny or huge, aspires to the same quality, obeys the same call to content and form, a desire to aspire to the absolute.

The stone which used to be alive and part of the great life of the mountain, becomes, once it has become detached, by virtue of its matter and its structure, dead and suspended in time, awaiting its own perfection. The river, by doing its work, is capable of accelerating this process, allowing the stone to attain a state of calm.

It is impossible to think about or work the stone differently from the river. Chisels (pointed, round-ended, serrated, straight-ended), abrasive stones, glasspaper, these are all the tools of the river.

Carrying away a stone sculpted by the river, following the river towards its source, discovering the place in the mountain from which the rock came, extracting a new block of stone, and repeating exactly what happened to the river stone on a newly quarried block of the same stone is to be river; producing a stone from a stone is the perfect sculpture, it re-enters nature, it is our cosmic heritage, pure creation; the natural quality of a good sculpture gives it a cosmic value. It is the fact of being river that makes it a true stone sculpture. GP 1981

somehow or other they're all embedded in the kinds of values with which you invest your materials when you work with them. In one piece you've brought stones into a gallery from a forest or from a quarry and then in another there seem to be traces, ghostly suggestions of people, of figures in the landscape.

GP I found a stone in a river in the mountains and then I went back to a quarry near the river, and I took a block of stone from there and I carved it into exactly the same form as the river stone. This was because the process of sculpting stone is very similar to the process that happens to a stone in the river, where sand and water wear the stone away. And in my opinion that is a perfect way of making a sculpture. That tautology was the idea of those pieces.

This work is actually similar to the tree pieces. My work was just to follow the form of the stone from the river, so I became like the river. I made a work that was close to the work done by the river. Its title was *To Be River*. In a photograph it is hard to see that one is carved and one is from the river. If it were a photo of a person and a sculpture of a person, that would be easy, but with a stone it's not easy, because we have so few ways of understanding form. We just understand form that is human, we understand anthropomorphic form and animal forms. That is why I have to show the two stones together, because if I didn't, nobody would understand that my stone is a work.

In the works where I discovered the tree in a piece of timber by carving, the wood was static and the form I found in it was fixed whereas the human action was dynamic. But there is another work, *Gesto Vegetale/Vegetal Attitude* (1983), in which the reverse is the case: there is the shell of a human form cast in bronze and a tree is planted inside it: as the tree grows it generates a human figure, so the human form is static and the tree is dynamic.

WF What about *Soffio di Creta* (*Breath of Clay*), this ceramic work? It has a kind of organic quality to it.

GP This work is made of clay, terracotta. I was thinking about breath. When we breathe we take air in and then expel one body of air into another body of air, and this is already a sculpture, because you are changing the space, you are enclosing one form in another form. But it's not visible, except perhaps in winter when it's very cold, and I thought that earth was a good material to make a representation of the shape of a breath that is blown out. Looking at the form of breath, it will always have the same form. It's like the breath in glass-blowing: when you blow the glass, your breath takes the form of the glass. Well, breath has a form that is very close to that of the interior of the body, like the negative form inside a coffin. Incidentally, the first sarcophagi were made of clay.

WF Yes. It seems to evoke the idea of an interior space: the negative space of the lungs; it's a thing that has an inside as well as an outside.

PATH 3 (SENTIER DE CHARME)
1985-86

bronze, vegetation
180 x 60 x 500 cm
Park of the Domaine de Karguéhennec,
Bignan en Locminé, France 1986

Penone made a human form in clay. While the clay was still soft, he made hollows in it with his hand. The empty spaces thus created were then filled with wax, and the wax, once firm, used to make bronze casts. The same method was used to sculpt the path trodden by the figure, evoking the rise and fall of each foot as well as its contact with the ground. Finally a sapling was planted within the figure.

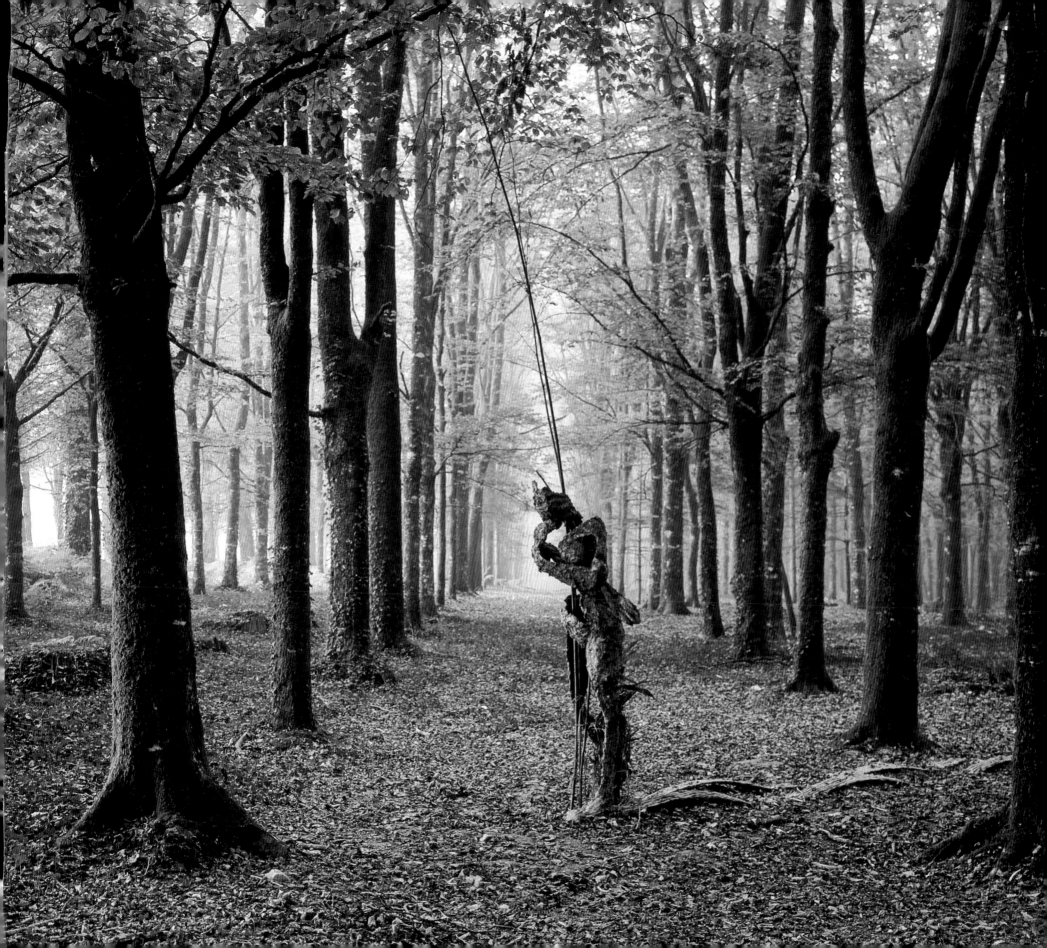

SOFFIO n. 7/BREATH no. 7
1979

terracotta
180 x 60 x 60 cm

ZUCCHE/PUMPKINS
1978-79

bronze
40 x 80 x 130 cm; 40 x 80 x 110 cm

GP One of the first works that I made in bronze was a negative mould of the human face, and I put a little pumpkin inside and as the pumpkin grew it took on the form of the face, and then I cast the pumpkin in bronze. I did that because bronze is a material that is very close to the vegetal. It is a material that can change with the patina, it takes on the colour of the atmosphere, of the landscape; rain makes it green like vegetation. The process of casting in bronze refers back to a time when there was a strong sense of animism in things. In this ancient process, which still exists today, tree branches are often used to make the connection between the different parts of the sculpture, to distribute the bronze through the work. Because of this very strong sense of the equivalence of the natural object and bronze, I feel that bronze is the material to use if you want to make a permanent image of vegetal plant material. I have cast a big tree in bronze for that reason. So I use bronze for works related to vegetation, but not for other things.

WF It has that resonance, doesn't it? It makes permanent something that will decay, something that is ephemeral.

GP It becomes a permanent cast, like a fossil. There is a big branch from a tree that I cast in bronze. There had also been a smaller branch that had died and in the place of that branch I put some clay. I made an impression of my hand in the clay, and from each finger water flows, and the water goes into the hand and after that down into a well: I did this because the fluidity of the tree and the water have the same form, the same structure. So the river has the same structure as a tree, the tree has the same structure as a hand, the hand can have the same structure as the lava from a volcano when it is flowing, so there is a kind of *structure* of fluidity. That work was about relating together different elements that usually, culturally, we distinguish between: river, tree, human. It shows that they all have the same structure.

159

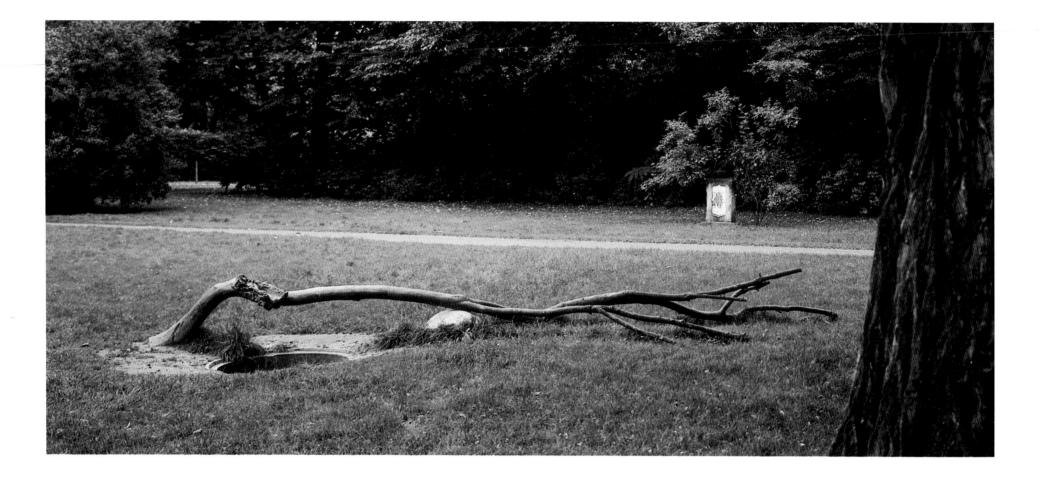

POZZO DI MÜNSTER/MÜNSTER WELL
1987

bronze, water
100 x 800 x 300 cm
Alten Hörster Friedhof, Münster, Germany

The water that flows underground, which knows the secret of the ground below the surface. The mysterious sound of water when it drops into a well and produces a circular movement. The cylinder of air penetrating the earth. The five sources of the fingers all descending towards the confluence of the palm of the hand, with the water flowing into the arms and thence into the well. GP 1987

WF Yes. And again you've relocated it back into a natural setting. Or is that just for the photograph?

GP No. That work was located in a garden, it was close to a big tree where it became like one of the branches that had fallen from the tree, and you had that water flowing down, like a spring.

WF Can we talk about this next work, which looks like a cast of a branch or of a stem placed back into the setting of tree's own branches?

GP This is a branch that is cast in crystal, and then relocated close to the kind of tree from which it was originally taken. Wood is carbon, and glass is silica: two elements that are basic for chemistry, one an organic chemical and one an inorganic chemical. In fact, these two elements are very close, with very similar characteristics. And you have two worlds that are in competition: one animate and the other inanimate. Of course, the whole structure of a tree is determined by the need to catch light, because light gives life to the tree, and when the rays of light enter the glass they are not dispersed, because the rays are parallel. So there is a lot of relation between two elements that are nevertheless completely different. And I was fascinated by this paradox: a contrast where the two things are in fact very similar.

WF Your work is often referred to in the context of the Arte Povera movement of the 1960s. How do you feel about being identified in this way? Is it a useful definition of your work or is it just a historical label?

GP This was a group of artists working in the same period who showed the same general feeling. Germano Celant made a book in 1969 which put together the work of different artists – Italian artists, German artists – and the title of the book was Arte Povera. What they had in common was perhaps more to do with the fact that they were responding to contemporary reality, with reflections about society, than it was about belonging to an art movement. We did several shows together, but if you look at what was shown, the artists were producing very different work.

WF It was a time when social and political change seemed inevitable. The artists in Celant's book seemed able to do many different things; the art came out of many different sources. It wasn't an orthodoxy, there wasn't a formalism. What emerged came from very independent positions and was often to do with materials and the celebration of materials, or with the land and the artist's relationship to the land.

GP This use of materials was also a reaction, mainly on the part of European artists, although there were a few Americans, to the iconography of pop art, because at that moment American art was very strong in terms of political power, and its art was like a kind of colonialist art.

Overleaf, left to right

TRAPPOLE DI LUCE – CARPINO/LIGHT TRAPS – HORNBEAM
1994

TRAPPOLE DI LUCE – NOCE/LIGHT TRAPS – WALNUT
1994

TRAPPOLE DI LUCE – NOCCIOLO/LIGHT TRAPS – HAZELNUT
1994

TRAPPOLE DI LUCE – CASTAGNO/LIGHT-TRAPS – CHESTNUT
1994

crystal, tree

The gaze falls upon the bark of a tree, the form of which is the space that is enveloped by its skin.

It is difficult to keep your gaze fixed on the surface of the crystal. The look goes through crystal in the way that light goes through it, insinuating itself into the brain.

Crystal does not have a single skin, a single point where the look can rest; it is the sum of innumerable skins.

Innumerable trees, innumerable skins of bark. When the look rests on the outside of a forest, it takes in innumerable skins of trees, of innumerable years' growth.

The look goes through the trunk of crystal, back through years, and the skins of the trunks, and we eventually come to see, in a small space, the infinity of time.

GP 1995

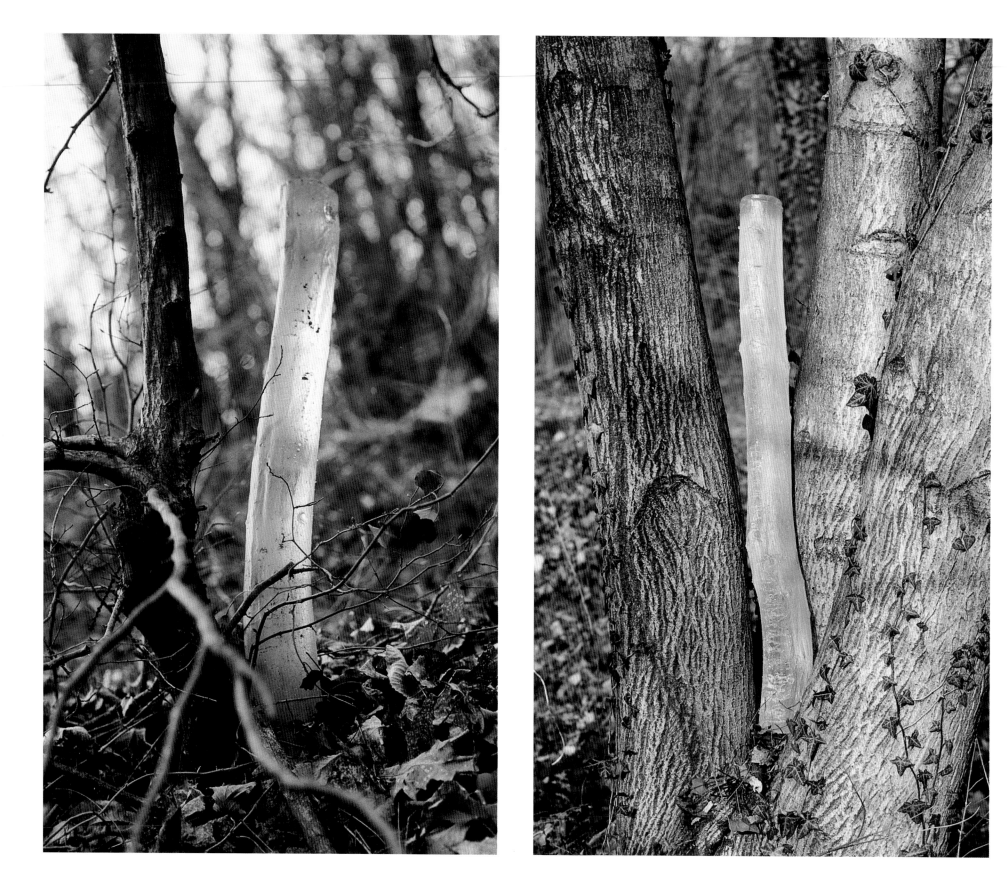

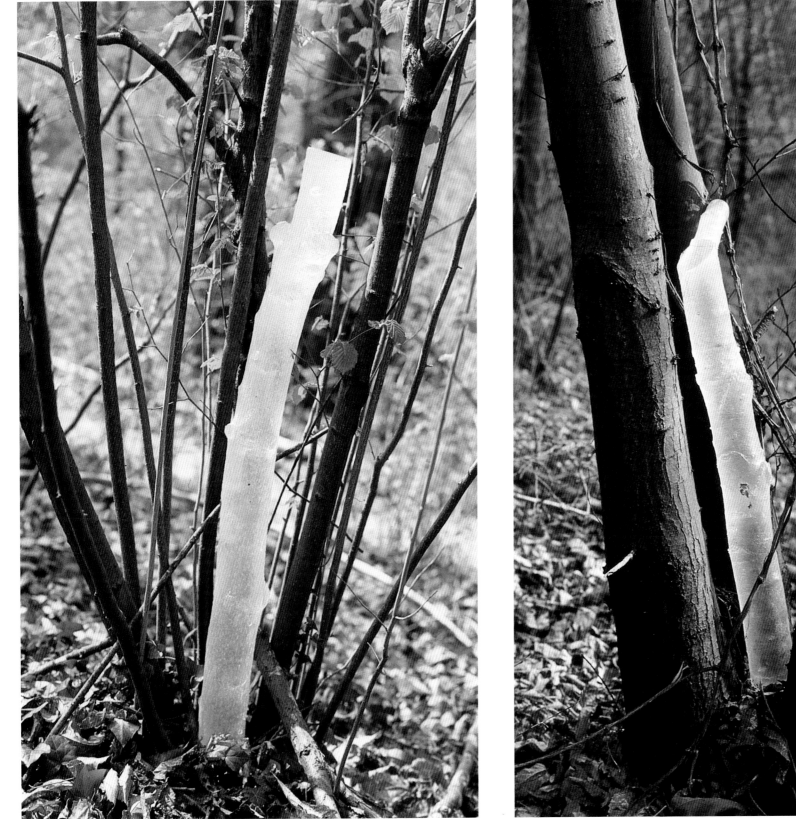
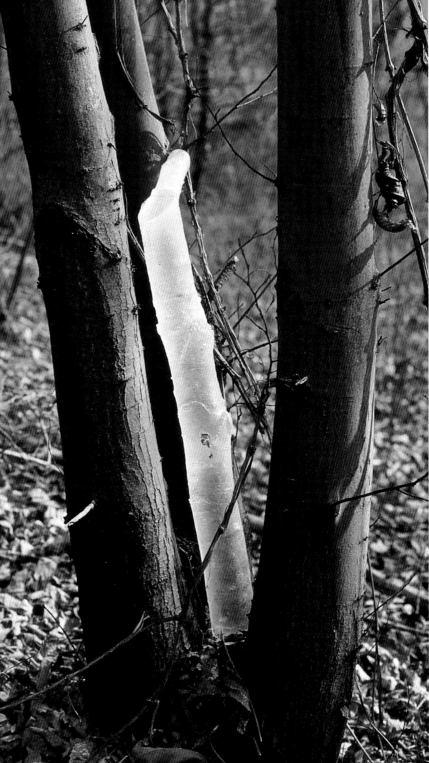

WF So you see Arte Povera as a reaction to that?

GP Pop art at that time was very strong and very clear, and I think it was good, it was interesting, but there *was* a kind of reaction to it. And the use of the materials chosen by me or other artists, was a reaction to that idea of art based on media. It was not a matter of refusing to accept it. The problem was one of identity. We live in Europe, and we have an identity, a strong identity. And this was to do with different ways of feeling in terms of culture and how that is expressed in form.

WF Do you work in a studio?

GP Sometimes I work in studios. But usually I don't need that kind of space. It is not a real studio where I work.

WF I'm interested in your working methods as an artist. When you make a work, what is the starting point?

GP Mainly when I make a new work, it reflects a need that comes out of a line of thought, it is a reaction to reality.

WF Do you use a stock of materials that you have in the studio or do you start with an idea?

GP I find the material, I find the form, but usually the work comes out of an idea. It doesn't come simply from the material, no. I made a wall with leaves which was about shadow. In painting, you can have a painted shadow, but not in sculpture. How do you make a shadow in sculpture? I made a piece with leaves, because leaves are related to the idea of shadow. There is an association between leaves and shadows. And I constructed walls that were flat boxes made out of wire mesh, like a cage, and filled them with leaves. It was the idea of shadow that started the piece.

WF In a way this is another work like the one to do with breath. You are making permanent things that in nature are ephemeral, like breath and shadows. When

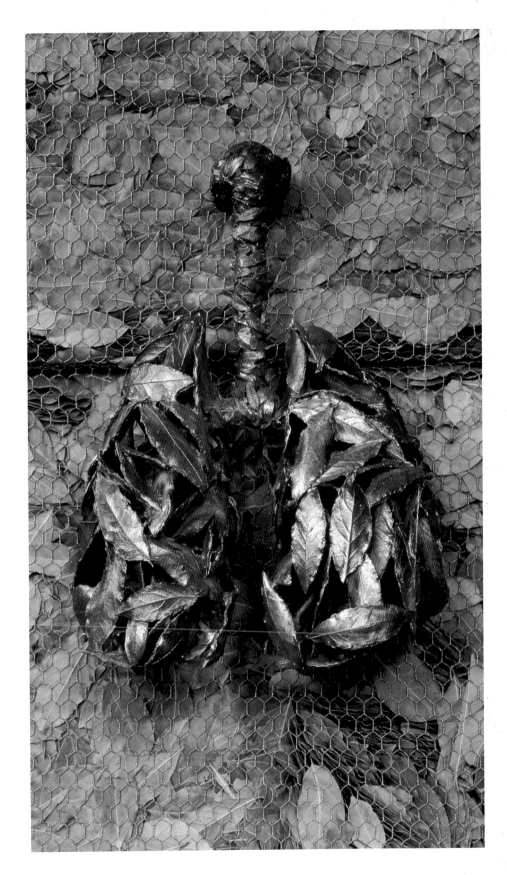

RESPIRARE L'OMBRA/TO BREATHE SHADE
2000

bronze, bay leaves, chicken wire
468 x 549.5 x 7.5 cm
Synagoge Stommeln, Pulheim, Germany

Cages of bay leaves cover the walls of the room, and the visitor is plunged into an aromatic environment. Bay was chosen by the artist not only for poetic reasons, but also because of the durability of its leaves: the fragrance endures and the leaves' colour varies little with time. A bronze sculpture of lungs is fixed to one of the cages; for the artist, the shadow is not threatening but beneficent: that of protective vegetation which gives off oxygen and absorbs the carbon dioxide exhaled by lungs.

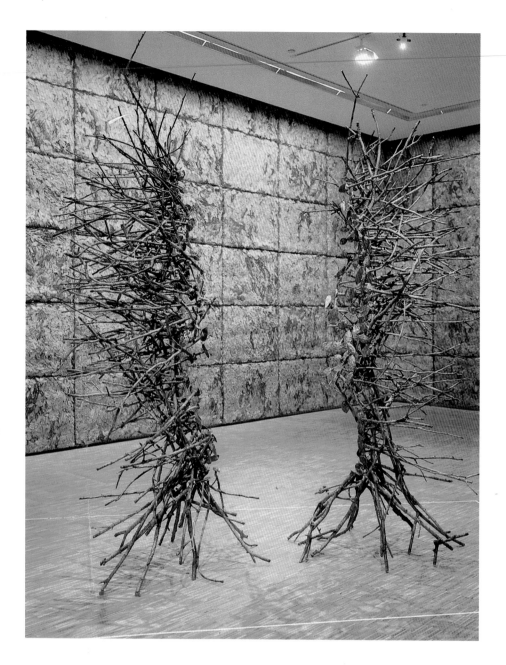

PELLE DI FOGLIE/SKINS OF LEAVES
bronze
2000

Penone made a plaster model of the human form, which he then split longitudinally so that it could be laid flat on a work surface. He laid bronze leaves over the form, as if to create a skin, and attached bronze branches to the leaves to make a structure and to hold the leaves in their original positions. The pair of sculptures, intended to complement the work *Respirare L'Ombra*, thus enclose an anthropomorphic void.

the leaves are cast in bronze, something that is ephemeral is fixed in time. Why does this idea of 'fossilising' something interest you, this idea of making something permanent of the ephemeral?

GP Perhaps because it is to do with the tension of contrast. If you make something stable that is not usually stable, you make language, or communication, or a discourse, possible.

I think there is perhaps a difference between artists from Europe and artists from America. European art is usually informed by a history of ideas, and forms tend to be produced as alternatives to what has gone before. American art, on the other hand, is less inhibited in this respect. In addition to this, art in America came to be thought of as a product, more than is the case in Europe, and there are issues or problems that surround the relation between the artwork and the market. The problem with the market is how the artist can retain control over the form of the work; the work itself must be controlled by the artist. This was one of the ideas of the 'sixties, and it marked a big shift. If artists make the same form over and over again, then it's easy to sell, because it's easy for the collector to recognise the artist from the form – almost like a kind of branding. It's a kind of simplification of the problem of the art. But if you continually redefine the form – perhaps it's the same idea and a different form – you change that process. Each time you have to *think* about the work, and that is not easy. It also creates problems as far as disseminating the work is concerned, but at the same time I think it is more interesting for the artist making the work.

WF The kind of work you're doing cannot be given to twelve assistants to make in the way that Warhol might have done, for instance, or as Donald Judd did if he sent the pattern to his assistants or even as Lawrence Wiener does in sending his text to someone to fabricate in situ. That very close engagement with the object itself is something that does identify what you are doing with the practice of a number of other artists. Richard Long, for instance, doesn't have assistants; Sol Le Witt does. You have to maintain that personal engagement.

GP Yes.

WF In America, being an artist is bound up with the sense of dominance and authority. In the 'fifties, Abstract Expressionism became a vehicle for an international cultural statement. Perhaps in Europe art hasn't really ever been used in that way, at least to the same extent. How does the way Beuys thought and worked as an artist fit into all this?

GP Beuys's work started in the 'fifties, and it was close in conception to other art of that period. Soon after, he changed and his work became more to do with performance. For me, his work was not especially relevant. Beuys was a good

RESPIRARE L'OMBRA/TO BREATHE SHADE
1997-99

five bay trees (480 cm high), bronze (242 cm high)

Five bay trees enfold the space of a human body
made from bronze bay leaves fused together.

artist, and a good artist is always a miracle! But I was amazed by his ability to make himself a king in a public context. On the whole, I was more impressed by this than by the work. Beuys had a vision. But I think his influence was felt most by the new Expressionist painters. The media never stopped talking about him, and, in my opinion, that eroded some of the mystery and appeal of his work.

WF I mentioned Beuys because of the way in which he talked about his drawings, which drew on sources in legends and myths and were concerned with the processes of life and with his own personal history. I saw some possible parallels there in terms of objects and materials being worked through and explored. It's almost the opposite of what you've been saying in terms of influence. What you are saying is that at that time – in the 'sixties and 'seventies – you created your own objectivity and worked with a sense of identity that wasn't to do with influence.

GP The culture that existed in Europe between the two world wars was a culture that became more and more limited to a highly elitist social group and it excluded many people. You had to know people in order to be inside the art world, and to understand what was happening. At the end of the 'sixties, the situation was then reversed, and suddenly art could be understood by large numbers of people coming from different cultures. European artists, I think, went deep into European culture to find elements that were not exclusively European, but had aspects in common with other cultures that could be understood in Japan, in Africa, in America, anywhere. Perhaps the artists didn't realise they were doing that, but that is what they did. I think I also did something similar. It was to do with finding an identity that is separate from or beyond the immediate social context, something that is deep in our subconscious, an identity that can be easily understood, no matter where you come from. That was a huge change in terms of our thinking about art.

Paris, April 1999